BLUE RIDGE PARKWAY

America's Favorite Drive

THROUGH TIME

AMY WATERS YARSINSKE

AMERICA
THROUGH TIME®
ADDING COLOR TO AMERICAN HISTORY

America Through Time is an imprint of Fonthill Media LLC
www.through-time.com
office@through-time.com

Published by Arcadia Publishing by arrangement with Fonthill Media LLC
For all general information, please contact Arcadia Publishing:
Telephone: 843-853-2070
Fax: 843-853-0044
E-mail: sales@arcadiapublishing.com
For customer service and orders:
Toll-Free 1-888-313-2665

www.arcadiapublishing.com

First published 2018

Copyright © Amy Waters Yarsinske 2018

ISBN 978-1-63500-067-2

Typeset in Mrs Eaves XL Serif Narrow
Printed and bound by CPI Group (UK) Ltd, Croydon CR0 4YY

CONTENTS

Introduction – An All-American Road 5

 I A Way of Life Fades from the Hollows and Hillsides 9

 II America's Premier Scenic Byway Comes to Life 41

 III From Milepost Zero – Virginia 85

 IV Folklife Legacy 117

 V Magnificent Mount Mitchell 151

 VI Where Construction Began and the Parkway Ends – North Carolina 178

 VII Must-See Mileposts 205

Endnotes 236

Select Bibliography 246

About the Author 249

Introduction –
An All-American Road

The Blue Ridge Parkway is many things, the National Park Service informs all who explore "America's Favorite Drive." The parkway is the longest road planned as a single unit in the United States – the first long-distance rural parkway developed by the park service – and it is an elongated park, protecting significant mountain landscapes far beyond the shoulders of the road itself. But what else is it? According to the park service, it is a series of parks providing the visitor access to high mountain passes, a continuous series of panoramic views, the boundaries of its limited right-of-way rarely apparent and miles of the adjacent countryside seemingly a part of the protected scene. It is a series of nature preserves replete with high mountain fastness, splendid natural gardens of flowering mountain plants, waterfalls and water gaps, deep forests and upland meadows. It is what they call "a museum of the managed American countryside," one that preserves the roughhewn log cabin of the mountain pioneer, the summer home of a textile magnate, and traces of early industries such as logging, railways, and an old canal. It is miles of split-rail fence, moss on a wood shingle roof, broomcorn and flax in a pioneer garden. It is picnic pullovers, observation points that open up to extraordinary views of mountain ranges and valleys and a stopping off point to purchase the arts and crafts of the mountain artisans. It is the fleeting glimpse of a deer, a bear, a wild turkey and perhaps just something a bit more domesticated – a herd of cattle, a pasture filled with horses. Yet there is more – so much more. The Blue Ridge Parkway is the product of a series of major public works projects that provided a boon to the travel and tourism industry and helped the Appalachian region climb out of the depths of the Great Depression. This extraordinary engineering marvel extends nearly five hundred miles along the crest of the Blue Ridge Mountains through Virginia and North Carolina, encompassing some of the oldest settlements of both prehistoric and early European settlement.[1]

Traveling the Blue Ridge Parkway, the scenes change from miles of untouched natural beauty to those reshaped by human development. Visitors are reminded in its length and breadth of the culture and history of the Southern Highlands. Stanley William Abbott (1908 – 1975), a gifted young landscape architect and first superintendent of the parkway, reflecting more than two decades later of the importance of planning and development of the winding roadway, observed: "[...] and then we accept another responsibility when we make the determination to let people into the park or preserve in order that they 'may enjoy.' Then we do indeed commit ourselves to design. Good design implies restraint, which is creative of itself. We should not," he iterated, "minimize the art we practice. We thought positively: Now we are coming in here amidst this natural beauty. We had better design and build thoughtfully, sensitively, creatively. We had better not have dully, insensitive people doing it. It requires sensitivity to design even such a comparatively minor detail as a sign and a signpost, as you usher men and women into the presence of the natural gods, as at the foot of Old Faithful."[2]

The parkway follows its namesake Blue Ridge some three hundred-and-fifty-two miles from the southern boundary of Shenandoah National Park at Rockfish Gap in Virginia, to Ridge Junction near Mount Mitchell, where it shifts to follow several mountain ranges west of the Blue Ridge. Here it skirts the southern end of the Black Mountains, the highest range in the east, then passes through the Great Craggies before descending into the valley of the French Broad River. It then climbs along the Pisgah Ledge before crossing the Great Balsam and Plott Balsams highlands and dropping to its terminus at the Oconaluftee River near Cherokee, North Carolina, at the boundary of Great Smoky Mountains National Park. The Appalachian Mountains, which include all these chains, are among the oldest in North America. Originating at the close of the Permian Era, they once rivaled the Alps in height. Over the millennia, they wore down to a fraction of their former size, but remain the highest in Eastern North America. In the Balsam Mountains, the parkway reaches an elevation of 6,053 feet, making it the highest continuous motor road east of the Mississippi River.

The parkway passes through a series of distinct ecological zones, which the National Park Service has defined and delineated in order to divide the parkway into a system of scientifically based management districts. In each of these districts, the design and management of the road is influenced by the local topography and conditions. At the northern end, the parkway passes through the Ridge District, climbing and descending mountain ridges and gaps. Most of this section is forested, though several small agricultural areas are encountered. At one point, the parkway drops along Otter Creek to the James River, but most of the zone is characterized as a ridgeline route, offering spectacular views of the Great Valley to the west and adjacent mountain ridges to the east. The broad range of elevations along the parkway offers the motorist the experience of traveling through varied ecosystems, ranging from the Southern Piedmont with its rich hardwood forests to high mountain peaks with periglacial spruce-fir forests more characteristic of northern Canada. The rich abundance of flora is one of the chief attractions for parkway visitors, and visitation peaks during summer displays of flowering rhododendron and during the brilliant fall color season. Most of the different plant zones can be observed along the road or from parkway overlooks. Some parkway trails lead

to rare patches of old-growth forest. This varied topography along the parkway reflects the complex structural geology of the Appalachian Mountains. It crosses six mountain ranges, four major rivers and more than a hundred gaps. It provides the motorist with a variety of experiences ranging from intimate glimpses of isolated mountain farmsteads to long-reaching views of the highest peaks and dizzying depths. All along the way are parks to explore, trails to wander, exhibits to visit and overlooks from which to take in the marvelous views.

Below Roanoke, the parkway enters the Virginia Plateau District. The overall elevation is lower, averaging between 2,000 feet and 3,000 feet, and much of the land adjacent to the parkway is in agricultural production. For most of the distance to the North Carolina border, the parkway closely parallels the Blue Ridge escarpment, offering views down to the Piedmont region to the east and across broken mountain terrain toward the Allegheny Mountains to the west. Farm lands characterize the region, and motorists enjoy seeing what parkway landscape architect Stanley Abbott called "a managed museum of the American countryside,"[3] replete with old homesteads, barns, fields and pasture. But this very countryside is rapidly changing as residential developments are replacing many of the old farms. The relatively narrow right-of-way through Virginia exacerbates the problem, and many of the new developments are unfortunately visible from the parkway. From the Shenandoah south for sixty miles, the parkway follows the main crest of the Blue Ridge before dropping sharply along Dancing and Otter creeks to the James River, one of four rivers to cut its way through the mountain chain. At 649 feet in elevation, this is the lowest point along the motor road. The parkway then climbs rapidly to the crest of the Blue Ridge, reaching its highest point in Virginia, Apple Orchard Mountain [located at 3,950 feet], in only eleven miles. It continues southwest, passing the spectacular Peaks of Otter before traversing a knife-edge ridge for another fifty miles before dropping to the Roanoke River, the second of the rivers to cut through the chain. Skirting Roanoke, the largest city in western Virginia, the parkway enters the Virginia Plateau District, characterized by gentler terrain, much of it in agricultural production. Passing the stony outcrops of Rocky Knob Park, it continues another fifty miles to reach the North Carolina border [Milepost 216].

Entering North Carolina, the parkway gains elevation as it climbs into the Highland District. Experiences are quite varied; in some places, the road is a ridge-line route; at other points, it crosses mid-slope sections as it drops to follow streams. Much of the district is heavily forested, but small farms appear from time to time. The plateau character of the countryside where the parkway crosses into North Carolina gives way to larger and more ridge-like mountains. Swinging around lofty Cumberland Knob, it traverses an especially rugged terrain, the Devil's Garden, before breaking out into the high mountain meadows of Doughton Park. From there, the parkway drops to Deep Gap, then crosses more broken mountain country before reaching the North Carolina resort community of Blowing Rock. Continuing its course to the southwest at an elevation of greater than 3,000 feet, the parkway passes by the summer resort community of Blowing Rock, and the large Moses H. Cone and Julian Price memorial parks before entering the Black Mountain District where it climbs the shoulder of the highest point in the Blue Ridge, 5,945-foot Grandfather Mountain, via the magnificent Linn Cove Viaduct, a structure designed to alleviate scarring of this fragile and

beautiful mountainside. Eleven miles further southwest, the road drops to the Linville River Valley; just to the south, the river plunges over Linville Falls into the spectacular Linville Gorge. The parkway itself begins another steady climb, following the Blue Ridge another thirty miles to Ridge Junction [Milepost 355.4]. At Gillespie Gap, also known as Etchoe Pass, the Museum of North Carolina Minerals highlights the importance of the minerals industries to the region.

At Ridge Junction the parkway leaves the Blue Ridge to skirt around the edge of the Black Mountains, climbing on the shoulder of 6,684-foot Mount Mitchell, the highest peak east of the Mississippi River, before negotiating the Great Craggies, a cross range known for its early summer displays of rhododendron and mountain laurel, and the Pisgah District. A downhill glide of more than 3,000 feet carries the parkway to Asheville and the French Broad River. Skirting around the city to the south, the parkway then climbs steadily up to Mount Pisgah, whose conical summit is a distinct landmark of the region. Running south along Pisgah Ledge, the parkway ranges through a wild high-mountain landscape, passing the exposed granite dome of Looking Glass Rock, the purportedly haunted Graveyard Fields, and lofty Devil's Courthouse before making a descent to Balsam Gap. Here, the parkway makes a sharp turn to the northwest and climbs to its highest elevation where it crosses the Balsam Mountains. It passes over a final range, the Plott Balsams at Waterrock Knob, before dropping to Soco Gap, passes over a spur of Heintooga Ridge, then drops through the Qualla Reservation, home of the Eastern Band of Cherokee Indians (EBCI), to reach its terminus at the Oconaluftee River in Great Smoky Mountains National Park, 469.9 miles from the road's beginning.

For most of its distance, the parkway right-of-way is a narrow band, rarely exceeding 2,000 feet in width except at widely spaced parks or protected areas. For more than 200 miles, the parkway passes through national forest lands administered by the United States Forest Service. In Virginia, the parkway traverses sixty miles through the Pedlar Ranger District of the George Washington National Forest, and thirty-five miles of the Glenwood Ranger District of the Jefferson National Forest. In North Carolina, it extends eighty-five miles across the Grandfather, Catawba and Pisgah ranger districts of the Pisgah National Forest, and twenty miles of the Highlands Ranger District of the Nantahala National Forest. The parkway also borders North Carolina's Stone Mountain State Park for five miles along the boundary between Ashe and Wilkes counties, and for a mile-and-a-half, follows the border of the Thurmond Chatham Wildlife Management Area near Doughton Park. Several adjacent areas are protected as parts of the Asheville, Hendersonville, and Waynesville watersheds. All the rest of the route is flanked by private lands. The parkway's relatively narrow width is rarely evident to the traveler. The designers of the road were careful to select locations along mountain crests, midslope sections, and occasional valleys, mostly out of view of towns and developed areas. For the motorist, the experience is that of a park without boundaries, with views extending far beyond the actual right-of-way over the greater part of the distance.[4]

I

A Way of Life Fades from the Hollows and Hillsides

Cultures long predating the Indians of historic times once occupied the mountainous region through which the parkway passes. Archaeological evidence shows the area was inhabited in pre-Columbian times. By the early eighteenth century, the region was home to a number of tribes, including the Catawba, Tutelo, Monoacan, Saponi, and Cherokee. As the eighteenth century progressed, the powerful Iroquois confederation defeated most of the smaller tribes in the north part of the range, while the Cherokee ruled the south mountains.

With the coming of European settlers, conflicts inevitably arose and today several points along the parkway route mark scenes of conflict between them and the Indians who lived on the land. Beginning in the 1730s, white settlers began establishing themselves in the mountain region. Many of these were Scots-Irish and Germans who preferred to live apart from the predominantly English settlements to the east. By the time of the Revolutionary War, a distinct pattern of subsistence farming had emerged. Most settlers occupied small farms, planting crops, tending livestock, and supplementing these stores with native game. Cattle and livestock were driven to markets in the fall, producing income that could be used to purchase manufactured goods. Corn and apples were often distilled, as liquor was far easier to transport than crops and brought a better price. These practices all survive, albeit on a reduced scale. By the early nineteenth century most of the natives had been driven out.

The Southern Highlands remained a predominantly agricultural region until the parkway was created. By the early 1930s, however, much of the land had been denuded by poor farming and logging practices. Steep slopes were badly eroded, and the remaining thin soil produced less and less in the way of crops. Even before the outbreak of the Great Depression, many mountain residents faced extreme difficulties. For many local residents, the coming of the parkway would change their lives dramatically. Many sold off their lands for the new road, and their old farms were allowed to return to nature, or carefully restored to keep up the

familiar agricultural landscape. Others were resettled to make room for recreational parks. Some found employment with the parkway itself, and others were able to make better livings by providing for parkway visitors. For many, this first good road in the region marked an end to generations of isolation.

When the parkway designers arrived on the scene for the first time during the mid-1930s, they quickly observed the problems of poor farming practices and soil erosion. Of the overgrazed pastures and muddied streams, agronomist Daniel W. Levandowsky (1903 – 2000) noted that "the results of soil abuse are plainly seen when harvest time comes and there is not much to harvest. The few cattle that one sees do not promise a good price at the market. The farms are in a run-down state." Accordingly, as the designs of the parkway were developed, they included construction details that would correct many of these problems. New drainage and water runoff improvements, fertilizing and liming, seeding and mulching, and the planting of trees and shrubs were undertaken as the parkway progressed. In many instances, the newly acquired parkway land was leased back to the neighboring farmer, who could farm the land with a degree of environmental control that preserved the visual assets seen from the parkway. This also ensured good soil stabilizing agricultural practices. By the postwar period there were almost five thousand acres of parkway land in agricultural use. Blue Ridge Parkway superintendent Granville Brinkman Liles (1913 – 1991), looking back at this period decades later, offered this narrative:

> In December 1937, [the resident landscape architect] sent a message to the hundreds of neighbors along the parkway route. It read: 'Not all people realize that the farmlands of the Blue Ridge add much to the scenery. In our opinion, the long stretches of grain, the fruit orchards and the green pastures of the sheep and cows are part of the picture which we all want to preserve.' [This] message set the tone for a cooperative program that not only became popular with local people, but ultimately preserved a declining rural scene and a vanishing culture. More than 5,000 acres, ranging from simple garden plots to vast meadows, became incorporated in the strategy of making the mountain farm the centerpiece of an effort to capture and preserve the pastoral character of the region.[5]

But what of the mountaineer's opinion of the road that would cut a swath through the rugged and pastoral landscapes of the Appalachian Highlands. During one of his outings to scout the parkway's route, an elderly mountaineer told Stanley William Abbott, the remarkable young landscape architect who threaded the road through the mountains of Virginia and North Carolina, what he thought of it: "Wal, I been livin' on this hyar mountain well-nigh onto eighty years," he explained to Abbott, "and I been wonderin' what this mountain was fer. Now I know it's fer to put a road on it."[6] Abbott did.

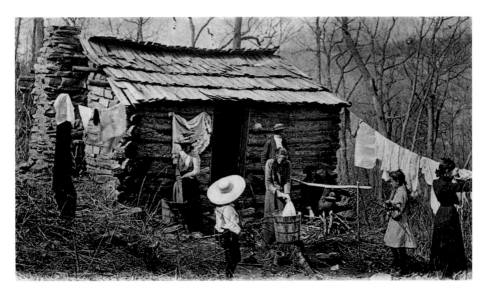

Well's Smoke Shop, of Asheville, North Carolina, sold this real picture postcard of wash day at a mountain home above the city. The backdrop of this hillside scene is a small cabin with women doing laundry and several other family members doing chores in the yard. The photograph was taken sometime in the first decade of the twentieth century. *University of North Carolina Chapel Hill*

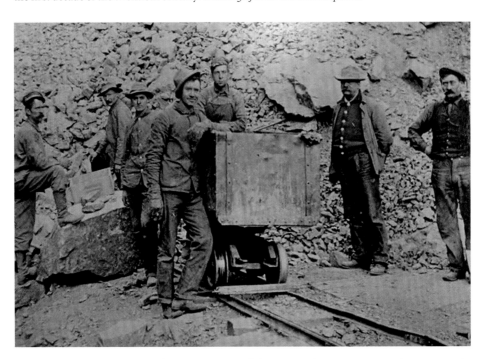

President Theodore Roosevelt (second from right) (1858 – 1919) visited a mineral mine in Little Switzerland, an unincorporated community straddling McDowell and Mitchell counties along what is today North Carolina 226A [NC 226A] off the Blue Ridge Parkway, directly north of Marion and south of Spruce Pine. The town has since earned the title "the jewel of the Blue Ridge Parkway." The picture shown here, perhaps taken during the years of Roosevelt's presidency – 1901 to 1909 – is on display in the North Carolina Mining Museum located in Little Switzerland's Emerald Village. *State Archives of North Carolina*

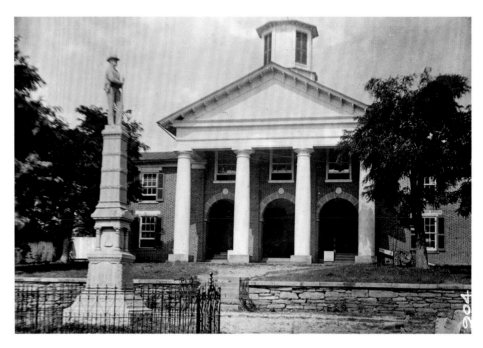

The Carroll County Massacre took place in this courthouse, located in Hillsville, the county seat, in 1912. The incident involved the locally celebrated Allen clan. Five were killed in the courthouse shootout, including the judge. The story was sensationalized in newspapers around the world, to include the manhunt for Wesley Victor Edwards (1891 – 1939) and Jeremiah Sidna Allen (1866 – 1941). The shooting also wounded Floyd Allen (1856 – 1913), the father of Claud Swanson (1889 – 1913) and Sidna Allen. Sidna Allen was a resident of Fancy Gap [Milepost 199.5], which became an important access point to the Blue Ridge Parkway. Edwards was the nephew of Floyd Allen. A Harris and Ewing photographer took the picture. *Library of Congress*

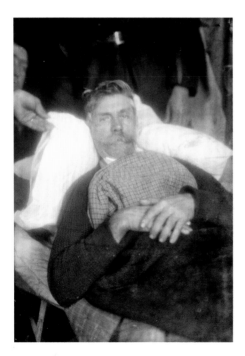

Floyd Allen, wounded in the shootout, is shown in jail after his capture. A Harris and Ewing photographer took this photograph. *Library of Congress*

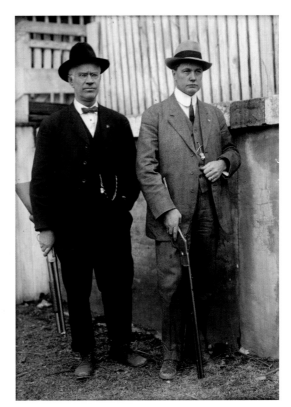

This Harris and Ewing photograph of William Gibboney Baldwin (left) (1860 – 1936) and Thomas Lafayette Felts (1868 – 1937), of the Baldwin-Felts Detective Agency, was taken between March and May 1912 in Carroll County. The pair was in the Virginia mountain community attending to the second trial of Floyd Allen after he killed the judge at his first trial – in the courthouse. *Library of Congress*

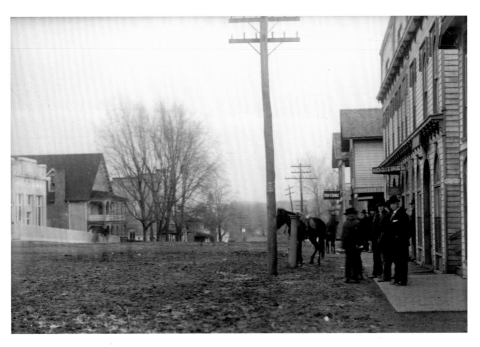

This Harris and Ewing photograph of Hillsville, Carroll County, Virginia, was taken between March and May 1912 during the second trial of Floyd Allen after he killed the judge at his first trial. The men on the right are standing in front of Nuckolls Drug Company. *Library of Congress*

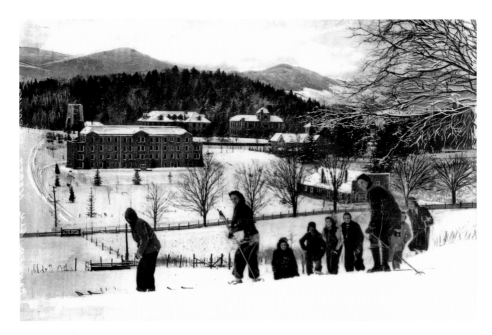

Long before there was a Blue Ridge Parkway, vacation and recreational spots dotted the Virginia and North Carolina mountains. This Albertype shows Pinnacle Inn visitors on skis. The inn is located on Beech Mountain, Banner Elk, Avery County, twelve miles from today's Blue Ridge Parkway, near Linn Cove Viaduct and Grandfather Mountain, and is the highest resort east of the Rocky Mountains. The picture was taken between 1910 and 1930. *University of North Carolina Chapel Hill*

This Albertype of Blowing Rock was taken near the turn of the twentieth century. A landmark in Watauga County, it is today accessed at Milepost 291.9 at the Highway 221/321 crossover, seven miles north to Boone and two miles south to Blowing Rock. *University of North Carolina Chapel Hill*

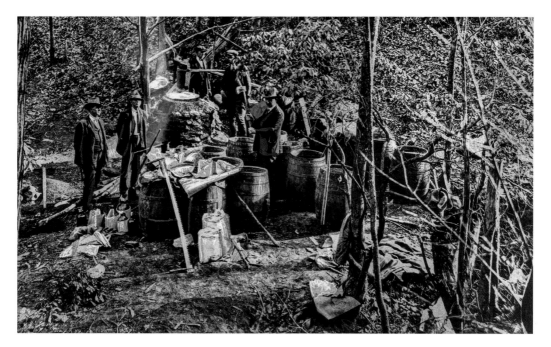

Moonshining was very much a money-maker for the mountain people of western North Carolina living in and around what is today the Blue Ridge Parkway. Taken also in the early twentieth century, this Albertype shows moonshiners at work near Blowing Rock. *University of North Carolina Chapel Hill*

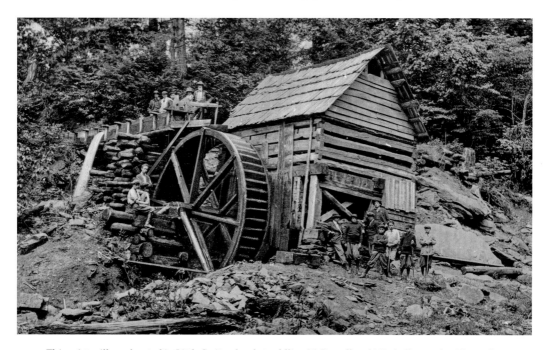

This grist mill was located in Little Switzerland straddling McDowell and Mitchell counties. The parkway was still more than a quarter-century from being built when this picture was taken. Today's visitors can access Little Switzerland from Milepost 334 where the North Carolina 226A crossover takes them into the town. *University of North Carolina Chapel Hill*

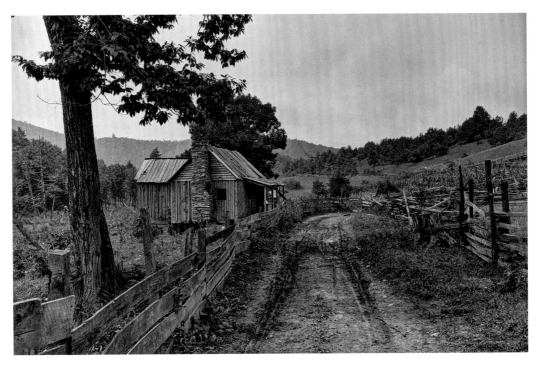

An unidentified cabin in Little Switzerland, McDowell County, is shown in this early twentieth century Albertype photograph. *University of North Carolina Chapel Hill*

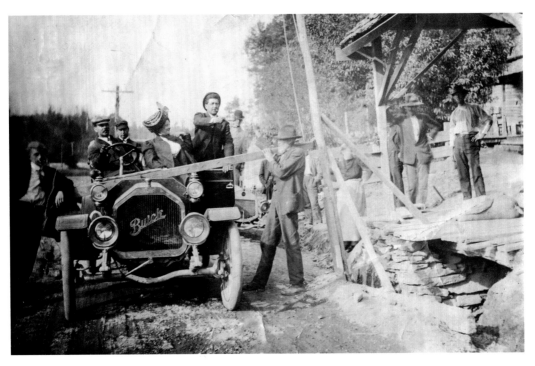

Taken between 1910 and 1919, this photograph shows the state of roads in the mountain communities of Watauga County. *University of North Carolina Chapel Hill*

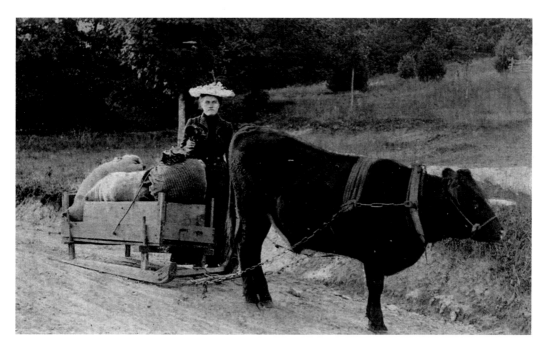

The postcard shown here, postmarked on September 1, 1908, shows a woman in an ox-drawn cart loaded with galax plants on a dirt road near Blowing Rock. The card was printed in Germany and sold by the Lenoir Drug Company. *University of North Carolina Chapel Hill*

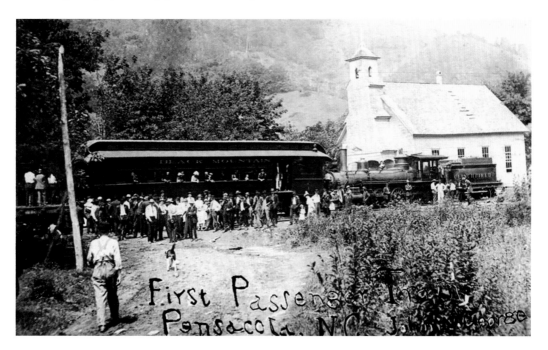

The first passenger train to run through the mountains was photographed at the Pensacola, Yancey County station in 1913. The train was bound next for Weaverville in nearby Buncombe County. A large crowd was gathered alongside the track. The names "Black Mountain" and "Clinchfield" are visible on the railroad cars. *University of North Carolina Chapel Hill*

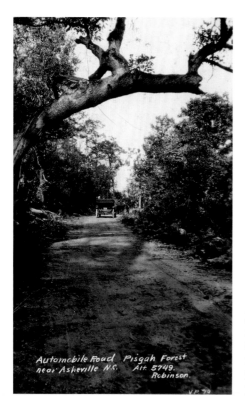

John Graham Robinson (1878 – 1923) took this photograph of two automobiles traveling on an unpaved road in the Pisgah Forest near Asheville, North Carolina, in or about 1915. The altitude where Robinson took the picture was 5,749 feet above sea level. *University of North Carolina Chapel Hill*

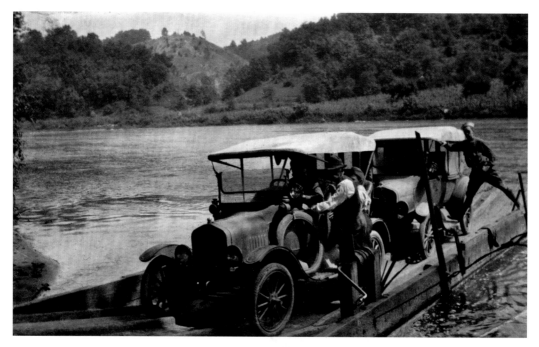

American Red Cross workers were photographed crossing the New River, Grayson County, Virginia, traveling through rural, mountainous Virginia, where they carried a complete motion picture set up to show films in communities that had never-before-seen a movie. The picture was taken on March 12, 1920. *Library of Congress*

A fertile plateau in the Blue Ridge Mountains of Virginia's Shenandoah National Park near Old Rag Mountain was photographed by Arthur Rothstein (1915 – 1985) for the United States Farm Security Administration/ Office of War Information (FSA/OWI) and first published in October 1935. "I went out there and lived in a cabin on the top of a mountain for a few weeks, walked around and became acquainted with these people," Rothstein recalled later. "At the beginning they were very shy about having pictures taken, but I would carry my camera along and make no attempt to take pictures. They just got to know me, and finally, they didn't mind if I took a few pictures."[7] Rothstein's photographs are illustrative of what life was like in the Virginia mountains before two major highway projects displaced residents like the ones he photographed in the shadow of Old Rag Mountain. The Shenandoah National Park connects the northern end of the Blue Ridge Parkway [which does not enter the park] with Skyline Drive, the scenic roadway that runs 105 miles through the length of the park. The southern entrance to Shenandoah National Park at Rockfish Gap on Afton Mountain is the northern terminus of the Blue Ridge Parkway. The 469-mile parkway, America's longest linear park, passes through twenty-nine Virginia and North Carolina counties, linking Shenandoah and Great Smoky Mountain national parks. *Library of Congress*

Robertson, Madison County, Virginia dry goods merchant and postmaster William Austin Brown (1861–1952) was photographed at his home at Old Rag, Virginia, Shenandoah National Park, by Arthur Rothstein, who published the picture in October 1935. Brown was the son of Andrew Hampton and Jane Grey Lillard Brown and the husband of the former Martha Cornelia Berry (1865–1950). He died at Syria, Madison County, on March 16, 1952, at the age of ninety. *Library of Congress*

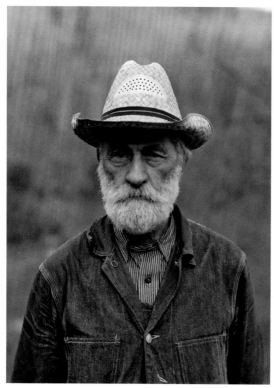

John Russell "Russ" Nicholson (1861–1935), the grandfather of all Nicholsons in Nicholson Hollow, located in Nethers, Madison County, Virginia, was photographed by Arthur Rothstein, whose picture of Nicholson was published in October 1935, just before Nicholson's death on December 16 of that year. Russ Nicholson was the son of Aaron (1832–1911) and Tabitha "Bittie" Corbin (1832–1895) Nicholson. He was included on a list of elderly residents permitted to live out their lives in what became their Shenandoah National Park homes but he went to live with his son, John Taylor Nicholson, instead. *Library of Congress*

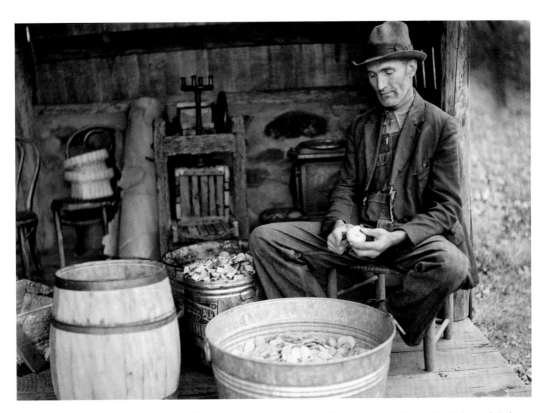

John Taylor Nicholson (1894 – 1961), the son of John Russell and Mary Elizabeth Corbin Nicholson of Nethers, Madison County, Virginia, was peeling apples on the porch of his Nicholson Hollow homestead before climbing to the roof to lay them out to dry in October 1935 when Arthur Rothstein took these pictures. Madison was one of the major apple producing counties of Virginia. Drying apples was one of the few sources of income for mountain people in the Virginia Blue Ridge Mountains. *Library of Congress*

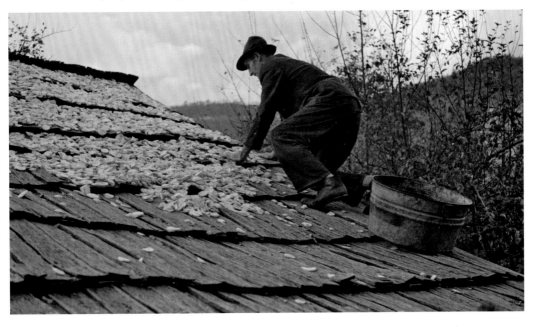

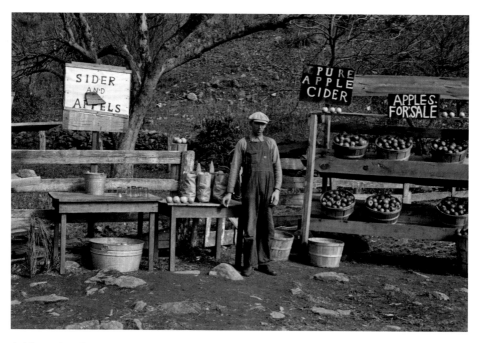

A cider and apple stand on the Lee Highway, Shenandoah National Park, Virginia, was photographed by Arthur Rothstein and published in October 1935 for the United States Resettlement Administration. *Library of Congress*

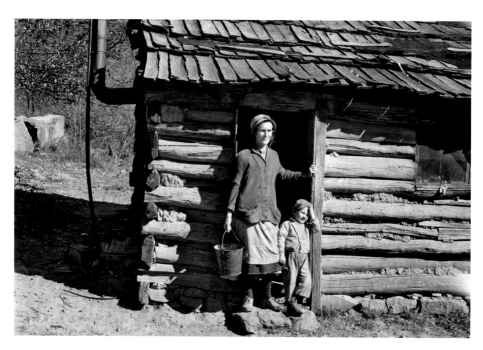

Edward Houston "Eddie" Nicholson's wife, the former Blanche Elizabeth Corbin (1893 – 1976), and child are shown in their Nicholson Hollow home. Eddie Nicholson was the son of David and Martha Buracker Nicholson. The child in the doorway is Leroy Nicholson (1930 – 2005). Arthur Rothstein published the picture in October 1935. *Library of Congress*

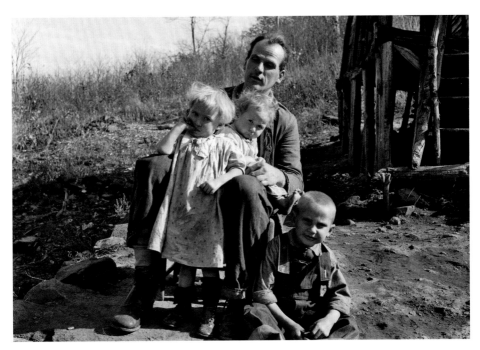

Charles Edward Nicholson (1889 – 1938), of Corbin Hollow, Madison County, Virginia, is shown in these Arthur Rothstein photographs, also published in October 1935, sitting outside his cabin with three children and in the second picture, of his cabin from a distance, he is kneeling with one of the children in the first photograph. Other family members are sitting off to the right. He was the son of James Morris and Mary Ella Nicholson, and married to the former Inez Vetter Smith (1895 – 1976). Charles Nicholson was struck by a truck up on Skyline Drive on March 10, 1938, and died instantly. He left behind ten children. *Library of Congress*

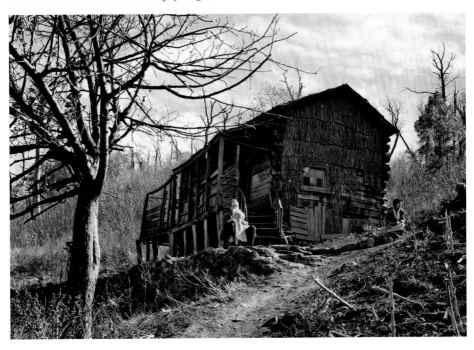

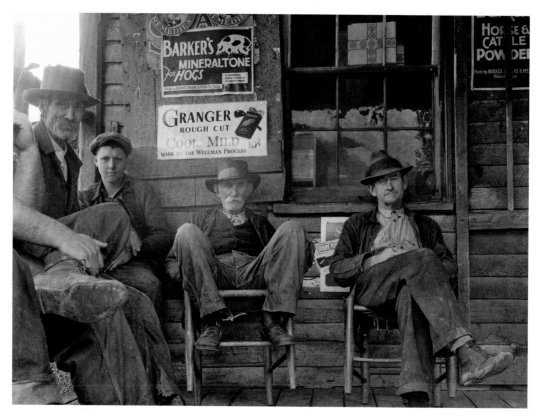

Residents of Nethers, Madison County, Virginia, were photographed by Arthur Rothstein in front of the dry goods store and post office. The picture was first published in October 1935 from Rothstein's travels through the hollows and hillsides of the county. *Library of Congress*

Adam John Nicholson (1921 – 1992), photographed by Arthur Rothstein during his visit to the Virginia mountains, was caught eating an apple behind his Madison County home. The apple orchard belonging to the Nicholson clan is in the background. Adam Nicholson, the son of Albert Aylor and Mamie Corbin Nicholson, left the hollows of the Virginia Blue Ridge for a career in the United States Merchant Marine and a life lived in other places across the country. After he died at Charlottesville, Virginia, like so many other former residents of Madison County hollows displaced by the Shenandoah National Park, he was returned to his birthplace for burial. *Library of Congress*

Tena "Tenie" Florence Corbin Nicholson (1886 – 1970), the daughter of James Madison and Mary "Mollie" Nicholson Corbin, and the widow of Nethers preacher and farmer George Bailey Nicholson (1873 – 1931), was photographed by Arthur Rothstein in front of her home. George Nicholson was killed on January 13, 1931, when a green chestnut tree his son was chopping down for firewood fell on him. The report in the January 27, 1931 *Page News and Courier* indicated that the tree was almost ready to fall when he got there and told his fourteen-year-old son: "Richard, let us get some dry wood; this tree is no good anyway." The two walked away and Richard moved off to cut on a dry limb. But his father had moved under the path of where the tree would fall, picking up limbs against Richard's warning to stay away. Then the tree fell. George Bailey Nicholson, crushed by the tree, died less than three hours later. *Library of Congress*

Samuel "Sam" Corbin (1891 – 1943), the son of Fennel and Elizabeth Angeline Nicholson Corbin (1894 – 1931) and the husband of the former Anne Nicholson, was about to be resettled from Corbin Hollow to new land out of the boundary of the new Shenandoah National Park, when he posed in front of his Corbin Hollow cabin for Arthur Rothstein, who published his pictures of Corbin and neighboring families in Weakley and Nicholson hollows in October 1935. Of note, pulmonary tuberculosis killed Sam Corbin, his wife, and the couple's three-year-old son Paul (1928 – 1932), who died in a Luray, Page County, Virginia hospital. *Library of Congress*

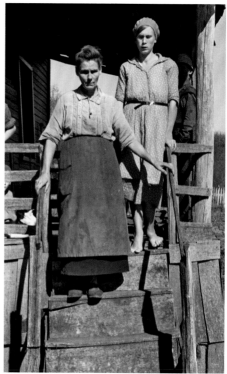

Charles Washington "Buck" Corbin (1892 – 1979), the son of James E. and Mary Elizabeth Nicholson, is shown in the first photograph. In the second photograph is Buck's wife, Fannie Belle Corbin (1887 – 1966), the daughter of James Madison and Mary "Mollie" Nicholson Corbin and sister of Tenie Corbin Nicholson, with some of the couple's twenty-two children. The third photograph shows the family farm. Rothstein published the photographs in October 1935. *Library of Congress*

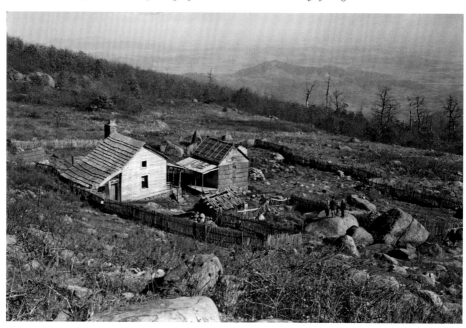

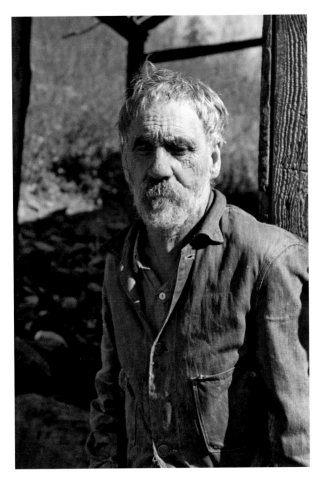

"The sociology of those mountain hollows does not follow Freud or Nietzsche," said an anonymous Virginia mountaineer, of the recent incursion by federal and state officials scoping out the area around Corbin Hollow. "It [that sociology] is taken from the Ten Commandments, the Golden Rule, which has but eighteen words, and a few hundred other words, with a couple of parables, from the New Testament: [it] requires no multitude of volumes, develops no fantastic, grotesque, distorted, bloodthirsty or destructive conclusions. The mountaineer thought is simple, plain and straight and does not lean much to suicides, fancily executed murders or crime – barring a little moonshining – or misanthropy or anarchy," he continued. "It runs along consistently with the thought and deduction of neighbor [Herbert] Hoover and neighbor Alvin York – the latter distinctly a mountaineer product [of Tennessee]." This mountaineer went on to observe that as "misguided" and "deplorably ignorant" as he might be, he would not swap "neighbors Hoover and York" for all of "the profoundly and elaborately learned" who explored Corbin Hollow and probably write about it in "tedious words and complicated sentences."[8] In short, the truth about the lifestyle there contrasted sharply with the negative portrait painted by federal and state authorities to justify relocation of residents to get the land for the national park. Fennel Corbin (1867 – 1945), the son of Strother and Mary Ann Morris Corbin and the husband of Elizabeth Angeline "Lizzie" Nicholson (1866 – 1926), first purchased land in Corbin Hollow, located in proximity to the developing Skyland resort, in 1894 and was among forty residents in six households located directly in the hollow, most of whom were children and grandchildren, when government surveyors gathered the data between 1931 and 1932. The residents of Corbin Hollow depended on the resort for employment and a place to sell their handicrafts. He was resettled to new land and died at Western State Hospital in Staunton, Virginia. The picture was taken by Arthur Rothstein and published in October 1935. *Library of Congress*

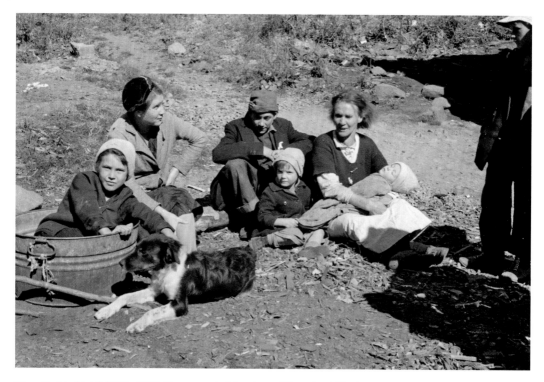

Dicey Corbin (right) (1889–1946), the unmarried daughter of Fennel and Elizabeth Nicholson Corbin, is shown with some of her children and grandchildren in this Arthur Rothstein photograph, also published in October 1935. She had three sons – Odie Washington (1909–1981), George Luther "Boot" (1910–1980) and Harry Hardin (1920–1981) – and a daughter – Betty Ann (born in 1926 and shown sitting in the wash tub). *Library of Congress*

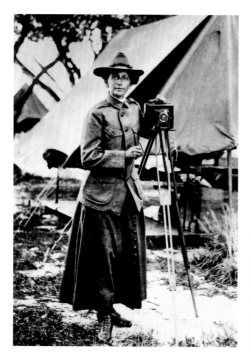

Mary Bayard Morgan Wootten (1875–1959) [shown here], who dropped the "Mary" from her professional name, was best known for her photographs of people living in the impoverished rural areas of her home state of North Carolina. As a pictorial photographer she combed the hollows and hillsides during the Great Depression documenting the men, women and children – black and white – who would be forgotten to history were it not for her pictures. The Bayard Morgan Wootten photographs included herein are of that period. *State Archives of North Carolina*

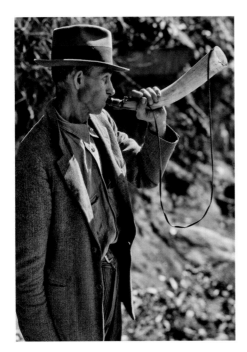

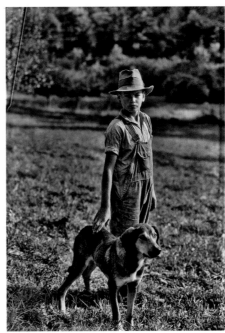

Above left: George Timon "Tim" Wyatt (1884 - 1960), of Snow Creek, Mitchell County, North Carolina, a mountain hunter and lifelong farmer, was photographed by Bayard Morgan Wootten. When he died at Penland, also in Mitchell County, he was survived by his wife, the former Mollie Conley. *University of North Carolina Chapel Hill*

Above right: A boy and his dog became the subject of this Bayard Morgan Wootten photograph. *University of North Carolina Chapel Hill*

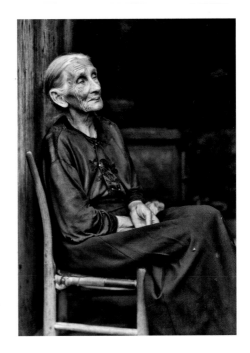

Mary Webb Haney Hollifield (1850 – 1941), of North Cove/Little Switzerland, McDowell County, North Carolina, and the widow of James Webster "Webb" Hollifield (1845 – 1914), was photographed by Bayard Wootten as she sat in the doorway of her cabin. *University of North Carolina Chapel Hill*

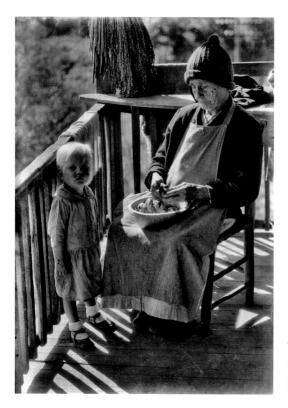

The old and the young of the Grindstaff family, of Mitchell County, are pictured in this Bayard Wootten photograph. *University of North Carolina Chapel Hill*

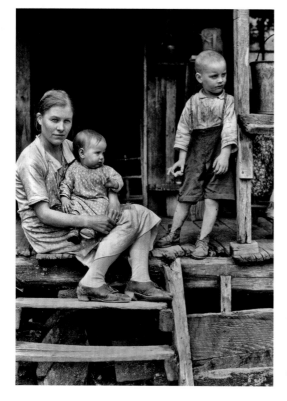

Wesley William "Wes" Johnson's family, of Marion, McDowell County, North Carolina, allowed Bayard Wootten to take their picture. Johnson (1881 – 1941) was a farmer and wood cutter. *University of North Carolina Chapel Hill*

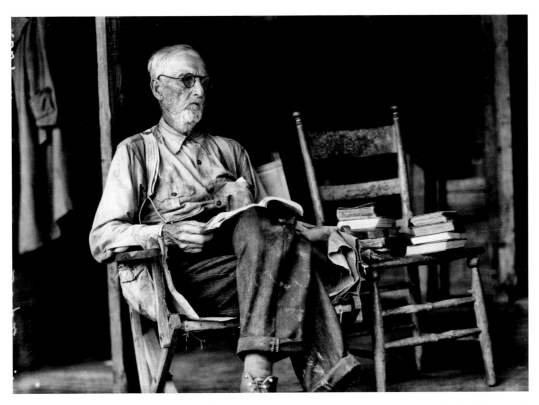

This unidentified man, photographed by Bayard Wootten, sat on the front porch of his cabin reading, a stack of books off to the chair on the right. *University of North Carolina Chapel Hill*

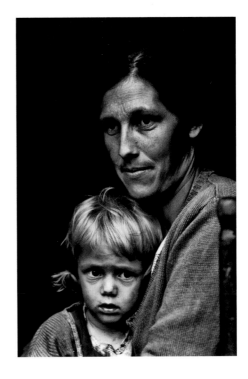

The wife of William "Will" Carpenter and one of his children are shown in this Bayard Wootten photograph. *University of North Carolina Chapel Hill*

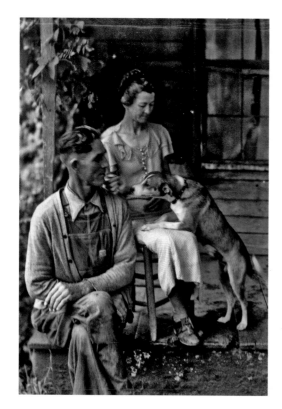

Seated on the porch of her home in this Bayard Wootten photograph is Azza Wilma Hatchett McNab (1896 – 1991) and husband Clyde H. McNabb (1901 – 1984). The picture was taken at Notla, Cherokee County, North Carolina. *University of North Carolina Chapel Hill*

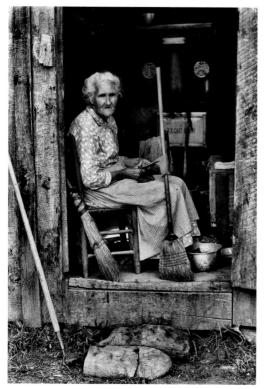

Polly Jane Wilson, of Cane River, Yancey County, North Carolina, was the subject of this photograph by Bayard Wootten. She was married to George Wilson, who had either died or left her by 1930; he was her second husband. She had five children, only two of whom lived to adulthood. Details of her life are hard to come by but it is believed she was born in or about 1865 and died in or about 1939, shortly after this picture was taken. *University of North Carolina Chapel Hill*

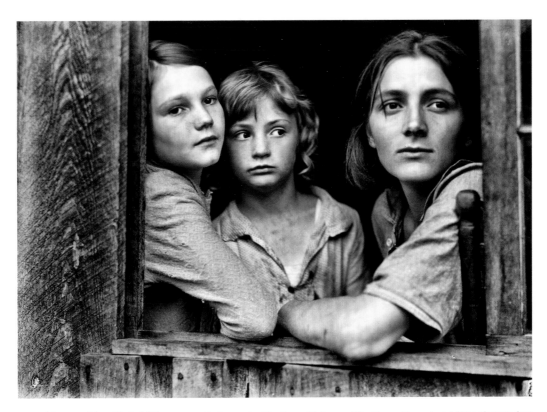

Three unidentified children were photographed by Bayard Morgan Wootten as they stared from the window of their mountain cabin. *University of North Carolina Chapel Hill*

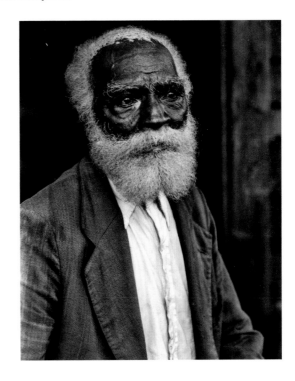

Taken somewhere in the North Carolina Blue Ridge [possibly Mitchell County], this distinguished looking man appeared in several of Bayard Wootten's photographs. *University of North Carolina Chapel Hill*

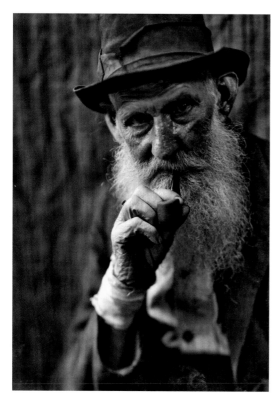

Thomas M. "Tommy" Sparks Jr. (1850 – 1930), of Snow Creek, Mitchell County, North Carolina, was photographed by Bayard Wootten in this portrait and also sitting on the porch of his cabin. Sparks and his wife, the former Sadie Queen (1852 – 1895), are buried on Rabbit Top in the woods. Both photographs – as do others of her work shown in this chapter – bear the Wootten-Moulton signature. Wootten opened her first studio in 1928 with half-brother George C. Moulton, a partnership that lasted over thirty years. *University of North Carolina Chapel Hill*

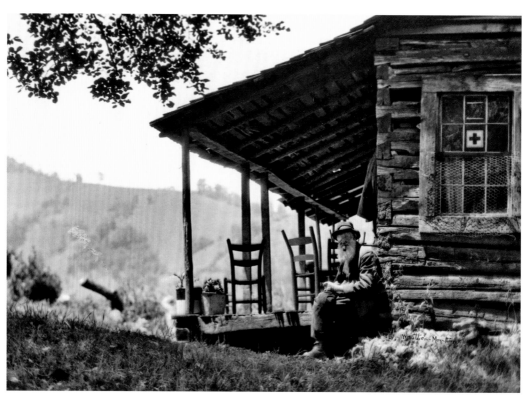

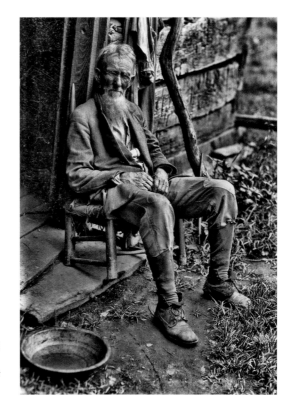

Known only as "the snake doctor" in Bayard Wootten's notes, this man lived in the mountains near Little Switzerland, an unincorporated community in McDowell and Mitchell counties. The snake doctor's cabin was a modest one room structure. *University of North Carolina Chapel Hill*

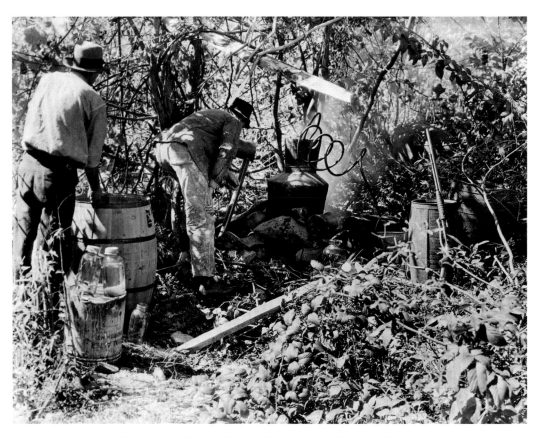

Two men are shown working around a liquor still in the isolated town of Penland. The mountainous terrain of Mitchell County led to the initial seclusion of what would later become Penland and the rest of the Toe River Valley and limited development to small farms along the many tributaries of the Toe River. All of this changed during the 1870s when what was then referred to as Bailey Station became a frontier post after early settlers found mica, kaolin, and feldspar mineral deposits in addition to extensive logging opportunities in the region. Spruce Pine was the biggest town nearby and considered a mining town while Bailey Station continued as a trading post. Penland today lies on both sides of the North Toe River in the Toe River Valley and is situated in the south-central part of Mitchell County. The town is within the lands that Milton Pinckney Penland (1813 – 1880) acquired starting in 1852, a historic tract that was once over fifty thousand acres. The picture was taken by Bayard Morgan Wootten. *University of North Carolina Chapel Hill*

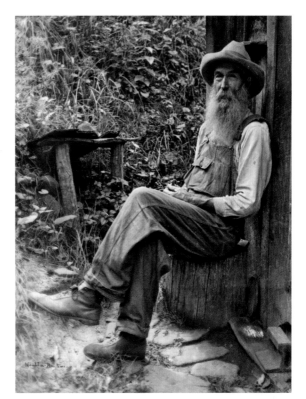

John William Lafayette "Daddy" Bostain (1845 – 1934) [the last name is also spelled "Boston"] was photographed by Bayard Wootten sitting in his Snow Creek [in the vicinity of Penland], Mitchell County, North Carolina cabin door before his death in 1934. Daddy Bostain, a farmer and moonshiner, and his wife are buried at Wing, also in Mitchell County. *University of North Carolina Chapel Hill*

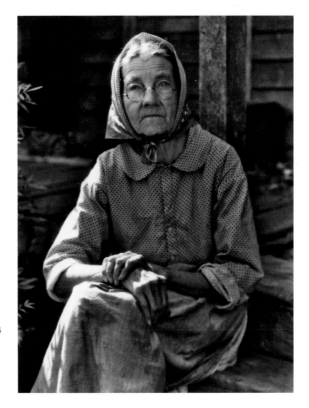

Bayard Wootten took this picture of a woman wearing a scarf seated on cabin steps in the vicinity of Penland, an unincorporated community in Mitchell County. The community is located on the northern edge of western North Carolina's Black Mountains and is bisected by the North Toe River, a tributary of the Cane and Nolichucky Rivers. *University of North Carolina Chapel Hill*

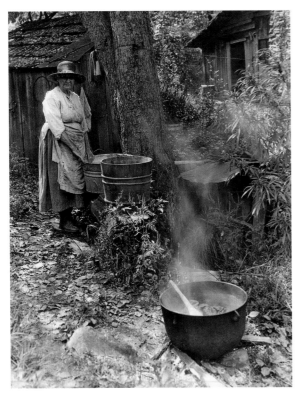

Martha Eveline Teague Bostain (1847 –
1934), also pictured just before her death
in this Bayard Wootten photograph, is
shown washing clothes outside her Snow
Creek cabin, located in the heart of the
North Carolina mountains. The Bostains
were born in Alexander County, North
Carolina, and moved around between
Alexander, Madison and Mitchell
counties, and rented the cabin where
the pictures were taken. Wootten also
took the picture of the Bostains' cabin.
University of North Carolina Chapel Hill

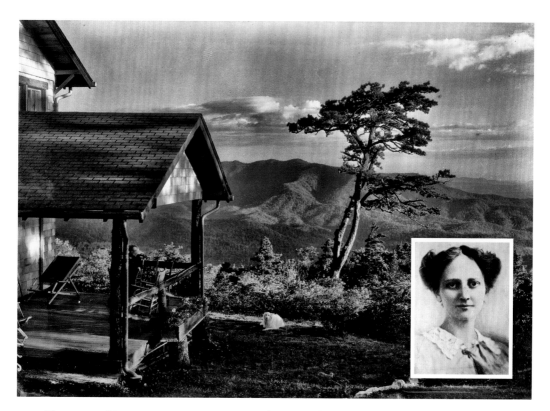

The cottage of Harriett Morehead "Hattie" Berry (1877–1940), often called North Carolina's "mother of good roads," owned this cottage, which she named Laurel Ledge, in Little Switzerland, McDowell County, North Carolina. History informs that she was one of Little Switzerland founding father Judge Heriot Clarkson's biggest boosters in his efforts as legislative chairman of the Old North State's Good Roads Association. Berry was the secretary of the North Carolina Geological and Economic Survey from 1901, and assistant secretary of the North Carolina Good Roads Association, to which she became acting director in 1917. It was Berry who was instrumental in the passage of the state's landmark highway act in 1921 that gave North Carolina a unified highway system. Seven years later, in 1928, she built this house on Laurel Lane (shown here), which she came to during the summers from her year-round home in Chapel Hill. Bayard Wootten took the photograph of the cottage. Berry is shown in the inset picture. At the time of her death, Berry's will left the cottage to her sister, Mary Berry Brown, for the duration of her life and then to her niece, Mary Strudwick Berry, for the same. *University of North Carolina Chapel Hill*

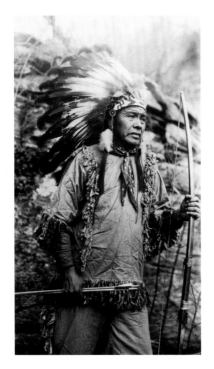

Carl Wesley Standing Deer [also known as Awigadaga] (1881–1954) is pictured at Cherokee, Swain County, located within the one-hundred-square-mile Qualla Reservation [the Qualla Boundary] in or about 1940 and wearing the Sioux headdress memorialized in family photographs taken of him from the late 1930s and before his death on July 23, 1954. Tourists came to call him "the world's most photographed Indian." The Qualla Boundary takes up part of five counties to include Cherokee, Graham, Jackson, Haywood, and Swain. Standing Deer was also champion archer of the Eastern Band of Cherokee Indians in his lifetime. The most complex of early controversies over the parkway's path occurred with regard to Cherokee, North Carolina. The Eastern Band of Cherokee Indians had to grant a right-of-way for the parkway's fifteen miles over the land of the Qualla Boundary, a process which took five years to negotiate. *University of North Carolina Chapel Hill*

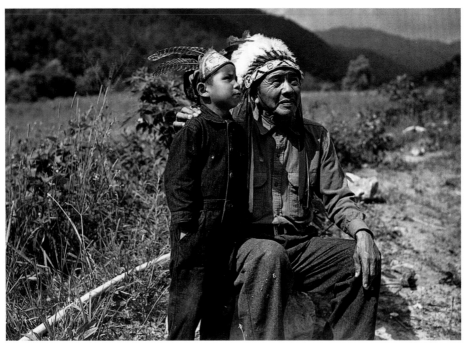

Photographer John H. Hemmer (1892–1981) took this picture of Carl Standing Deer (1881–1954) and his grandson in June 1945 in Cherokee, Swain County. Carl Standing Deer was the first to practice what came to be called "chiefing by the roadside," selling Indian crafts and also permitting tourists to take pictures with him and because of this, Hemmer did a full photography shoot with Standing Deer and his grandson next to the roadway. *State Archives of North Carolina*

II

AMERICA'S PREMIER SCENIC BYWAY COMES TO LIFE

"You ask my appraisal of the natural beauty and human interest of these eastern mountains to which we became so attached," recalled Stanley W. Abbott, the Blue Ridge Parkway's first superintendent, reminiscing of his experiences more than two decades after he came on board the project. "The grandeur derived, of course from the six days of the Lord's creation and the human interest from the overlay of history in the pioneer days—a persistent culture isolated in the crowded East. Some would wish for the pristine beauty of these tree-clad mountains unspoiled— but this is idle—there has been imposition of man on nature and this was the condition we had to work with in developing the Parkway—logging, soil erosion, forest fire. Rudyard Kipling wrote in 'Brazilian Nights': 'Once you tamper with nature, you had better keep it up."[9] Construction began on the Skyline Drive, tucked within the area being acquired by the commonwealth of Virginia for Shenandoah National Park, in 1931. While not technically a parkway in that it was an internal park road rather than a connecting link between different parks or sites, this scenic mountain crest drive was the direct progenitor of the Blue Ridge Parkway. Indeed, the Blue Ridge Parkway was conceived as an extension of the Skyline Drive all the way to Great Smoky Mountains National Park.

In the 1930s, the National Park Service proposed an elaborate parkway development program aimed at extending the concepts proven in the New York and early federal parkways to significantly longer projects. These came to be called "scenic rural parkways." In contrast to the relatively short suburban parkways surrounding New York City and commemorative routes such as the Mount Vernon Memorial Highway and the Colonial Parkway, the rural parkways were intended to stretch for long distances with broader recreational areas provided at regular intervals. Although a large number of such roads were proposed, only a handful were actually constructed. The Blue Ridge Parkway was the epitome of this concept.

The National Park Service did not undertake the construction of rural parkways on its own, but worked in close cooperation with the Bureau of Public Roads (BPR), which since

1926 had assumed responsibility for the construction of most roads in the parks. Bureau of Public Roads chief Thomas MacDonald, who eagerly supported the parkway concept, thought of parkways not as mere highways but as "elongated parks" that would contain "mass recreational areas" along the route, which could include natural attractions, picnic grounds, or other opportunities for outdoor activities.[10]

Whether long or short, a "parkway" was much more than the motor road itself. The concept included a substantial right-of-way to either side, partially owned outright (or "fee simple" property), and partly in scenic easements which left the land in private ownership but gave the government control over roadside uses and development. The width of the protected corridor would vary according to the topographic situation or the need to protect natural or cultural resources along the route. Certain larger areas along the Blue Ridge Parkway would be acquired and maintained as "parks," providing protection for larger areas such as entire mountains or valleys, or to afford for recreational developments such as campgrounds, picnic areas, or overnight lodging. National Park Service landscape architect Dudley Chamberlain Bayliss (1905 – 1977), who worked with national parkways beginning in 1934, stated that national parkways were "essentially elongated parks, in which the campgrounds, picnic areas, lodges and other visitor services are planned and developed [and] selected to best fit the topography and requirements of the project."[11] In 1936, the Recreational Committee of the National Resources Committee also issued a definition of "parkway," terming it "a strip of public land devoted to recreation which features a pleasure-vehicle road through its entire length, on which occupancy and commercial development are excluded, and over which abutting property has no right of light, air, or access."[12]

By the mid-1930s, Secretary of the Interior Harold LeClair Ickes (1874 – 1952) had approved basic standards for the various national parkway projects. These set forth requirements for sufficient right-of-way to protect roadside environments, the elimination of grade crossings for railways and major highways, limiting access from minor roadways, a high standard in road design to allow for easy and safe motoring, design of bridges and structures to harmonize with the adjacent scenery, roadside landscape treatments to enhance the appearance of the roads, and recreation and service areas to provide for recreation and motorist needs.[13] These high design standards called for carefully studied alignment and grades, easy curvature, and location to present scenic features to one traveling at motorway speeds. Properly designed bridges, overpasses and underpasses, and other road-related structures might entail construction in native materials, or at least unobtrusive design so as not to call attention from the natural setting. Development of roadside parks and other developments would provide opportunities for outdoor recreation such as picnicking and hiking, or for motorist services such as gas stations, coffee shops, or overnight lodging. Some such areas might be set aside only to protect natural or cultural features.[14]

The plan further included acquisition of right-of-way in order to protect the sides of the Blue Ridge Parkway. No one was reinventing the wheel to come up with the process to acquire sufficient right-of-way; it was borrowed from earlier precedents such as the Westchester County parkway system, as was the provision for limited access. By avoiding grade crossings with railways and major highways, and limiting the number of crossings of

minor roads, "friction" in the traffic stream would be reduced. Traffic would not have to halt at major intersections or slow for cars entering from side roads. The wide right-of-way would provide both for protection of the roadsides and allow for naturalistic landscape treatments along the corridor. Parkways differed from national park roads in that their locations were established to conform with the selected route, whereas park roads were developed within existing designated areas. They differed from ordinary state and federal highways in that they carried no commercial traffic, featured wide rights-of-way to protect the roadside environs, and were located for the best scenic effect. Most ordinary roads followed the shortest route between destinations; and little attention was paid to aesthetic issues.[15]

The Interior Department established a policy that the states through which a national parkway would pass would be required to acquire the necessary land for rights-of-way and scenic easements, then deed them to the federal government. The Interior Department would then work with the Bureau of Public Roads [and its successors, the Public Roads Administration and the Federal Highway Administration] to design and construct the road. To direct the states in the acquisition of the requisite land, the Interior Department prepared a pamphlet on the standards, entitled Requirements and Procedures to Govern the Acquisition of Land for National Parkways.[16]

The Blue Ridge Parkway was not originally authorized as a National Park Service project; however, it soon became the park service's responsibility. Other parkways that followed in close succession were designated park service projects from the beginning. The Natchez Trace Parkway, connecting Natchez, Mississippi, and Nashville, Tennessee, was authorized on June 19, 1934; it was to share characteristics of both the Colonial and Blue Ridge parkways. As with Colonial, it was intended largely as an "historical parkway," following the route of the Indian trail and post road and interpreting various related historical sites along the way. Of note, it also was designed to showcase the varied natural scenery along the way, from southern blackwater swamps of Mississippi to the rolling hill country of Tennessee's Highland Rim. Like the Blue Ridge Parkway, it includes a number of roadside parks or developed areas along its 445-mile stretch. Construction of the Natchez Trace Parkway began in 1938 but some segments remained incomplete as of 1998.

The Colonial Parkway, Skyline Drive, and early segments of the Natchez Trace Parkway were all largely funded with public works funds as a part of the New Deal, President Franklin Roosevelt's relief program aimed at bringing the United States out of the throes of the Great Depression. The main objective was to relieve unemployment. The projects placed thousands of unemployed workers back on the payrolls. Funds spent on materials, supplies and construction equipment also had a beneficial effect by stimulating economic growth in these industries. The public works aspects of parkway construction would be epitomized by the Blue Ridge Parkway, the most extensive, and expensive, of all parkway projects.

Though what is today the Blue Ridge Parkway was proposed in 1933, its current name, route and appearance had not yet been determined although for a brief period it was referred to as the Appalachian Scenic Highway. To many state officials, what was proposed was merely a new road to connect two new national parks. State officials gave little thought to design details and limitation on frontage rights and access. Rather, they mostly thought of the parkway as

another road project, albeit on a lengthy scale. The bill that passed by the Virginia General Assembly in February 1934 merely authorized the State Highway Commission "to add to the State highway system a route from a point at or near Jarman Gap running generally in a southwesterly direction, at or near the crest of the mountain as it may deem advisable, to the North Carolina or Tennessee line."[17] The reason given for this vague language was due largely to the fact that outside the northeast United States, parkways were a rarity.

Most construction was carried out by private contractors under federal contracts under an authorization by Harold Ickes in his role as federal public works administrator. Work began on September 11, 1935, near Cumberland Knob in North Carolina; construction in Virginia began the following February. On June 30, 1936, Congress formally authorized the project as the Blue Ridge Parkway and placed it under the jurisdiction of the National Park Service. Some work was carried out by various New Deal public works agencies. The Works Progress Administration (WPA) did some roadway construction. Crews from the Emergency Relief Administration (ERA) carried out landscape work and development of parkway recreation areas. Personnel from four Civilian Conservation Corps (CCC) camps worked on roadside cleanup, roadside plantings, grading slopes, and improving adjacent fields and forest lands. During the Second World War, the CCC crews were replaced by conscientious objectors and the Civilian Public Service program. Before the war, in a January 20, 1938 report to National Park Service associate director Arthur Edward Demaray[18] (1887 – 1958), Abbott described the parkway concept as "a relatively new and highly specialized solution for the traffic problem."[19] The Blue Ridge Parkway was a pioneer type of interstate recreational planning of a magnitude never before attempted. Abbott defined it as "a road devoted to recreation and located within an 'elongated park.'" According to Abbott, a broad strip of surrounding park land would eliminate the "parasitic and unsightly border development of the hot-dog stand, the gasoline shack, and the billboard," and allow the natural scenery to be preserved and beautified. Road crossings would be eliminated through grade separation structures, and at-grade accesses would be restricted to reduce disruptive and dangerous cross-traffic.[20]

Of note, long before the Blue Ridge Parkway was conceived, there was a proposal for a mountain roadway following much of its route. In 1906, Joseph Hyde Pratt Ph.D. (1870 – 1942), the head of the North Carolina Geological and Economic Survey and a professor at the University of North Carolina at Chapel Hill, launched a campaign for the construction of a scenic highway down the spine of the Blue Ridge. The road was intended as a toll road, but Pratt and his backers hoped that the counties through which the road would pass, as well as the state and federal governments, would make appropriations for the project. The road was planned to extend from Marion, Virginia, to Tallulah, Georgia, via Boone, Blowing Rock, Linville, Altapass, Little Switzerland, Asheville, Hendersonville, Brevard, Lake Toxaway and Highlands, then on into Georgia. Pratt estimated the 350-mile road would cost $55,000 per mile for a total cost of $1.75 million. The right-of-way would be twenty-four-feet wide and the road itself would be nine-feet wide and surfaced with sand and clay or gravel. He touted the merits of the proposed road, boasting that "it is destined to be one of the greatest scenic roads in America, surpassing anything in the East and rivaling those in Yosemite Valley and the Yellowstone National Park."[21]

The route was surveyed, and in June 1912, Pratt announced that work would begin on the section between Altapass and Linville. He stated that the forty-mile Blowing Rock Turnpike had already been taken over and would form an integral link. Newspapers hailed the plans, stating that the road construction would open up a heretofore inaccessible area to development, and that the highway would be "lined on either side by handsome summer homes."[22]

In March 1914, Pratt and his associates secured a charter for the "Appalachian Highway Company" from the North Carolina General Assembly. At the 1912 meeting of the Good Roads Association of North Carolina, Pratt had reported that his associates had been surveying the road for ten years. The highway would be financed by private subscription, repaid through the collection of tolls. Construction began that July on a stretch between Altapass and Linville. One hundred men were reportedly at work, and the company hoped to have the first fifty miles open by the following summer. Pratt reported that landowners along the road were donating rights-of-way and subscribing in the venture, which he characterized as one of the grandest in the nation.[23] Construction was ultimately completed between Altapass and Pineola, and the road was graded north to Humpback Mountain [one-and-a-half miles southwest of Linville Falls] but the outbreak of the First World War spelled the end for the grand scheme when manpower and materials were diverted to the war effort. Work quickly came to a halt. In the end, the Blue Ridge Parkway would follow virtually the same routing for a brief segment between parkway Mileposts 317.6 and 318.7.[24]

The Blue Ridge Parkway is no closer than a distant relative of the parkways near New York City and those found in and around the nation's capital, nor does it bear more than remote likeness to the Skyline Drive in Shenandoah National Park from which it grows. In his April 21, 1938 correspondence, Stanley Abbott added: "While, by accepted legal definitions, 'a parkway is a road devoted to recreation,' it is notable that those parkways carry a large volume of traffic which is clearly not pleasure or recreation bound. From them the Blue Ridge Parkway has borrowed the basic design principle of the broad right-of-way but the project is not simply a first use of this principle over a greater length of rural countryside. It is the first use of the parkway idea," he continued, "purely and wholeheartedly for the purposes of tourist recreation distinguished from the purposes of regional travel."[25]

The originator of the Blue Ridge Parkway concept has been debated for decades. Senator Harry Flood Byrd[26] (1887–1966) and Governor John Garland Pollard (1871–1937) of Virginia; Bureau of Public Roads chief, civil engineer and politician Thomas Harris "Chief" MacDonald (1881–1957); Senator George Lovic Pierce Radcliffe (1877–1974) of Maryland, and Public Works Administration advisory board member for Virginia, North Carolina and Tennessee [District 10], and Radcliffe's often "second in command," Baltimore engineer and entrepreneur Theodore Ellinger Straus (1873–1973) have all been credited with the original proposal, but the strongest evidence suggests that Byrd was the originator of the idea. While it may never be possible to reconcile the conflicting accounts of the parkway's origins, Shenandoah National Park's Skyline Drive was clearly the inspiration for the project. Begun during the early stages of the Great Depression as a public works project, the original thirty-mile mountain crest road proved so popular that it was extended north and south across the entire park.[27]

On August 11, 1933, President Franklin Roosevelt visited Shenandoah National Park for an inspection of one of the first Civilian Conservation Corps camps. Roosevelt was favorably impressed by the scenery from the Skyline Drive, then under construction, and Senator Byrd, a member of the party, suggested the mountain road might be extended all the way to the Great Smoky Mountains National Park. Roosevelt showed strong interest in this idea, and Byrd advanced the project.[28] In September, the Virginia senator attended a meeting of the League of Virginia Municipalities in Richmond. Following the conference, he attended a luncheon at the Executive Mansion that included Governor Pollard and Theodore Straus. The groups discussed the extension of the road to the Great Smokies, and Pollard agreed to appoint a Virginia committee to study the matter. Pollard then telegraphed Tennessee governor Harry Hill McAlister[29] (1875 – 1959) and North Carolina governor John Christoph Blucher Ehringhaus[30] (1882 – 1949) to ask them to appoint similar commissions to work with the Virginia body.

On October 7, 1933, Byrd corresponded about the nascent parkway project via a telegram to North Carolina senator Josiah William Bailey[31] (1873 – 1946). Funding for the project would come from Federal Works Program funds, though the states would have to maintain the road. President Roosevelt suggested a small toll to liquidate the costs of the project. About four hundred miles of road was contemplated just then, to include seventy-five in Virginia, forty in North Carolina and ninety-five in Tennessee. The cost of the project was estimated at $16 million. Ten days later, Byrd convened a meeting at his offices to discuss the project. In attendance were Asheville native and United States senator Robert Rice Reynolds (1884 – 1963) of North Carolina; National Park Service director Arno Berthold Cammerer (1883 – 1941) – just the third to hold this post – and landscape architect, conservationist and park service assistant director Conrad Louis Wirth (1899 – 1993); Bureau of Public Roads chief Thomas MacDonald; Maryland senator Radcliffe; Theodore Straus; Joseph C. Kirchner[32], regional forester of the United States Forest Service for the eastern district and subsequently the southern portion of the country; delegations from Virginia and North Carolina, and Otto Frank Goetz[33] (1892 – 1951), chief engineer for the Tennessee State Highway Department. Byrd opened the meeting by announcing that plans had been confirmed to extend Skyline Drive in Shenandoah National Park down the full length of the park, and that President Roosevelt was amenable to the proposal to extend the road roughly five hundred miles further to Great Smoky Mountains National Park. Byrd had called the group together to prepare a definite proposal for funding to be presented to the Public Works Administration. He credited MacDonald with the idea for the project. MacDonald, however, demurred, claiming the parkway concept originated in a conversation between Byrd, Radcliffe and Straus.[34] Virginia state highway engineer James Aylor Anderson[35] (1892 – 1964) suggested in an October 10, 1933 letter to Byrd that there were three ways by which the project could be realized. The first proposal called for the formation of a not-for-profit corporation, which might build the parkway as a toll road and then turn it over to the states for maintenance. The second called for a public authority to be created, which would build and operate the parkway, again as a toll road. The third alternative called for the federal government, through the Bureau of Public Roads and the National Park Service, to build the road. This

would require an act of Congress. The group discussed also the merits of building the new parkway as a toll road. MacDonald was unenthusiastic about that proposal, believing returns from concessions operated along the route might cover some of the financing, but otherwise feeling the state highway departments should carry much of the burden. Other discussions mainly centered around the possible route for the parkway, which had yet to be determined. Radcliffe ballparked a preliminary project cost of $16.8 million, which would allow for the construction of 414 miles at a cost of $40,000 a mile, the figure adopted for the final section of Skyline Drive. Such a project would, he observed, provide employment for four thousand men for two years. Byrd concluded the meeting by suggesting the creation of a committee with representatives from the three states, the National Park Service, and the Public Works Administration, then recommended that Radcliffe serve as chairman.[36]

Landscape architect Edward Henry Abbuehl (1903 – 2000), one of the first employees of the parkway, offered a different version of the genesis of the parkway idea in a draft history of the parkway he prepared in February 1948 and which has been cited in successive National Park Service histories. Abbuehl claimed that Radcliffe contacted Bureau of Public Roads chief MacDonald to discuss several highway projects, and in the course of the conversation suggested that a road to connect the Shenandoah and Great Smoky Mountains national parks would be an ideal federal public works project. Straus then supposedly relayed the suggestion to Governor Pollard, who subsequently appointed Senator Byrd head of a committee to work out arrangements for the new road. According to Abbuehl's report, like Byrd, Tennessee senator Kenneth Douglas McKellar[37] (1869 – 1957) also gave credit for the proposal to MacDonald. Testifying before an initial parkway planning meeting in February 1934, McKellar, who had been one of the two sponsors of the bill creating the Shenandoah and Great Smoky Mountains national parks, stated that MacDonald had suggested "a scenic highway" between the two parks while the bill was being discussed.[38] Straus would later claim he had suggested the establishment of the parkway. Over the years, he would periodically ask the parkway to forward him information on its progress. Eighty-nine years old and still pondering his parkway legacy, Straus penned a letter to the National Park Service [Blue Ridge Parkway] on April 10, 1962, in which he asked when the parkway would to be completed, stating that he hoped "to be here on earth to participate in the ceremonies," again claiming he had originated the idea for the road.[39] More than two decades after the parkway was set in motion, Hunter Miller, a Bedford, Virginia businessman long involved with the Peaks of Otter Company, wrote in the November 9, 1951 *Roanoke Times* [a letter to the editor] that Byrd had merely suggested extending the Skyline Drive south to the Peaks of Otter, but that representatives from Tennessee and North Carolina "got on the bandwagon" and pressed for the road to be extended to the Great Smoky Mountains. In 1953, Senator Byrd wrote Samuel Paul "Sam" Weems (1904 – 1993), then superintendent of the Blue Ridge Parkway, that he had suggested connecting the two parks, and that President Roosevelt not only heartily agreed, but suggested the road be extended all the way to Maine; however, the governors of Maine and other northern states were lukewarm to the proposal, and the project was reduced to a parkway between the two southern national parks.[40] But what is known also, from the park service account, is that two years after Miller wrote his letter, Byrd was more

willing to accept the credit for conceiving the idea of the parkway. In a letter to parkway superintendent Weems dated December 7, 1953, Byrd stated he had been invited to ride with President Roosevelt at the dedication of the first Civilian Conservation Corps camp in Shenandoah National Park, and at that time recommended extending the park's Skyline Drive to Great Smoky Mountains National Park.[41]

While the originator of the road concept seemed fuzzy to the politicians making plans for it at the height of the Great Depression, the proposal quickly gathered the support of federal agencies and representatives from the three states then involved in the process. A report on the proposed road was then presented to Interior secretary Ickes, who signed an order on November 24, 1933, authorizing the construction of the so-called "park-to-park road." The Blue Ridge Parkway was no longer a concept, but a full-fledged federal works project. Although the Blue Ridge Parkway was proposed as a park-to-park road, the impetus for its construction was firmly rooted in the New Deal policy of creating massive public works projects aimed at bringing the country out of the throes of the Great Depression. The depression of the 1930s hit the Appalachian region especially hard, throwing thousands into desperate subsistence living conditions. A project such as the Blue Ridge Parkway, which might provide employment both through construction jobs and tourist services, would have a major economic effect on the troubled region. The National Industrial Recovery Act of June 16, 1933, initiated a program of public works to relieve the endemic unemployment. Under the terms of Title II, Section 202a of the act, President Roosevelt was authorized to construct a program of public works, including "public highways and parkways."[42] This clause would allow projects such as the Blue Ridge Parkway to be built by the government, not just to provide for new roads, but for much-needed employment. Certainly, the concept of using road construction for public relief did not originate in the New Deal. At the start of the Great Depression, President Herbert Hoover's administration began a series of limited public works projects, some of which were employed in the early development of Shenandoah National Park; however, Roosevelt's New Deal programs were on a scale unheard of in American history.

On December 5, 1933, the Public Works Administration (PWA), one of the principal New Deal agencies, officially authorized the first expenditures for what would become the Blue Ridge Parkway project, a $4 million allotment to begin construction of a "scenic highway connecting the Shenandoah and Smoky Mountains National Parks."[43] Over the next decade, the aforementioned alphabet soup of New Deal agencies would be involved in the project, to also include the Civil Works Administration (CWA). From the outset, the Blue Ridge Parkway project was administered to provide the greatest economic benefit to the blighted region of the mountains through which it would be built. In the acquisition of land for the right-of-way, the National Park Service urged the states to offer landowners better than fair prices for their properties. Companies were required to hire as many unemployed local men as possible for the parkway construction, often under quotas specified in the contracts. Abbott announced six years after it was authorized, in 1939, that at least one thousand workers would be engaged in roadside planting and cleanup programs, giving further encouragement to area unemployed, especially those untrained in modern road construction methods. A project superintendent for one of the contracts observed that "about ninety percent of the hand

labor came from nearby creeks and coves. Only the skilled labor was brought in from the outside."[44] There was no lack of opportunity to work on the parkway nor was one mountain community favored over another because the construction was carried out in discontiguous sections by contract.

The National Park Service holds a letter from Doughton Park [formerly Bluffs Park] area resident George Elihu Blevins [of Wilkes County] (1866 – 1941) dated October 10, 1937, in which Blevins described how the project had given new hope to residents in terms that epitomized the project's public works agenda and underscored its value as an embodiment of New Deal principles.

> The building by the Government of the Blue Ridge Parkway with the several recreation Parks have given a great stimulant to all this Blue Ridge section, thousands of worthy citizens are being employed from the Shanadoh [*sic*] to the Smokies ... Hunderds [*sic*] of us who have stood arround [*sic*] like an owl grumbling at the sun must now wake up and take a part however humble our stations of life. We was crushed by defeat, our traditions all gone. We had no money, credit or employment, we was confronted with the gratest [*sic*] problem that ever confronted human intelligence. As ruin was never before so overwhelming, never has restoration been more swifter, from the ashes left in 1932 our President has raised a brave and beautiful country, for some reason the people have caught the sunshine in the motar [*sic*]of their homes, prosperity is being handed down to the most humble.[45]

Even after work was complete on the first segments, the parkway offered employment to individuals who were engaged to maintain the road and its roadside features. Concessions along the parkway offered other opportunities, and visitors attracted to the parkway bolstered the local economies of communities located near the route.

Excitement for the parkway grew exponentially after Ickes made it known it was coming. Ickes, in his dual role as administrator of public works, turned the project over to the National Park Service but the park service had no one on staff with any experience in the design and construction of a rural parkway, especially one that would extend nearly five hundred miles along the crest of the Blue Ridge Mountains. The park service's closest experience with anything remotely similar was the Westchester County parkway system and the commission that governed it. On December 26, 1933, Thomas Chalmers Vint (1894 – 1967), the National Park Service chief of the branch of plans and design, hired Gilmore David Clarke[46] (1892 – 1982), a landscape architect and civil engineer for the Westchester County Park Commission (WCPC) and a member of the National Commission on Fine Arts, as consulting landscape architect for the new scenic road. He also engaged WCPC chief engineer [1934 – 1941] Jay Downer (1877 – 1949) as consulting engineer. On Clarke and Downer's recommendation, Vint appointed twenty-six-year-old Stanley W. Abbott as resident landscape architect.[47] The choice of the WCPC staff was somewhat unusual, in that the National Park Service generally assigned personnel already in its ranks to administer park units and projects, but Vint wanted to engage someone who might know something about parkway design and build-out, even if that meant the experience was with a suburban parkway.

Unquestionably, the hiring of Abbott was a pivotal moment in the history of the parkway. Park service history informs that Abbott was a native of Yonkers, New York, and like Clarke and another landscape architect, Wilbur Herbert Simonson[48] (1897 – 1989), chief of the Bureau of Public Roads' roadside branch [1932 – 1965], Abbott attended Cornell University, from which he earned a landscape architecture degree in 1930. While Abbott was a talented draftsman and possessed with an uncanny ability to adapt roadways to the landscape, the Westchester County Parkway Commission used him as the modern-day equivalent of a public relations specialist. Clarke and Downer must have recognized his other talents, and his choice to manage the new federal project was subsequently proven to be a propitious one. Not only could he develop the broad concept for the road and oversee the myriad details of its planning, but he could also "sell" the ideas to the state highway departments and other government agencies which cooperated on the project, and to the mountain people who would be most directly affected.[49] There was also some merit, only time would tell, to having pigeonholed Abbott in public relations. Abbott reported to the new Department of Interior building in Washington, D. C., at the beginning of 1934 to receive his appointment papers allowing him to begin work on the project. In front of the building was a heavy Dodge truck, with which he was instructed to "lone-wolf it down to the Great Smokies and to get to know the mountains." Two weeks later, Clarke, Downer and Vint would join him for their first look at the challenges ahead. Abbott later recounted his introduction to the Blue Ridge.

> I lone-wolfed for two weeks of winter weather through the mountains; wound along on those little mountain roads, sometimes snow drifted, sometimes frozen, many times thawing in the middle of the day in the southern sun; getting stuck and unstuck; pulled out by horses or mules or a chestnut rail taken from a nearby snake fence. But by the end of the first trip with Clarke, Downer and Vint, I had some sense of those awesome mountains.[50]

Part of Abbott's trip was spent in the company of Bureau of Public Roads civil engineer William Ira Lee (1872 – 1946) from Great Smoky Mountains National Park. Bureau of Public Roads district engineer Harold James Spelman (1888 - 1982), also a Cornell University graduate, in charge of the bureau's eastern office, and senior highway engineer William Milnes Austin (1886 - 1947), a native of the Roanoke Highlands who had worked in Robertson, Madison County, Virginia, on the development of Shenandoah National Park, later joined the party. Spelman had been part of the Mount Vernon Memorial Highway project with Simonson and with the National Park Service on the construction of the Colonial Parkway. Austin had supervised the park service's reconstruction of the Generals Highway in Sequoia National Park, and later oversaw much of the work on the Pan American Highway.

From correspondence in the park service archive, we know that Abbott went back to New York to consult with Gilmore Clarke from January 6 – 9, 1934. By January 12 he was in the Virginia mountains to make a detailed inspection of the parkway route between Jarman Gap – the southern boundary of Shenandoah National Park – and Reed's Gap [Milepost 13] in the company of the locating engineers. The following month, the Public Works Administration held a meeting in Baltimore, Maryland, to review the project. George Radcliffe, the chairman

of the steering committee, presided. Among those present were Spelman, Clarke, Vint, Abbott, Theodore Straus, and officials of the Virginia and North Carolina highway commissions. The purpose of the meeting was to set forth to the landscape architects the opinions and concerns of the states regarding the general character and route of the road. On the first day of the meeting, Virginia's delegation set forth two possible routes. Virginia Department of Highways commissioner Henry Garnett Shirley[51] (1874 – 1941) reported that initial surveys had been completed for a route extending from the terminus of the Skyline Drive south to the Peaks of Otter. No land for rights-of-way had been acquired, because the commission had yet to be granted the proper authority, though the necessary bill was already before the legislature. The choice of a route south of Peaks of Otter had been deferred a pending decision regarding the larger question of whether a general route through North Carolina or Tennessee would be selected. Virginia had no preference in the latter matter, and the highway commission officials reported they could design a route to connect with whatever route was chosen further south. Clarke then announced that an interbureau agreement had been reached between the Bureau of Public Roads and the National Park Service to construct the parkway. The states were to supply a right-of-way of two hundred feet in width and the federal government would do the actual construction. Clarke then spoke on the difficult design challenges ahead:

> Mountain roads as such in the past have been altogether too crooked, the grades have been too steep, to provide for arteries for motors having a speed of thirty to forty miles per hour. It is hoped we can build a road which will give the motorist a pleasurable drive, and with sufficient ease that he won't feel that he is going to slide off a brink [of] 2,000 feet down, if he goes too fast around a corner.[52]

Clarke believed that locating the new parkway would be the greatest challenge yet faced by highway engineers and designers.

The Virginia delegation then laid forth general plans for two different routes south of the Peaks of Otter. One would follow the Blue Ridge south to Roanoke, through the Pine Spur country and Rocky Knob southwest to the North Carolina state line at Fancy Gap. The other proposed route was to the east, leaving the Blue Ridge for the higher chain of the Alleghenies to a point on the Tennessee line. Representatives from the various counties along the two routes spoke on the respective merits of each alternative, but the state officials affirmed they would be satisfied with either. The crux would be the selection of the route further south, whether through North Carolina or Tennessee; Virginia could supply a route to connect with either choice.

North Carolina representatives, including Governor Ehringhaus, senators Robert Reynolds and Josiah Bailey, congressmen Robert Lee Doughton (1863 – 1954), of Alleghany County, North Carolina and sometimes called "Farmer Bob," Zebulon Weaver (1872 – 1948), William Bradley Umstead[53] (1895 – 1954), Alfred Lee Bulwinkle (1883 – 1950), and Franklin Wills Hancock Jr.[54] (1894 – 1969), and state highway department officials, testified the next day; the Carolina case was set forth by Governor Ehringhaus, state highway commission chairman

Edwin Bedford Jeffress[55] (1887 – 1961) [for whom a parkway recreation area would later be named], and the state's chief highway location engineer, Romanus Getty Browning (1884 – 1966). The Carolinians argued for an all-Carolina route, stressing its scenic advantages – such a road would be located at a higher general elevation than a line that diverged into Tennessee – and the importance of the parkway to the nascent tourism industry of the state.

The Tennessee delegation testified on February 7, 1934. Speaking for the state were senators Kenneth McKellar and Nathan Lynn Bachman (1878 – 1937); congressmen Brazilla Carroll Reece (1889 – 1961), Gordon Weaver Browning (1889 – 1976), John Ridley Mitchell (1877 – 1962) and James Willis Taylor (1880 – 1939); state highway commission chairman and civil engineer Frank William Webster (1888 – 1952); Colonel David Carpenter Chapman (1876 – 1944), of Knoxville, an army soldier, politician, business leader and notably president of the Great Smoky Mountains Conservation Association, and various highway officials. Senator McKellar began by insisting that Tennessee sought no advantage over North Carolina, only an "equal share" of the road. To him, the proposed road should not favor either state, but rather follow the main line of the mountains that separated the two. True, these mountains were not as high as North Carolina's Mount Mitchell, the highest point in the east, but they were only ten feet or so less in elevation. The scenic values of the border line route would rival any all-Carolina route, he maintained, and might even be superior. Having made these points, McKellar issued a warning that the planners would face an uphill battle if Tennessee were denied its share of the road. The money had not been appropriated, and might not be forthcoming if Tennessee did not receive its fair share of the new parkway. Frank DePue Maloney (1879 – 1952), a Knoxville civil engineer, highway contractor and conservationist[56], representing the Tennessee Highway Commission, supported McKellar's proposed route, but conceded that a route built strictly on the state line would be extremely difficult from an engineering standpoint due to the complex topography of the high crest of the Unakas. Instead, he proposed a crossover route, which would follow the Blue Ridge from the Virginia line through North Carolina as far as Linville, then swing west into Tennessee at Roan Mountain, at which point it would veer southwest to the Great Smoky Mountains National Park. He argued that an approach to the main range of the Smokies from the Tennessee side would be more dramatic, as the whole mountain mass would rise before the visitor for a distance of more than five thousand feet, where the approach from the Balsams in North Carolina would involve much less contrast in elevation. If there were any objection to having Gatlinburg, Tennessee, selected as the sole entrance for the parkway into the park, this could be remedied by constructing a loop through the Cataloochee country to Cherokee, North Carolina, giving both states an entrance point. By the end of the meeting, the views of the states had been put forth, but no decision had been reached on the ultimate route of the road.

At this point, the planning team lost two of its key figures. Clarke and Downer had been hired as consultants because of their experience with the Westchester County parkway system, but their association with the Blue Ridge project was to be short-lived. Following another inspection of the mountains with Abbott and Vint, the party returned to Washington and were called into a meeting with Secretary Ickes. Ickes greeted the group, and then turned and said, "Mr. Clarke, I understand the government is paying you $75 a day and your expenses

for your services." Clarke replied, "That is right, Mr. Secretary." Ickes then said, "We have a policy here in Interior of not paying consultants more than $25 a day in these Depression times." Clarke, a man of firm temper – Abbott later wrote that he was known for his initials as Major God Damn Clarke – stepped forward, pounded Ickes' desk, and thundered "I have worked, Mr. Secretary, for years for the government at $1 a year, which I would be glad to continue to do. My regular fee here, as elsewhere, is $75 a day." He turned and left the office, the quiet engineer Downer following him. They never returned. The major responsibility for planning the project now rested on young Stanley Abbott, who immediately had to deal with a number of critical concerns.[57]

The first major policy question to be resolved was financial: who was going to pay for the road? President Roosevelt had suggested the route be constructed as a toll road, but the governor of North Carolina was adamantly opposed to toll roads and the state rejected this proposition. Both North Carolina and Virginia wanted the federal government to assume all costs, but Ickes insisted the states bear a major share of the burden, reasoning they would benefit from the road and the tourist revenues it would generate. A compromise was soon reached, under which the states would purchase the land for the right-of-way, and the federal government would build the road. Virginia's state senate formally approved the project on February 21, 1934, when it passed a bill authorizing the road. The legislation treated the road as a *de facto* state highway, though it was understood the land acquired for the right-of-way would be transferred to the federal government, which would construct it or improve existing roads as segments of the newly planned parkway. At this point, it would cease to be a state road, and all responsibility for its construction and upkeep would be vested with the federal government. North Carolina adopted similar legislation soon afterwards.

Another early consideration concerned the extent of right-of-way necessary to secure protection for a scenic parkway. Normal highways of the time generally had a right-of-way of sixty feet or less. At the meeting in Baltimore, Clarke recommended a width of two hundred feet, which had been adopted for the Westchester County parkways. But Abbott raised his eyebrows, clearly concerned that the width would be insufficient, to which Clarke said, "Well, maybe you better have scenic easements of about four hundred feet on either side for added protection."[58] In the crowded New York suburb, with relatively gentle terrain, the two-hundred-foot buffer had proved just adequate, but in the Virginia and North Carolina mountains, with their far more expansive views, it would be far too little. This became the basis for the early right-of-way acquisition, which would lead to myriad problems in the near future, especially with the management of scenic easements.

One of the first problems faced by project planners was a dearth of maps of the areas through which the road would pass. Maps of most areas in the mountains were very poor, and in some cases, unavailable. There were, for instance, no United States Geological Survey maps of the Floyd Plateau; a sketch map from the Appalachian Trail Club was the only map available for that area. Consequently, much time would have to be spent in the field inspecting the layout of the land or preparing adequate topographic surveys. Abbott also had to assemble a staff, prepare budgets, review location surveys, deal with a skeptical mountain people, and see the project through its crucial initial stage. Luckily, he had both

the skills and the stamina to carry out these immense tasks. Following Abbott's death, his successor as superintendent, Sam Weems, spoke of his predecessor's pivotal role in the design and planning of the parkway:

> Stan was a dreamer, and it took a dreamer to do the planning job he did on that Blue Ridge Parkway. To me, this Parkway will be a planning monument to Stan Abbott if to no one else. The very concept of the location of it, the proportion of recreational areas all along its nearly five-hundred-mile route, the selection of parking overlooks along the way at strategic places, the location of the road itself around certain mountains and through certain gaps--this was the result of Stan's fine planning hand.[59]

Abbott did not, or course, work alone, but rather established a talented staff with their own special skills. He quickly brought in an old friend and former professor, Edward H. Abbuehl, as his chief assistant. Abbuehl received his master's degree in architecture from Cornell University in 1928. He was an instructor in descriptive geometry and mechanics there until 1933 when Cornell, like other institutions faced with Depression-era financial problems, had to let him go. In April 1934, he joined Abbott's staff as parkway landscape architect.[60] Mary Dandridge Frantz Crumpler (1911 – 2004), the first secretary assigned to the parkway project office in Roanoke, later recalled in a July 22, 1971 interview that if Abbott was the visionary, then Abbuehl was the realist. A third key figure also joined the team in April. Hendrick Enno van Gelder (1884 – 1954), a native of the Netherlands, was another veteran of the Westchester County Parkway Commission. Described by Abbott as "a very picturesque Dutchman," he was a landscape architect by profession, but his specialty was road location, making him an invaluable asset. The planning work for the vast project was now divided up. Abbuehl would oversee the route reconnaissance in North Carolina, and van Gelder took responsibility for the Virginia section. Abbott remained in overall charge. In February 1934, Abbott established offices for the parkway project. The first headquarters for what would become the Blue Ridge Parkway was the dining room of Abbott's apartment, a converted second story in a private residence in Salem, Virginia. The dining table was the drafting board over which the initial plans were made. These makeshift arrangements continued for three or four months before Abbott was able to secure offices in the Shenandoah Life Insurance Company building in Roanoke. Roanoke remained parkway headquarters until 1972.

In June 1934, a report on the parkway project was submitted to Secretary Ickes by George Radcliffe, chairman of the project coordinating committee, Bureau of Public Roads chief MacDonald, and National Park Service director Cammerer. They reported that Virginia, North Carolina, and Tennessee had all submitted data on their proposals for the route through their respective states. Field examinations of the routes had been conducted by MacDonald, Radcliffe, Clarke and Theodore Straus. The report recommended a route beginning at Shenandoah, passing the Peaks of Otter and the Pinnacles of Dan in Virginia, then south into North Carolina as far as Grandfather Mountain, at which point the road would veer west to the Unakas, then down that chain to the Great Smoky Mountains at Gatlinburg, Tennessee. As the road approached the Smokies, they suggested it might fork to provide for termini at

both Gatlinburg and Cherokee, North Carolina. The committee favored this route for its variety of topography, easy road alignment, and excellent scenery.

The name for "America's Favorite Drive" was up in the air through much of the first two years of its development. Park planners first called it the "road to connect the Shenandoah and Great Smoky Mountains national parks." In 1934, Theodore Straus suggested the "Shenandoah-Great Smoky Mountains National Parks Parkway and Stabilization Project," emphasizing stabilization because of the economic role the project was expected to play in revitalizing the depressed mountain economy. This name was not catchy – nor short – enough to be used. National Park Service acting director Arthur Edward Demaray suggested the simpler name "Appalachian Parkway" in January 1936. Later that month, Secretary Ickes formally designated the project the "Blue Ridge Parkway." The name was confirmed by House Resolution 12455, Number 848, Seventy-Fourth Congress, introduced by North Carolina representative Robert Lee Doughton on April 24, 1936, the same bill that placed the project under the administration of the National Park Service. Even after the Blue Ridge Parkway designation was officially adopted, there were several attempts to reopen the naming debate. Following the death of President Roosevelt on April 12, 1945, several citizens called for the parkway to be renamed in his honor. Stewart Minor Woodward[61] (1904–1961), then of Raleigh, North Carolina, suggested extending the parkway to Warm Springs, Georgia, and renaming it the "Roosevelt Memorial Highway." He estimated the cost of the 230 additional miles at $100,000 a mile, or $23 million to complete the project.[62] Seven years later, in 1952, North Carolina representative, industrialist and philanthropist Richard Thurmond Chatham (1896–1957) introduced a bill to change the name of the parkway to the "Robert L. Doughton Parkway" after the retiring North Carolina congressman who had long sponsored the project. While Chatham's bill passed the United States House of Representatives with only Congressman Doughton dissenting, the Virginia and North Carolina legislatures, city councils and chambers of commerce objected, and the bill was defeated in the United States Senate. Doughton's name had recently been applied to the former Bluffs Park recreational area on the parkway, which probably mollified the supporters of the name change. Chatham's name was later given to a large North Carolina wildlife management area adjacent to Doughton Park. The road remains the "Blue Ridge Parkway."[63]

Four months after the parkway report reached Ickes' desk, in October 1934, the Bureau of Public Roads was formally assigned the task of constructing the motor road. Initial Bureau of Public Roads parkway planning took place in its Luray, Virginia office where the bureau was overseeing completion of the Skyline Drive; the following year the office relocated to Roanoke. The Bureau of Public Roads was charged with construction supervision; major planning efforts for the endeavor remained the responsibility of the National Park Service. On September 25, 1935, Secretary Ickes, in his capacity as public works administrator, announced that $6 million had been appropriated to the National Park Service to begin the project. Construction began shortly thereafter.

The parkway would be built along the crest of the Blue Ridge between Virginia and North Carolina. What happened to Tennessee? The 1933 authorization of the "Road to connect the Shenandoah and Great Smoky Mountains national parks" did not specify a route, only

that the project provide a connection between the two new national parks, then still under development. A significant part of the route would necessarily run for two hundred miles or more through Virginia, but both North Carolina and Tennessee were determined to have the lower section of the road routed through their states. Gatlinburg, Tennessee, was the principal gateway to the Great Smokies, and Tennesseans naturally favored that town as the terminus. North Carolina wanted the road to enter the park from Cherokee, which would require a route through the North Carolina mountains, likely bypassing Tennessee altogether.

Each of the states considered several alternate lines for the parkway. Virginia, already assured of a significant part of the road, was ambivalent about the route once it left the commonwealth. North Carolina and Tennessee each tried to claim the lion's share of the southern part of the road. North Carolina submitted a proposal that was essentially the same as the line eventually adopted and built, and its rival Tennessee suggested a line entering that state from Virginia near Bristol and continuing southwest to Gatlinburg. As an alternative, Tennessee also proposed a "compromise" route generally following the North Carolina – Tennessee border, but this was never seriously considered because the high ridge of the mountains separating the two states proved too rugged for construction of the road. There was even discussion, at one point, of a route that would run into West Virginia, then down through Virginia, bypassing North Carolina entirely. Recall that on October 17, 1933, delegates from the three states met in Washington and all pledged their state's support for the project. There was some discussion of routing possibilities but no action was taken. Representatives called for an allocation of $16 million to construct the parkway. In mid-November, they met with Secretary Ickes, who told them President Roosevelt had approved the road and the Interior Department was prepared to begin surveys for the route. The parkway would be funded through Public Works Administration funds, though the states were to defray the costs of the surveys, and to acquire and deed to the federal government the necessary rights-of-way.[64] The delegates were delighted at the good news, but soon the states would begin an ugly fight to capture the largest part of the parkway route.

North Carolina wanted the route south of Virginia to stay within its boundaries, entering the state at Low Gap and continuing from there to Roaring Gap, Glendale Springs, Deep Gap, Blowing Rock, Linville Gorge, Little Switzerland, Buck Creek Gap, along the Craggies into Asheville, then west and northwest to Great Smoky Mountains National Park. Tennessee favored the same route as far south as Linville Gorge, but then wanted it to veer northwest through Carver's Gap to Roan Mountain, then turn southwest along the Unakas to the Gatlinburg entrance to the Great Smokies.[65] The National Park Service at first leaned toward the Tennessee proposal, which it saw as a compromise route, giving both states a major portion of the road. The park service suggested that as the road approached the eastern end of the park, it might fork, providing spurs for Gatlinburg, Tennessee, and Cherokee, North Carolina. Park service planners spent much of the first summer investigating these routes.

The three states were asked to consider all proposals for routes within their respective boundaries and consolidate them into a recommendation for a single route. The three state proposals would be considered at a hearing in early 1934. Abbott, Abbuehl, and other parkway planners were concerned about the difficulties involved in the proposed North

Carolina route; it would cross some of the most rugged mountains in the east – the Blacks, the Craggies, the Balsams and Plott Balsams. Routing a road through such terrain was bound to leave construction scars. Some conservationists were also alarmed at the potential for devastation, concerns that Abbuehl would recall later, when asked about the route deliberations. The decision, however, would not be made by the staff in Roanoke, but by higher level authorities. Then came the January 1934 meeting in Baltimore to consider the three state proposals for the parkway route. George Radcliffe, who was by then a Maryland senator, presided over the meeting in his capacity as chairman of the project committee. Officials were present from the National Park Service, the Bureau of Public Roads, and each of the three states. Virginia officials were generally restrained, as much of the route would necessarily pass through their state, but North Carolina and Tennessee each wanted as much of the road as possible. No decision was reached at the meeting, but the park service organized a reconnaissance field trip of the various routes in March 1934. From an early history of the Blue Ridge Parkway, reported on January 10, 1937, and reports from the resident landscape architect covering the years 1934 to 1936, we know that inclement weather unfortunately hampered the inspection, as well as a second survey of the parkway lines made by airplane in April. A third survey was made by state and federal officials in May. The parkway staff in Roanoke made a more detailed investigation of the routes, and in June recommended a line extending south from Virginia into North Carolina as far as Linville, then shifting west to the Unaka Mountains of Tennessee. The road would then run southwest to Great Smoky Mountains National Park, terminating in a loop that served the Gatlinburg and Cherokee entrances, connecting with each other across the present Newfound Gap area.

A June 13, 1934 joint report from the National Park Service and the Bureau of Public Roads to Secretary Ickes recommended the crossover route that would carry the parkway west from the Linville area into Tennessee. Senator Radcliffe and his advisor, Theodore Straus, both worked on the preparation of the report; it listed a number of advantages for the crossover route.

> This route will provide for the wider variety of topography, scenery and roadside conditions. It will provide mountain, flat plateau, interior valley and stream side location. It will permit relatively easy road alignment. Its altitude will be generally high, since the interior valleys will be largely at elevations of 2,500 feet or more, and it will be the most directional in character.[66]

In addition to its scenic variety and ease of construction, the crossover route would also lend itself to the construction of the fork road leading to both the Tennessee and North Carolina gateways to the Great Smokies. The joint report even suggested the road could possibly fork at Linville, allowing for the construction of the very line the North Carolina interests were proposing. This would have entailed the construction of two parallel parkways over half the length of the project. Although the report was kept secret for several weeks, North Carolinians heard rumors of its findings and were outraged. Asheville Chamber of Commerce manager Fred Lewis Weede (1873 – 1961) met with National Park Service director Cammerer and told him that North Carolina would not accept the compromise route. Weede

noted that Cammerer was clearly disappointed in the rejection of the plan, and made what was described as a chilly exit from the meeting. Weede and other Carolinians then tried to take the issue to the President. They assembled an album of photographs of North Carolina mountain scenery that Governor Ehringhaus presented to Roosevelt. While pleased with his favorable reaction, they did not receive any commitment from the President regarding a resolution of the matter. The North Carolinians also elicited the support of Josephus Daniels (1862–1948), a newspaper publisher and editor who was just then the United States' minister to Mexico. A native of the Old North State who maintained a summer home at Lake Junaluska in western North Carolina, Daniels was a close friend of President Roosevelt. Meeting with a delegation of Carolinians, Daniels told them he would do whatever he could to promote the Carolina route.[67] A little over a month later, on July 19, Secretary Ickes approved a route from Jarman Gap in present Shenandoah National Park to the James River, and from Adney Gap south of Roanoke southwest to Blowing Rock, North Carolina. The final section between Blowing Rock and the Great Smoky Mountains was yet to be determined, but the adoption of the first sections would allow construction to proceed. Ickes scheduled a hearing to discuss the remaining section for September 1934. That fall, Robert Marshall[68] Ph.D. (1901–1939), Interior Department director of forestry and devoted conservationist and environmentalist, spent five days on an inspection of the two routes per Secretary Ickes' direction. Marshall reported that the choice between the two routes was "so close that you could with perfect propriety pick either one and justify yourself." He suggested five factors should be considered in the choice of the route. Three favored Tennessee, and two North Carolina, but two of the factors could be rated essentially the same.

To Marshall, the North Carolina route had two advantages: first and foremost, it was more scenic, due to a significant section that would be sited at high elevation on the slopes of Mount Mitchell. Secondly, Mount Mitchell itself would be a major attraction, as many tourists would wish to boast of visiting the highest mountain in the East. The other factors favored the Tennessee route: it would be less costly to construct; it would scar the scenery less than construction in the North Carolina mountains, and the Tennessee route, being at somewhat lower elevation, would be blocked less often by snow in winter and less shrouded by fog in summer. Marshall considered another matter more important than the actual choice of location between the two states, and that was "the necessity of keeping the parkway out of the few important primitive areas which are still left in this region."[69] He determined that such forests and mountain lands that were still undisturbed should not be invaded by the parkway. Marshall thought these areas should be protected as wilderness. The parkway should be planned through areas already developed, saving the primitive forests for those who enjoyed their special charms. He thought three areas in particular should be avoided by the parkway: the crest of the Blue Ridge between Shenandoah and the Peaks of Otter, and in North Carolina, the Pisgah Ledge and the Balsam Mountains. As it turned out, the parkway would eventually traverse each of these areas. Citizens from both states urged their representatives to fight for securing the necessary rights-of-way, citing both the potential economic impacts and the chance of finally having a good road to provide access to the outside world. Both North Carolina and Tennessee had stopped working together to advance

the parkway project, and each state increased its efforts to secure road for their respective states. North Carolina's well-orchestrated fight, led by state highway location engineer Romanus Getty Browning, was strongly supported by state government officials and the important tourism industry. Tennessee forces gathered behind powerful Senator McKellar. In September 1934, Secretary Ickes agreed to a second hearing to discuss the location matter.[70] Ickes kept the speeches short. As planned, Browning was the principal speaker on North Carolina's behalf. He touted the state's scenic advantages, calling attention to views from different locations, continuing until Ickes indicated he was tiring. Browning stated he had a great deal more evidence, but Ickes bluntly directed him to "File it."[71]

Tennessee's pleas were chiefly voiced by McKellar. McKellar dropped a bombshell by bringing up the ostensibly secret Radcliffe report, which favored the Tennessee route. The Tennesseans also protested that North Carolina had "no monopoly on the land and sky," and made the case that North Carolina was seeking to deny Tennessee any benefits from the parkway. It would only be fair, they insisted, for all three states to share in the project they had jointly supported so far.[72] At the conclusion of the presentations, Ickes commended both states for their efforts, and assured them that he would render a decision based entirely on the merits of the proposed routes. Promising he would "take my head between my hands and after wrapping a wet towel around said head shall try to be fair and just," he dismissed the hearing.[73]

In correspondence dated November 10, 1934, from Ickes to McAlister and Ehringhaus, Ickes rendered his decision: "After a careful study," he wrote, "I cannot escape the conclusion that the decided weight of the evidence is in favor of the so-called North Carolina route." The new parkway would follow the route proposed by the Carolina contingent, running southwest from Blowing Rock along the Blue Ridge, then through the Black and Craggy ranges to Asheville, then by Mount Pisgah before veering northwest to enter the Great Smoky Mountains National Park near Cherokee, North Carolina.

An Interior Department press release issued two days later set forth the reasons for Ickes' decision. Both the Tennessee and North Carolina routes seemed equal from a scenic standpoint, but as Tennessee already had the chief entrance to the Great Smoky Mountains at Gatlinburg, it seemed unfair that it should receive the new approach road. The nascent western North Carolina tourist industry would be decimated if all parkway traffic were diverted away toward the Tennessee side. Tennessee, on the other hand, would still be the chief gateway to the park for travelers approaching from the west and northwest. Tennessee was already the recipient of millions of dollars in federal funds for the new Tennessee Valley Authority project, while North Carolina had nothing comparable. As a final consideration, if the parkway were to become a part of a greater Appalachian parkway extending from New England into Georgia, the Carolina route would provide a more logical connecting link. Should this extended route be successfully completed, Ickes visualized a second parkway following the main Appalachian chain, running from western New York, Pennsylvania, West Virginia, eastern Kentucky, and thence through Tennessee to Gatlinburg. Tennessee might secure a parkway after all, according to the press release dated November 12. In the end, the state secured two, the Natchez Trace Parkway and the incomplete Foothills Parkway.

North Carolinians were jubilant. The *Asheville Citizen* carried the headline "Ickes Decision Placing Route for Parkway in N. C. Hailed as Great Victory by Entire State." A grand victory celebration dinner was held at the George Vanderbilt Hotel to honor those who worked on the effort. Across the western border, however, Tennesseans were outraged in their defeat. Senator McKellar rushed back to Washington for a meeting with President Roosevelt, urging him to reverse the decision. Roosevelt, however, refused to get involved, and the lower part of the parkway was built in North Carolina.[74]

In contrast to the Skyline Drive, the Blue Ridge Parkway was not planned as a ridge-line route, though extensive segments do follow the crest of the mountains. Rather, variety was introduced by routing the road along mountain sides, beside mountain streams, and in a few places, through broad river valleys. "Changing road position" was an important factor. Stanley Abbott's plans stated that "only intermittent sections will ride on or near the skyline in the manner of the Shenandoah drive," reasoning that "rugged topography has served to deflect a continuous skyline location," and adding that the designers "have deliberately chosen to avoid certain mountains in order to introduce other types of scenery."[75] Further, parkway designers aimed to provide the road with a high standard of grade and curvature so that motorists might safely devote much of their attention to the viewshed. The parkway was not, however, designed for high speed motoring, but rather leisurely travel. Prohibitions against commercial vehicles helped enhance safety and distinguish the drive from normal traffic arteries. Great care was taken to plan the route to cause the least possible scarring of the wild mountain terrain. Roadside grading was "warped" into the contours to reduce the appearance of heavy machine work. Such damage as was unavoidable was concealed wherever possible by landscape plantings of native trees and shrubs. In focal points, concentrations of flowering trees and shrubs heightened the natural beauty. Vistas and bays were opened to allow "glimpses" into the surrounding woods and fields, as well as distant views. Certainly, too, local communities often pressured parkway planners to route the road through their area. "Everybody figured that they had the best views in the State of Virginia or in the entire East right in their backyard and insisted that they be included," Abbuehl later recalled. The staff's public relations skills – especially Abbott's – were often called upon. Once in the field, they had to be somewhat circumspect about their activities, lest word that the parkway was coming through would drive up real estate prices.[76]

Parkway planners interpreted Ickes' instructions to follow the mountain crest as a general guideline, and consequently routed the road away from it at various points for scenic effect or to inject variety into the motoring experience. The location of almost any road could be determined by following it in such a manner, but the successful design of the Blue Ridge Parkway involved more intangible factors. Asserting that the design process was "almost a form of sculpture," Abbott proclaimed:

> It takes a third-dimensional mind and insight into what is the main contour of this particular land form, whether one broad main curve, or sometimes since nature doesn't always deplore a straight line – there are places where the road wanted to straighten out for a while because the conformation of the land straightened out; or there had been a straight cut farm field against a straight line of woods.[77]

Shifting metaphorical media, he enthused, "I can't imagine a more creative job than locating the Blue Ridge Parkway, because you worked with a 10-league canvas and a brush of comet's tail. Moss and lichens collected on the shake roof of a Mabry Mill measured against the huge panoramas that look out forever."[78]

Several factors helped determine the final location of the roadway. These included horizontal alignment, grades and topography and cost. Views and directions of views were important factors, but planners soon decided that there would be many potential vistas from any chosen location, so locating the road in order to seek a view in itself rarely became an overriding consideration. Balancing costs against topographic conditions was not easy; often, land that states could acquire for modest costs was so rugged that construction would prove very expensive, and level land suitable for easy construction would require the states to pay higher right-of-way costs. The approximate boundaries of the right-of-way were determined by a park service landscape architect [in the early stages of the project, usually Abbuehl or van Gelder], who prepared preliminary property maps, which were based on the federal geological survey quadrangle maps where these existed. The landscape architect would determine the general boundaries for the right-of-way, but without the aid of a survey party to provide exact measurements, he could only approximate the boundaries on the maps. The maps were then turned over to the states, which sent out survey parties to determine the exact boundaries of each tract to be acquired.

Survey parties were in the field as early as January 1934. Abbott accompanied a Bureau of Public Roads survey team on its work preparing a line between Jarman Gap and Reed's Gap that month. The flagged line was inspected in March and approved by consulting landscape architect Gilmore Clarke, who was then still on the payroll. Parties then began laying out a general route between Reed's Gap and Fancy Gap [Milepost 198] in southwestern Virginia. By the end of February, the centerline location had been approved as far south as Irish Gap. Preliminary location surveys were underway between Peaks of Otter and Maggoty Gap, southwest of Roanoke. Also in March, Abbott and Bureau of Public Roads crews began reconnoitering on the North Carolina sections of the route between Roaring Gap [just south of the Virginia line] and Asheville. Some inspection was also made of lines proposed by Tennessee. As the decision on the parkway route through North Carolina or Tennessee had not yet been made, only general routes between principal control points were inspected. All work in Tennessee ceased after Ickes ruled in favor of the all-Carolina route. To guide the construction and design of the parkway, the project staff prepared the first of a long series of master plans in 1934; it was authorized the following year along with the first part of the route. A new plan was prepared and approved in 1936, showing the parkway location all the way to the Great Smoky Mountains and outlining nineteen areas proposed as recreational parks. Thereafter, master plans were issued or revised at regular intervals.

Once Abbott and Abbuehl had a rough idea about a desired routing, the Bureau of Public Roads assigned engineers to investigate the suggested route. The project was fortunate in having excellent personnel assigned to the task. Bureau of Public Roads resident engineers William M. Austin and William I. Lee both had experience locating park roads in the West prior to coming East Coast. Austin, who had determined the location for the Skyline Drive

through Shenandoah National Park, later headed the Roanoke office during the formative years of the Blue Ridge Parkway. Once the parkway and Bureau of Public Roads staffs agreed on a suitable location, they would call in Clarke and Downer [while they were still under contract to the National Park Service] and park service chief architect Thomas Vint and make a joint trip to finalize details so that work could get started. The earliest investigations extended southward from Shenandoah National Park.

Of interest, it is well established that much of the route between Asheville and Great Smoky Mountains National Park was investigated by North Carolina State Highway Department chief location engineer Romanus Getty Browning, who had spearheaded the state's effort to secure a route through its western mountains during the debate on road location. Walking over most of the difficult terrain himself, armed with maps, aerial photographs and a snake stick, he personally determined most of the roadway location through this section. He directed the state highway department crews in conducting the location surveys, running the preliminary lines, establishing levels, and preparing topographic maps. When troubles arose with the Eastern Band of Cherokee Indians over location of the final segment through the Qualla Reservation, he attended council meetings and helped work out the agreement that finalized the parkway route between Soco Gap and the Oconaluftee River. Once a route had been agreed upon and flagged by the National Park Service and the Bureau of Public Roads, parkway land acquisition maps were prepared and turned over to the states so that they could begin purchasing the necessary land for the right-of-way. The states would often object to the plans, and the park service would have to convince them why the proposed location was desirable from a scenic standpoint, even if it appeared impractical from an economic perspective.[79]

Abbott's proposed route for the northernmost section left the Blue Ridge at Tye River Gap [Milepost 29], dropped into the James River watershed, then rejoined the Blue Ridge crest at Powell's Gap just west of the Peaks of Otter. He also proposed an alternative that would have carried the parkway by Virginia's famous Natural Bridge, which he called "a chief natural wonder of the East." In March 1935, Abbott laid out the various arguments for and against the two routes. The second alternative would also provide access to the old James River and Kanawha Canal and two old blast furnaces from the antebellum iron industry, as well as providing easy access to the historic city of Lexington, Virginia, the county seat of Rockbridge County. From a scenic standpoint, the route afforded an "excellent psychological effect" through its descent and ascent along fine mountain streams and a traverse through the broad valley of the James River. A minor ridge paralleling the Blue Ridge would have provided splendid views of the main mountain range for thirteen miles. The lower line would make for safer driving, lower cost, and easier construction than a road in the more rugged mountain topography. The upland or Blue Ridge route, by contrast, would run for a greater distance through national forest land, thirty-one miles as opposed to seventeen miles, which would result in less expensive land acquisition. The route would display fine mountain scenery when considered separately from the distribution of similar scenery over the remaining 450 miles of parkway. There would be less conflict with developed real estate, and the route would provide more direct access to the Peaks of Otter. The average summer temperature would also be more favorable due to the higher elevation. Regardless of this,

Abbott still favored the Natural Bridge line. Even though he preferred Natural Bridge as a parkway recreational area, Abbott failed to secure it for that purpose. The lowland route was opposed by Virginia senator and newspaper publisher Carter Glass (1858 – 1945), who argued that land acquisition in the agricultural Shenandoah Valley would be much higher than the proposed mountain route, where much of the land could be turned over by the United States Forest Service. Although Glass did not state it publicly, the valley route would also divert the parkway away from his home town of Lynchburg, and this was highly likely a major factor in his opposition. Whatever his reasons, Glass succeeded in having the parkway kept to the top of the mountains through the area.[80]

In the late 1930s, the final location of the parkway in the Blowing Rock, North Carolina area remained uncertain. The state of North Carolina, seeking to avoid damage to a golf course[81] and numerous private resort properties in the area, was studying a new line through the estate of industrialist, philanthropist and textile magnate Moses Herman Cone[82] (1857 – 1908) known as Flat Top Manor by which the town could be passed to the north. The bypass concept was accepted by the state in 1940. Another problem area was in the Graveyard Fields area southwest of Mount Pisgah, where the United States Forest Service objected to the original line. The forest service also wanted the parkway to be routed away from its Bent Creek Experimental Forest on the outskirts of Asheville. This was resolved by introducing a long tunnel and increasing the overall length of the road in the area. Although the change would be more expensive, Abbott conceded that a much better alignment would result. Another early routing problem concerned the right-of-way through the Qualla Reservation of the Eastern Band of Cherokee Indians. Parkway planners intended for the road to enter Great Smoky Mountains National Park through the reservation over a parkway segment about fifteen miles in length. Late in 1934, the Cherokee raised objections to the plan. The tribe was not opposed to the parkway per se, but wanted frontage rights along the road so that they could establish commercial facilities. This idea of storefronts and tourist stands lining the road was at complete odds with the whole parkway concept. The Cherokee discussed the parkway project at numerous council meetings, and in 1936 voted against the federal government's proposal for the road. Parkway planners, seeking a compromise, recommended the state build a highway connecting a newly proposed parkway terminus at Soco Gap with Cherokee, North Carolina.[83] Plans up to that point called for the parkway to drop from Soco Gap down into Soco Creek Valley, which it would follow into Cherokee. The Cherokee rejected this proposal, claiming the road with its broad right-of-way would preempt much of their best farmland, while allowing parkway motorists to bypass their shops and tourist attractions. An alternate route that would carry the parkway down a ridge from Soco Bald into Cherokee was proposed in 1938, and the state planned to construct a new highway over the old parkway line between Cherokee and Waynesville. The new parkway route between Soco Gap and Ravensford, on the southern boundary of Great Smoky Mountains National Park, was surveyed and flagged by Bureau of Public Roads engineer William I. Lee in 1939. This location also called for a spur road to Black Camp Gap, where it makes a connection with the Round Bottom Road in Great Smoky Mountains park. [The parkway connector is the present Heintooga Spur Road.]

At the beginning of 1940, Congress passed a law giving authority to the state of North Carolina to purchase a right-of-way for the parkway across the Qualla Indian Reservation "with or without the consent" of the Cherokee. The tribal council approved the transfer in February, and the state proceeded with the land acquisition. The deed for the right-of-way through the reservation was accepted from the state in January 1941, allowing the advertisement of construction contracts for the southernmost two segments of the parkway. Also by 1940, the location of most of the route for the parkway had been determined. There were still several areas where the location had not been resolved. There was considerable uncertainty about how the road should be routed around the cities of Roanoke and Asheville, and exactly where it should cross the James River. Between Blowing Rock and Linville, North Carolina [Sections 2G and 2H], the parkway planners were at a quandary. The state wanted a route along the line of the old Yonahlossee Trail – U.S. Route 221 [U.S. 221] – but development along the route made it undesirable to parkway officials. The following year, in 1941, a second line on Grandfather Mountain, paralleling the Yonahlossee Trail at a higher elevation, was surveyed and flagged. This location was challenged by the owners of Grandfather Mountain, who ultimately delayed the completion of the parkway for another forty-six years.[84]

Harry Flood Byrd (1887 – 1966), largely credited with conceiving of the Blue Ridge Parkway, was a Berryville, Clarke County, Virginia native, *Winchester Star* newspaper publisher, president of the Valley Turnpike Company, and for four decades, a Democrat political leader in Virginia as head of a political faction that became known as the Byrd Organization. He served as Virginia's governor from 1926 to 1930, then represented the commonwealth as a United States senator from 1933 until 1965. Byrd led what has been described as a conservative coalition in the United States Senate, one that came to oppose President Franklin Roosevelt, largely blocking most of his legislation after 1937. The Blue Ridge Parkway bridge [officially dedicated on June 11, 1960 and attended by Byrd] over the James River at Big Island, Virginia, was named for and rededicated to Harry Byrd in September 1985, nearly two decades after his death. *Library of Congress*

Dr. Joseph Hyde Pratt (1870 – 1942), a geologist, conservationist, state and local civic leader and the head of the North Carolina Geological and Economic Survey, in 1906 launched a campaign for the construction of a scenic highway down the spine of the Blue Ridge that followed much the same route as today's parkway. The road was intended as a toll road but Pratt and his financial backers hoped that the counties through which the road would pass, as well as the state and federal governments, would make appropriations for the project. History informs that Pratt's road was planned to extend from Marion, Virginia, to Tallulah, Georgia, via Boone, Blowing Rock, Linville, Altapass, Little Switzerland, Asheville, Hendersonville, Brevard, Lake Toxaway and Highlands, then on into Georgia. Pratt's road was estimated to be 350 miles long.
University of North Carolina Chapel Hill

Selecting and surveying the proposed Blue Ridge Parkway route was the first step toward construction.
National Park Service

This photograph and other reconnaissance report photographs herein were taken in the early 1930s to preserve perspectives of the North Carolina landscape before determination of the roadway alignment. Stanley William Abbott (1908 – 1975), the young landscape architect and first superintendent of the Blue Ridge Parkway, realized that maps and plan drawings would mean little to his supervisors who were unfamiliar with the region and he thus chose photographs to communicate route alternatives. On the photograph [this one located between Milepost 282 and 289] would be a dashed white line to indicate the proposed route. Abbott's written reports included descriptions of the region to include suggestions of the acreages necessary to create the parkway, serving as an initiation to field trips with Blue Ridge Parkway engineers and United States Department of the Interior and National Park Service officials. *Library of Congress*

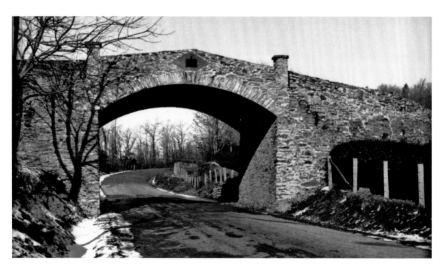

Taken on December 20, 1934, this photograph shows the original grade separation [Milepost 291. 9] on the Moses H. Cone estate used for a carriage trail crossing over the Yonahlossee Trail, now designated U.S. Route 221. The first parkway mileposts were erected in 1941. Historic photographs show that they were wooden hanging signs reminiscent of old tavern placards. The "lone pine" emblem, symbol of the parkway, was the prominent feature incised into the main chestnut placard. The cross arms indicated the distance to Shenandoah or Great Smoky Mountains national parks on the appropriate side. *Library of Congress*

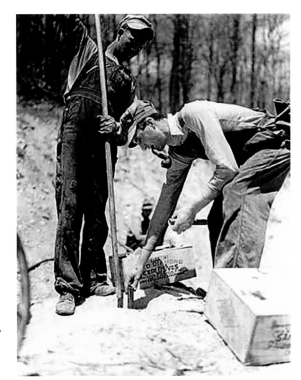

The Blue Ridge Parkway was designed to blend into the existing landscape but a great deal of heavy rock removal and blasting was necessary before final landscaping could take place. In this photograph, Civilian Conservation Corps (CCC) workers set blasting charges. *National Park Service*

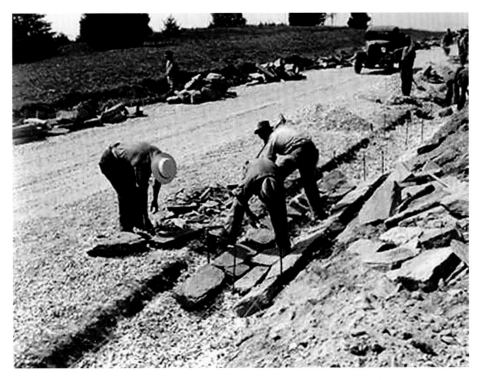

Every detail of parkway construction, to include these rock-lined ditches, added to the overall grace and beauty of the design. *National Park Service*

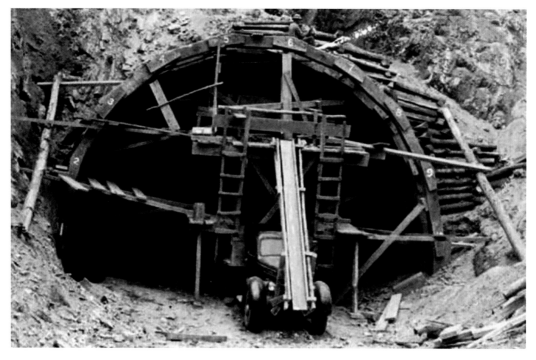

Parkway tunnel construction was ongoing when this picture was taken in 1935. *National Park Service*

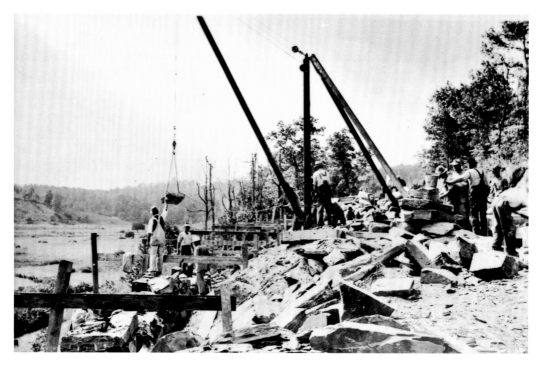

Taken on July 23, 1936, this photograph shows early construction of a stone masonry wall made with cement on section 2-A-1 of the Blue Ridge Parkway near Sparta, Alleghany County, North Carolina. This was the site of the first construction on the parkway. *Library of Congress*

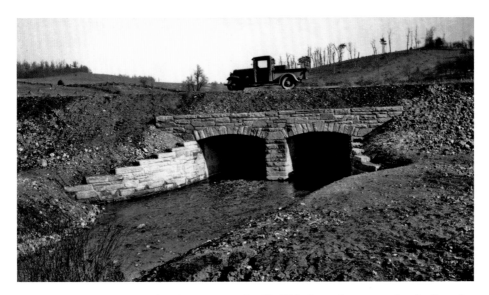

The location of this photograph, taken on December 13, 1936, shows the type two headwall used to construct the double concrete box culvert at Payne Creek [Milepost 150]. Payne Creek is located at the top of the Blue Ridge Plateau in southwestern Virginia's Floyd County. Roughly forty miles of the parkway runs along the southern border of the county. The parkway is only six miles from the heart of Floyd and the town's only stoplight. Also found along this stretch of the parkway are Rocky Knob and Smart View recreational areas, Rock Castle Gorge National Recreational Area, and Mabry Mill, which makes the top of the list of the most photographed attractions on the parkway. Rocky Knob is the principal recreation area on the southern Virginia section of the parkway. *Library of Congress*

John Kenna Hillers (1888–1945) took this picture of the Mabry grist and saw mill [Milepost 176.1], Meadows of Dan, in 1937, a decade before the National Park Service dredged the pond and razed the Mabrys' two-story white farmhouse. The Matthews cabin [Milepost 176.2], a fine example of mountain architecture and workmanship, was relocated from Woodlawn, Carroll County, Virginia, and rebuilt on the site of the Mabry residence in 1956. The cabin was built in 1869 near Galax by Samuel and Elizabeth Matthews and has been restored to how it appeared within the first decade of its construction. *Library of Congress*

This view of the parkway at Kelley Curve before it was paved and the shoulders seeded was taken on October 11, 1937. Kelley Curve is located at Milepost 149/50 in the Virginia Piedmont and in proximity to the historic Kelley School, a two-room schoolhouse that took its name – like the turn in the road - from the original family that owned the land on which it was later built. The school is located just off the parkway at Milepost 149.1 in Floyd County. *Library of Congress*

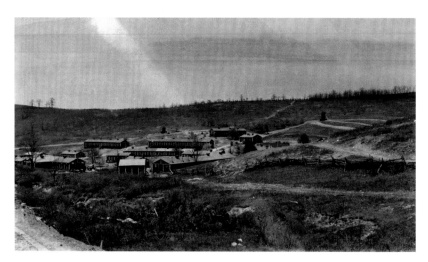

Civilian Conservation Corps (CCC) camp NP-21 was established at the Bluffs [first named Bluffs Park and situated between Mileposts 238.5 and 244.7] and located on what is now the Doughton Park maintenance area. The camp [shown here] opened on September 1, 1938, and was abandoned by July 17, 1942. From here, crews were assigned to the first landscape development on the parkway in the Cumberland Knob area. This work entailed removal of debris and downed trees, slope flattening and rounding, seeding shoulders and planting along the road, and improvement of fields and forest to the side of the roadway. Doughton Park is named for Laurel Springs, Alleghany County, North Carolina politician Robert Lee Doughton (1863 – 1954), sometimes called "Farmer Bob" and a United States congressman from the Tar Heel state for forty-two consecutive years (1911 – 1953). The Laurel Springs native was a Democrat who would hold the record as the longest-serving member of the United Sates House of Representatives from the state of North Carolina. *Library of Congress*

Robert Lee Doughton (1863 – 1954), farmer, banker and congressman, is shown in this 1942 photograph. Doughton, born in Laurel Springs, Alleghany, North Carolina, was for eighteen years (1933 – 1947 and 1949 – 1953) the chairman of the powerful House Committee on Ways and Means and as such cosponsored, held hearings on, and oversaw passage of the Social Security Act in 1935. Doughton was further instrumental in the creation of the Blue Ridge Parkway, America's most traveled scenic highway. The largest park and recreational area on the parkway, consisting of 6,000 acres and thirty miles of trails, was named in his honor in 1953. Doughton lived to see the renaming of the Bluffs Park; he died at his Laurel Springs farmhouse on October 1, 1954. *Library of Congress*

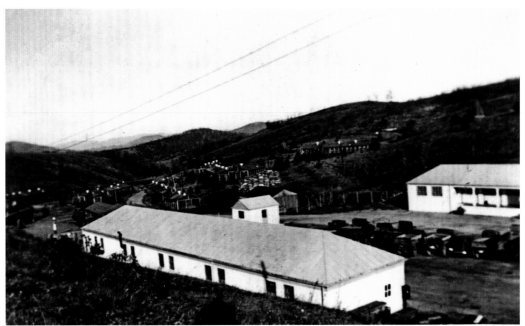

Civilian Conservation Corps (CCC) Camp NP-21 was established at the Bluffs [later Doughton Park] and photographed after the addition of larger maintenance structures had gone up. Although hampered by a lack of supervisory personnel, the crews were assigned to the first landscape development on the parkway in the area around Cumberland Knob. This work entailed removal of debris and downed wood, slope grading and rounding, seeding shoulders and planting along the road, and improvement of fields and forest to the side. This is one of four Doughton Park maintenance areas that were planned and built along the parkway. Much of the early construction was completed by CCC and Works Progress Administration (WPA) workers. *National Park Service*

A second CCC camp – NP-14 – was established at Rocky Knob a month after the first and was assigned landscape development work. This included fine grading or slope grading and rounding, as well as construction of gutters, in addition to traditional landscape items such as roadside cleanup and the planting of trees, shrubs and ground covers along the road. Two other CCC camps would follow – NP-15 and NP-29 – which were assigned to work on the Peaks of Otter recreational area and Piper's Gap, Virginia, just north of the North Carolina state line near Fisher Peak, respectively. In this photograph, CCC crews were loading a large tree for transplantation along the parkway. In 1940, the parkway planted an orchard of Chinese chestnuts at Rocky Knob. The blight-resistant trees were planted at 3,200 feet elevation in the hopes they might later be planted at higher elevations. The CCC camp at Rocky Knob was to tend the trees as a propagation nursery. As the trees began to bear, the parkway intended to distribute the chestnuts to farmers along the parkway who wished to start chestnut orchards. The exotic species was introduced to make up in part for the lost American chestnut, once the most useful tree throughout much of the Blue Ridge region. *Library of Congress*

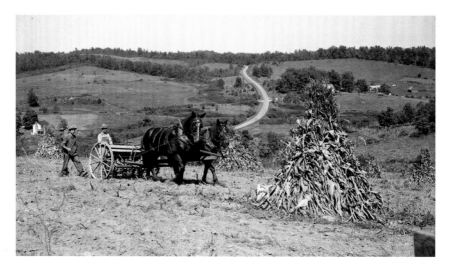

Traditional farming practices (shown here) continued beside the parkway after it was completed. This early view, though undated, was taken of farmers working a field along Kelley Curve, located in Floyd County, just after the parkway opened to the public. *Library of Congress*

Taken at Milepost 235/6, this view shows a stretch of the Blue Ridge Parkway near Devil's Garden overlook [Milepost 237]. There is a narrow view down into the lowlands due to the mountainous slopes on each side of the overlook. The Devil's Garden is believed to have gotten its name either from the ample number of rattlesnakes and copperheads that are in the area, or because the early mountain settlers often gave rough rocky features the devil's name. Note the split rail fences running along the left side of the road. *Library of Congress*

This view of a large trail shelter built for the United States Forest Service by the Civilian Conservation Corps in 1938 on Craggy Knob [Milepost 364.5] on the parkway near Asheville, North Carolina, was taken by David Haas for the HAER in 1996/7. The view is facing northwest. *Library of Congress*

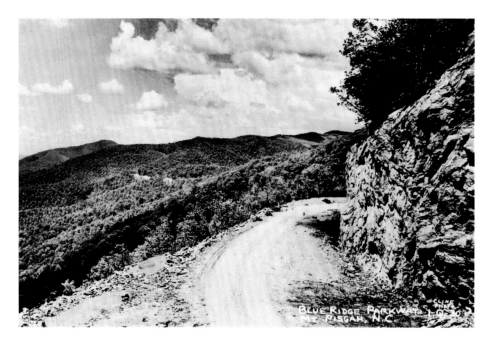

Mount Pisgah, located at Milepost 408, was the subject of this Walter Matson Cline (1873–1941) real picture postcard, published in the salad days of the parkway. From this point on the parkway, hikers can trek to the summit of Mount Pisgah or take the entire 16.3-mile Shut-In Trail. *University of North Carolina Chapel Hill*

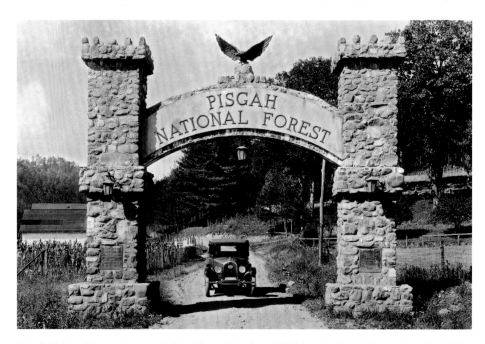

Pisgah National Forest is named after Mount Pisgah, a 5,000-foot-high peak located at Blue Ridge Parkway [Milepost 408], near the Cold Mountain of book and movie fame. Pisgah National Forest became the first national forest in the eastern United States in 1916. The entrance arch to the Pisgah National Forest is shown as it looked between 1916 and 1936, before U.S. Route 276 [U.S. 276] was constructed. *National Archives*

This picture of the early Blue Ridge Parkway ranger force was taken near Asheville, North Carolina, in or about 1940. *Library of Congress*

John Kenna Hillers (1888 – 1945), of the United States Public Roads Administration, took this picture of the Blue Ridge Parkway in Virginia in 1940. *Library of Congress*

The Bluffs picnic area [renamed later as part of Doughton Park] comfort station and shelter, building number 102, was built in 1941. In this pre-1956 view, the structure appears in a prominent position on the hillside. Since then, the vegetation has matured and this view has changed. Still the building remains in good condition and its position overlooking the road is still apparent. *National Park Service*

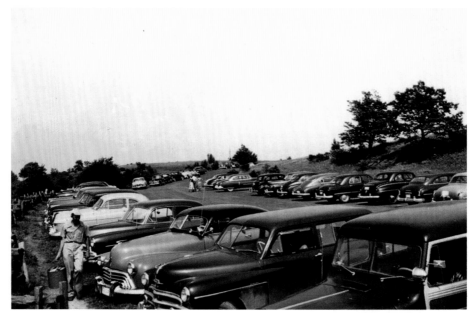

The first section of the Ridge Road in the Bluffs picnic area [now Doughton Park] was completed in 1939 with an extension constructed in 1957. The turnoff for this area is on the opposite side of the Blue Ridge Parkway from the defunct Bluffs Lodge and Coffee Shop [Milepost 241.1], which first opened in 1947 when the area was still called Bluffs Park and closed in 2011. The Bluffs Lodge was one of only three hotels directly on the parkway, the other two being the Peaks of Otter Lodge and the Pisgah Inn, still open. *National Park Service*

A group of picnickers were photographed at Bluffs [later Doughton] Park in this early undated photograph from the parkway. *Library of Congress*

The Wildcat Rocks overlook [shown here], located in Doughton Park near section 2-C of the parkway [Milepost 241.1] and concealed behind the Bluffs Lodge, was constructed in 1939, positioned for the excellent views of the surrounding hills and coves. Today, the viewsheds retain their original character and contribute to the feeling and setting of the landscape. For many travelers, the distinguishing feature of the parkway is its impressively varied array of scenic overlooks like this one. Many of these 264-scenic pull-offs provide stunning vistas and panoramas of the near and distant mountain scenery. Of note, local residents first referred to them as "balconies" as they were just that, a place from which to take in the view. Wildcat Rocks overlooks the Basin Creek watershed and the homestead of Martin Caudill in Basin Cove. *National Park Service*

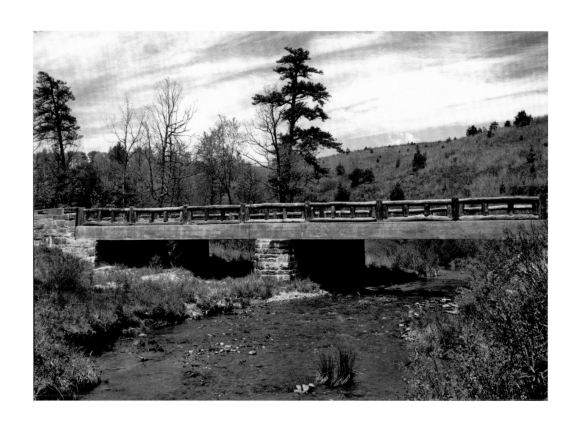

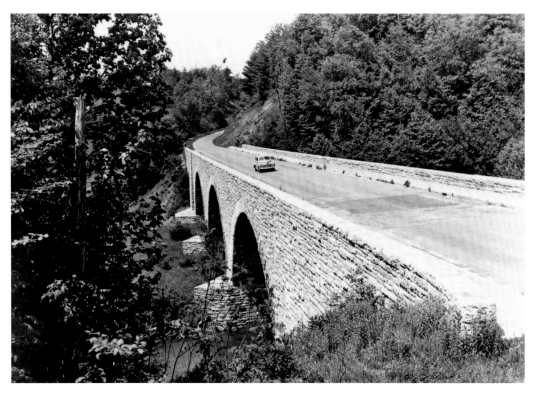

Thomas Welby Kines (1903 – 1989) took this picture of the south portal of the Rough Ridge Tunnel [Milepost 349/section 2-N], first excavated in 1936, in September 1951. The tunnel is a relatively short one at one hundred-and-fifty feet in length. Just a few more mileposts down the road – at Milepost 355.4 – is Mount Mitchell State Park. *Library of Congress*

Opposite page:

Above: The Big Pine Creek Bridge Number 6 with its old wooden railings is shown in this 1940 photograph. The bridge, built in 1937, is located in Alleghany County, North Carolina, at Milepost 224.7. *Library of Congress*

Below: This photograph of the iconic concrete-arch Linville River Bridge [Milepost 316.7], located in section 2-J of the Blue Ridge Parkway in Avery County, was taken in June 1946, six years after the structure was completed. The parkway has more than 168 bridges according to the North Carolina Department of Transportation, roughly half of which are faced in native stone that was usually quarried near the construction site. *Library of Congress*

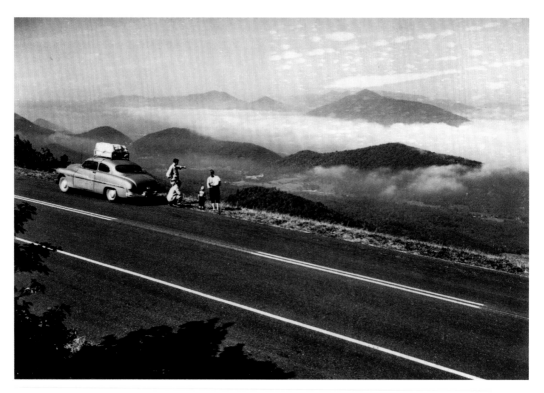

Tourists stopped at Milepost 92.1 [elevation 2,400 feet] to take in the view of Purgatory Mountain in the vicinity of Buchanan, Botetourt County, Virginia, in 1952. Purgatory Mountain rises above the Great Valley [also called the Great Appalachian Valley/Great Valley Region]. This gigantic trough – a chain of valley lowlands – stretches 1,200 miles from Quebec, Canada, to Alabama and has been an important north-south route of travel since prehistoric times. In the southern section, the Great Valley is bounded on the east by the Blue Ridge Mountains. Routes through the valley were first used by Native Americans. For the earliest European colonists, the Great Valley was a major route for settlement and commerce and became known as the Great Wagon Road, which started in Philadelphia. In the Shenandoah Valley, the road was known as the Valley Pike. Another branch at Roanoke was called the Carolina Road, where it led into the Piedmont regions of North Carolina, South Carolina and Georgia, passing through the town of Buchanan, Virginia, at the base of the mountain. Stagecoaches and wagons came over what amounted to little more than a rough trail in this section. The strenuous trip down the trail and around sharp bends of a creek had coach and wagon drivers referring to the trip as "going through purgatory." The creek became Purgatory Creek, and later the mountain took the same name. On a clear day, it is also possible to see the waters of the James River. *Library of Congress*

Opposite above: According to the National Park Service documentation, by the mid-1950s, only about one-half of the Blue Ridge Parkway had been completed. Much of the remaining work involved difficult construction in more rugged terrain than earlier sections. Meager postwar appropriations limited the extension of the road. The impetus for the completion of most of the remaining sections was a multi-year park service development program known as Mission 66. The construction of Back Creek Bridge over Back Creek and Virginia Route 613 is shown in this May 1952 picture taken by National Park Service photographer Jack Edward Boucher (1931–2012), who traveled through forty-nine states and two territories taking pictures for the Historic American Buildings Survey (HABS) and also the Historic American Engineering Record (HAER) and Historic American Landscapes Survey (HALS). Boucher, whose work helped document America's architectural heritage, started working for the park service in 1958. This Boucher photograph was chosen as a good example of a precast concrete bridge on the parkway. Note the fallen beam at the far end. The bridge is located at Milepost 124.4. *Library of Congress*

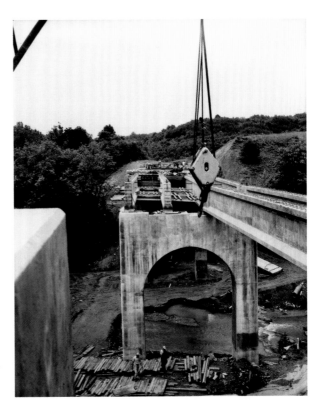

Below: A Blue Ridge Parkway tunnel – location unidentified – is shown in this early view with the lining installed before complete construction of the portal. *Library of Congress*

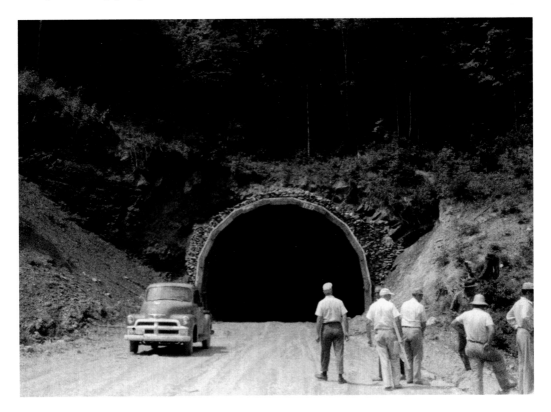

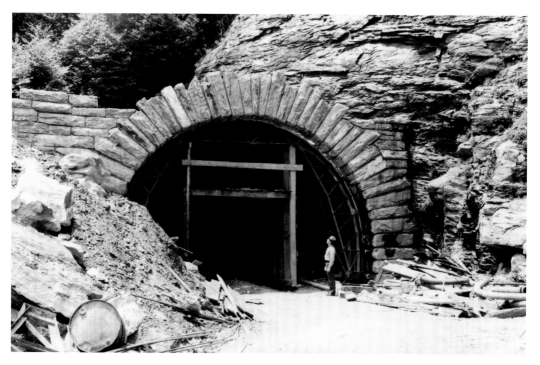

Construction of a tunnel portal on the parkway is shown in this 1955 photograph. Note the metal and timber bracing for the tunnel lining still in place. The milepost on this photograph is unknown. *Library of Congress*

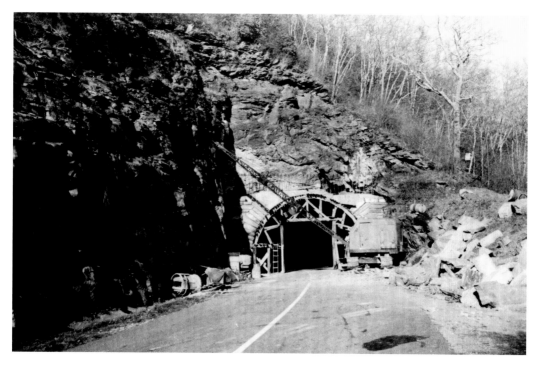

This picture of the south portal of the Craggy Flats Tunnel [Milepost 365.5/section 2-P] showing construction of the portal was taken in November 1956. The tunnel is four hundred feet in length. *Library of Congress*

Several of these checking stations, erected for fee-collection purposes but never authorized to operate as such, were constructed on the parkway in the 1950s. Since they were not authorized to collect money, they were generally used to provide information on area accommodations. Locations included Rockfish Valley, Adney Gap, north and south of Roanoke, Asheville near the Biltmore, and by the Oconaluftee River. All were removed by the 1980s after cars ran into two structures and demolished them. The islands where these were located have been since repurposed for Pillar of Truth information displays. This picture was found in the Blue Ridge Parkway archive, Asheville, North Carolina. *Library of Congress*

Thomas Welby Kines took this picture of the Doughton Park area gas station and sandwich shop [Milepost 241.1] on August 7, 1950. *Library of Congress*

This view of "The Fences" gunboard at Groundhog Mountain overlook [Milepost 188.8 – 189.9] was taken in 1952. The sign tells the story of the Blue Ridge's split rail fences, miles of which just then were built largely of dead chestnut trees. Several distinct types of construction were employed, to include the "snake," "post and rail," and the "buck." The overlook is located in Carroll County, Virginia, in the Blue Ridge Highlands. The early interpretive signs like this one featured a pioneer squirrel rifle and powder horn as identifying markers, and were thus called gunboards by parkway staff. The signs were constructed of two-inch-thick California redwood boards mounted on locust posts. The gun, powder horn and lettering were all prepared with an electric router; the letters were subsequently painted with white lead paint. In 1959, someone noticed the squirrel rifle had been incorrectly designed without a ramrod. The design was corrected and future signs incorporated the ramrods. The gunboard signs share a common color scheme, described by Stanley Abbott on August 6, 1947: "The rifle is painted Parkway blue, a color which we mix to simulate the deep blue of the mountains in the late evening. The powder horn and thong are just off-white or ivory color. The letters in the title are white. All of this is against our standard driftwood gray, a commercial stain made by Cabot."[85] Abbott noted that after the initial treatment with the driftwood stain, the signs were allowed to weather naturally. The gradual disappearance of the stain was concurrent with natural weathering and resulted in a pleasing silver-gray color. *Library of Congress*

III

From Milepost Zero – Virginia

The Blue Ridge Parkway was well underway when Edward H. Abbuehl observed: "When government technicians were searching the country for the proper parkway location, they would inevitably be informed by a local citizen that the 'best view' in the country was 'just over yonder,' and the parkway has included thousand and one of these 'best views.' There can be no question," he continued, "of the scenic values of the parkway."[86]

While Virginia is "Milepost 0," it is not where first construction of the parkway started. In January 1935, the North Carolina General Assembly passed an act authorizing the State Highway and Public Works Commission to acquire the right-of-way for the parkway through the state. Within six months, the commission had completed right-of-way maps for the route in Alleghany and Surry counties, and had filed the maps with the register of deeds in the counties, effectively designating the land for condemnation. By late summer, the first contract was issued and work got underway. Virginia, however, did not pass any right-of-way acquisition legislation until February 1936, delaying the start of construction in the Old Dominion. When the parkway was first proposed, the land acquisition concept was worked out in an oral agreement between Interior Secretary Harold Ickes and the chairman of the Virginia Highway Commission, Henry G. Shirley. After considerable negotiation, Shirley would only agree to purchase two hundred feet in right-of-way with an additional four hundred feet to either side in scenic easement. This was the same width recommended by Gilmore D. Clarke in the early planning phase for the parkway, and objected to by Abbott as woefully inadequate. Eventually, the state was told that such a narrow strip was unacceptable, at which time it began purchasing a right-of-way totaling one hundred acres per mile, making for an average width of eight-hundred-and-twenty-five feet. North Carolina, on the other hand, was more generous; the state legislature authorized purchases of right-of-way totaling one-hundred-and-twenty-five acres per mile, allowing for a strip about 1,030 feet wide.

Arguably the states were too optimistic that much of the right-of-way land would be donated by property owners. While a number of mountain residents did offer to donate land when the scenic highway was first announced, they had done so because, just then, they believed the new road would supplant the poor, unpaved roads of the region and end their relative isolation from larger population centers. But once property owners realized that access to the new road would be restricted and that it would require, at minimum, over one hundred acres per mile, they were no longer willing to cede over their land. Another miscalculation by Virginia and North Carolina was the willingness of property owners to go along with scenic easements. Residents were not jumping at the opportunity to donate or sell land at low prices, even though the states tried to make it clear that the property owners would not actually be giving up their land and could continue farming it. The mountain people were generally shrewd enough to realize that the easements would severely restrict the potential development of their land, and before long, the states were finding the price of scenic easements was nearly as great as fee simple acquisition. At that point, the National Park Service scaled back the easement program, and recommended the states take the money they had reserved for scenic easements and use it to purchase as much land as possible in fee simple.[87]

Instead of passing legislation specifically outlining a process for acquiring land for parkway purposes, the states proceeded under existing highway legislation. In the case of North Carolina at that time, the existing laws provided that if the state wanted to locate a highway, it merely had to stake out the route and post maps showing the location at the county courthouse. The property owner either had to accept the new road as an apparent benefit and thereby take fair market value or wait one year and sue the state for damages. In the case of the parkway, though, a much wider right-of-way was sought, and property owners would have restricted access if any at all. This situation was clearly unacceptable, and the parkway soon had the state notify property owners before construction began and compensate them for damages incurred. Then there was Virginia, where a wholly different process was used to get the land for the Blue Ridge Parkway. Virginia acquired by individual deed each parcel and transferred it to the federal government. After the state received the maps for the proposed rights-of-way, state engineers would conduct field surveys and prepare final right-of-way location maps. The state right-of-way engineer would then make a field inspection to appraise the various tracts and determine what deed reservations were required, whether property residues[88] would be left and if so, what access had to be provided for them. After determining other factors that might affect the purchase price, the state could begin negotiations with the property owner. If the owner was agreeable to the offer, the matter could be concluded quickly, but if condemnation proceedings were required, another two or three months might be required. The Virginia protocol – start to finish – could take six months or more, but at the end, the federal government would receive a clear deed to the property. North Carolina's system of using land maps to condemn properties, by contrast, did not leave an official record of conveyances of the properties from individuals to the state on file in any county courthouse. Over the years, this omission would cause periodic headaches for parkway land-use planners. The whole process might be drawn out for years.

Problems with the two separate land acquisition schedules caused long delays in awarding construction contracts for some sections of the parkway.[89]

While some landowners were not keen on selling, there were others along the proposed route who were more than willing to do so. The Great Depression had impoverished the mountain economy, and lands were generally worn-out from poor farming practices. Some residents, to reiterate, thought the construction of the first hard-surfaced road through the region would end their isolation and were willing to sell off a portion of their properties for this purpose. Still, others did not want to part with their land putting state land acquisition officials in an often-tenuous position working with mountaineers to acquire the needed right-of-way for the parkway. Blue Ridge Parkway ranger Edwin Maxwell Dale (1907–1987) recalled one incident:

> There was this mountaineer and his wife who had had quite a feud among themselves and they'd separated. And under Virginia law, the acquisition agent needed both their signatures in order to complete this land sale. So, by Joe, every time he'd see her, she never had anything but a bad word about her husband. And when he saw her husband, he hadn't anything but a bad word about his wife. But whenever the agent saw one or the other, he started building this up you see. As he went from one to the other he planted the seed; and he said, 'You know, I saw your wife the other day, and she was telling me how considerate you were about doing some little thing, chopping the wood instead of her having to do it.' Then the next time he saw her, she was cussing the old man as regular, and the agent said, 'Well, you know, I was talking to him the other day and he was telling me what an excellent cook you were.' And this is the way be finally got them together long enough to sign the deed, but he got it signed real quick before they found out we'd been lying like hell on both sides.[90]

In some cases, farmers had no deeds to their land. Years before, their ancestors or other settlers had simply taken possession of land and passed it down for generations. Lack of clear title was another complication in acquiring the necessary land for the parkway. Quite often existing surveys were inaccurate due to the practice of measuring lines on the slope of the ground, rather than by following the conventional standards of horizontal measure.[91] Parkway planners were reluctant to force people off their land unless absolutely necessary. Sometimes, they moved people's houses to residual property retained by the owners. In a few cases, life tenure rights were granted to property owners, generally elderly residents who did not want to relocate. In the case of the Brinegar Cabin at Bluffs Park [later Doughton Park], the widow Caroline Brinegar was allowed to remain in the single-pen[92] log cabin that had been her home since 1886.[93] These compassionate practices were in stark contrast to the draconian resettlement policies involved in the establishment of the Great Smoky Mountains and Shenandoah national parks, where hundreds of families were forced out of the mountains to lowland farms or resettlement communities. Still, condemnation proceedings, though not the rule, were reluctantly sought in a number of instances.

Nearly a third of the parkway route traversed the Jefferson, George Washington, Pisgah and Nantahala national forests. The Congressional Act of 1936 authorized the transfer of

forest lands for the parkway.[94] The states did not have to purchase these lands, and of course recommended the construction of the parkway through extensive sections of the national forests. This was also, in truth, a major factor leading to the rejection of the proposed Natural Bridge route for the parkway in Virginia [that and Senator Glass' personal objections to the route encroaching on his Lynchburg, Virginia hometown]. By keeping to the ridge, the parkway would remain in the Washington and Jefferson national forests, alleviating the need to acquire the property for the alternative right-of-way. Where the parkway passed through national forest land, a parkway zone was delineated on roughly the same equivalent as the right-of-way obtained by the states. The zone would have the same basic effect as a scenic easement. The parkway acquired a two-hundred-foot width of land outright for construction purposes, but the remaining land to either side would remain under United States Forest Service jurisdiction. In 1942, this concept was dropped and the forest service agreed to transfer title to land comparable to the one hundred acres per mile right-of-way on private land. Seven years later, in 1949, the forest service transferred title to 5,850 acres of land from the George Washington and Pisgah national forests to parkway administration. The parkway also received several key tracts as donations. These constituted the major part of three parkway recreational areas: Moses H. Cone and Julian Price memorial parks, and Linville Falls. A number of smaller tracts were also donated to the parkway, and certain lands were purchased by cooperating associations established for the protection of viewsheds. As welcome as these donations were, the majority of the route had to be purchased by the states or transferred from the national forests.[95]

By the Second World War, most of the land for the parkway had been acquired and more than half the road constructed. The commonwealth of Virginia still had not acquired the right-of-way for the crucial segment bypassing the city of Roanoke – a significant issue at that time. At the conclusion of the war, parkway superintendent Samuel P. Weems recognized that the land would need to be purchased before the population of Roanoke expanded into the area needed by the scenic road. He pressured former state engineer James Aylor Anderson, then chairman of the Virginia Highway Commission, to acquire the land. The commission assigned Thornton Carter Melton (1899 – 1989) to the task, and the troublesome fifteen-mile section around Roanoke was finally acquired. This section is novel in that there is not a single grade crossing on the entire section, in sharp contrast to most other Virginia sections where they are all too common. There were numerous road crossings through the area, and the cost of the grade separation structures was considerable. The parkway made a deal with the commonwealth: if the state agreed to eliminate all grade crossings, public and private, and to allow only limited access to the parkway over the entire section, the parkway would accept a limited right-of-way of only four hundred feet to five hundred feet. This reduced the price the state had to pay considerably, as unimproved land in the area was going for as much as $1,000 per acre in 1947.[96] Going forward, the land acquisition process for the parkway greatly improved. In 1961 Congress authorized the Interior Department secretary to purchase or exchange lands or interests in lands contiguous with the parkway. Since that time, most of the parkway's land acquisition efforts have been devoted to acquiring residual tracts served by the deeded reserved private road crossings that have plagued the project since its inception.

Of note, until 1965, the rights-of-way provided by the states seemed generally adequate to protect the scenic features on either side of the road. For nearly the entire route, the so-called "picture" was one of mountains and agricultural land, with mountain farms and historic places scattered along the way to add to the scene. But in the 1960s, lands adjacent to the parkway began to pop up with uses that disrupted the carefully planned series of views. Industries sprang up in the valleys and ski resorts appeared in the mountains. Businesses opened to serve the needs of parkway visitors – motels, restaurants, service stations and private campgrounds. Because parkway regulations prohibited signs on the road for commercial ventures, it was in the interest of the businesses to be located in clear view of the parkway, so that visitors might exit and patronize their establishments. Stanley Abbott warned that such commercial enterprises would inevitably be built along the road unless the parkway provided the full range of services through controlled concessions. But this was not the only problem. By the end of the twentieth century, the greatest threat to the parkway viewshed was residential development. In the vicinity of Roanoke and Asheville, especially, but increasingly in varied other locations, new subdivisions were being constructed in view of the motor road. New houses occupied old farm fields and forest glades, prompted by urban sprawl and a commensurate increase in rural populations. Many of these new homes were built as seasonal and vacation getaways. To face the threat of persistent commercial and new residential development, a land acquisition plan for the parkway was approved in August 1980. Federal land acquisition would be minimal. Land would be secured only to control hazardous private road access and road crossings, and to make minor boundary adjustments for management purposes. The primary responsibility for the preservation of scenic resources alongside the parkway would rest on neighboring counties, cities, towns and unincorporated communities; in other words, the weight of preservation was expected to be embraced by the public that benefited from and should rightfully steward the Blue Ridge Parkway. Under new Interior Department policy enacted in 1982, the land acquisition plan was renamed the land protection plan. It specified the use of tools other than fee simple acquisition to include employment of easements and compensation for development rights. The plan admitted that it was not possible for the government to acquire sufficient land to protect the parkway and its rural landscape; the people of the surrounding counties would have to strive toward this goal themselves.[97]

Back to the parkway's early years: once the necessary land had been acquired, contracts were let for construction. The parkway was divided into forty-five construction units ranging from 5.7 to 15.6 miles in length. Each unit was assigned a number. The first, or northernmost unit in Virginia, was Section 1-A, the next 1-B and so forth. From the North Carolina line, units were numbered southward as 2-A and so on [there are no sections 2-I or 2-O]. For each segment, several construction contracts were generally awarded. The first would entail clearing the route, grubbing or removing stumps, provisions for drainage, and rough grading. Subsequent contracts covered final grading and the surfacing of the roadway. Large bridges and viaducts were generally contracted separately, but smaller bridges were often combined with grading contracts. Although Ickes initially obligated $16 million for construction of the project, the work did not get underway as quickly as he had hoped. To

motivate and move along the build out, in 1935 he reduced the amount to $4 million and advised the National Park Service that the funds would expire if they were not obligated by the end of the year. This proved sufficient incentive, and the first contracts were awarded and paid out. Actual construction got underway in September 1935 with the award of the first contract, for Section 2-A extending twelve-and-a-half miles south from the Virginia – North Carolina state line to Cumberland Knob [Milepost 217.5] in Alleghany County. The first dirt was turned on William Paschal "Pack" Murphy's farm[98] just south of the state line on September 11. This contract was funded with Public Works Administration funds and included clearing, grading, crushed stone surfacing and drainage structures. The contractor – Nello Lequy Teer[99] (1888 – 1963), of Durham, North Carolina – assigned one hundred men to the task. Work began in North Carolina because the state legislature, meeting early in the year, had passed the aforementioned necessary laws to enable the state to satisfy the federal government that the proper right-of-way had been acquired to start the work. Virginia had not closed that loop at that time, and work there had to wait for its legislature to meet in January 1936 to pass laws to empower the acquisition and condemnation of the necessary land. Virginia did have adequate laws to acquire land for highway purposes, but there was a question, too, as to whether such land could be transferred to the federal government.[100]

Subsequent early construction included most of sections 2-B, 2-C, 2-D and 2-E, extending the parkway south from Low Gap. Work in Virginia began on February 29, 1936, on the section between Adney Gap and Pine Spur Gap, south of Roanoke, and on the segment between Jarman Gap and Rockfish Gap, just south of Shenandoah National Park. A discontiguous seventeen-mile section was constructed near Mount Mitchell in North Carolina. Several bridge contracts were awarded separately. Work progressed rapidly in the early years. By the end of 1937, 115 miles, or nearly a quarter of the route, had been graded under fifteen contracts totaling a little over $6.8 million in Public Works Administration funds. The greater part of the completed grading constituted a fairly continuous route between Roanoke, Virginia, and Blowing Rock, North Carolina. Seven contracts for structures had been awarded, which would involve the erection of fifteen bridges and grade separation structures at a cost of $468,000. More contracts would have been awarded under the initial $4.5 million congressional appropriation, but neither Virginia and North Carolina had not been able to keep up with right-of-way purchases.

Land acquisition was proceeding on schedule in North Carolina a year later [in 1938], but in Virginia, failure to produce the needed tracts of land to the federal government continued to delay construction work. Blame for this fell largely on three areas: circuit court judges who failed to expedite condemnations; the fact that the state had an insufficient number of land acquisition agents, and the propensity of the state to grant what has been described as "exorbitant" awards. All of these were factors cited by Stanley Abbott as reasons for the slow progress. The change from a two-hundred-foot wide right-of-way to an eight-hundred-foot wide combined purchase and scenic easement certainly contributed to further delays. Additionally, North Carolina laws provided for stepping onto land for construction purposes even before the title was passed to the federal government, which permitted construction to proceed on or ahead of schedule. Still, Abbott noted that barely one third of the ten

thousand acres that had been acquired had been officially conveyed to the United States government, which coincided with property owners who had yet to be paid for their land. Further, there were property owners who believed they could still continue to use their land and from this notion much abuse resulted. The situation was even worse in Virginia, where the delays afforded time for property owners to cut their standing timber and over-graze and over-crop their arable lands.[101]

The parkway construction was sufficiently advanced by the spring of 1939 that a fifty-mile section around Roanoke was opened to public use on April 1. No public ceremony was held to mark the occasion, but interest was considerable, as the public living in the vicinity of the parkway had been kept informed of the progress. By the end of the first three-month period, about 31,000 cars had traveled over the section. Later in the year, the section between the Virginia-North Carolina state line and Blowing Rock was opened to traffic. By the end of the year, more than 290,000 visitors had been counted. The traffic was nearly equally divided over the Virginia and North Carolina sections. Eight out of ten cars bore Virginia or North Carolina license plates; Abbott attributed the preponderance of local motorists to the park service's failure to publicize the completion of this initial section. Sunday afternoon drives were the most popular. Traffic was also allowed over the incomplete Section 2-P between Asheville and Craggy Gardens, and 10,000 made this trip on a June Sunday during Asheville's Rhododendron Festival. This section was opened on a "travel at your own risk" basis; it crossed lands belonging to the Asheville city watershed and was patrolled by watershed authorities. Travel was permitted only between nine o'clock in the morning and eight o'clock in the evening. Another partially complete ten miles between Buck Creek Gap and Mount Mitchell was also opened. These latter sections had crushed stone pavement but not the final surfacing just yet. The pavement was done by the process of stage construction, meaning the Bureau of Public Roads found it desirable to turn traffic over sections covered in crushed stone to compact it, allowing the bituminous pavement to be applied later. The demonstrated popularity of the parkway led Abbott to urge the establishment of a sightseeing bus concession. Bus tours, he suggested, would increase public use and enjoyment and produce considerable revenue for the government. Such buses, he insisted, should be of the smaller touring car type as commonly employed in western parks, holding fourteen or fewer passengers. The Interior Department demurred for years, and it was not until 1948 that such a service began. In May of that year, Smoky Mountains Tours began operating a sightseeing bus tour over the parkway between Roanoke and Asheville, using the passenger-car-type buses that Abbott had recommended. The most popular service was a day trip from Asheville to Mount Mitchell State Park, where a new paved road extending nearly to the summit had just opened.

The most popular attraction along the parkway, as well as the most photographed, is Mabry Mill at Milepost 176 near Meadows of Dan, Virginia. The picturesque wooden mill is visited by nearly three million people each year. Visitors marvel at the collection of mountain industrial artifacts, not realizing that most are unrelated to the site. Many travelers stop in the adjoining coffee shop for buckwheat pancakes, not knowing the flour was ground at an electric-powered mill far off the parkway. Although quite a few visitors motoring by the

site probably believe the picturesque mill dates from the nineteenth century, it is actually an early twentieth century structure. Edwin Boston Mabry (1869-1936), a native of Smiths River, Patrick County, Virginia, moved to the Meadows of Dan area in 1899, farming for a while before his interest in all things mechanical led him to construct a mill. To attain the money to do it, he would need to establish the operation so he worked for a period of time as a blacksmith for a West Virginia coal mine. Mabry Mill contains a grist mill, a sawmill, and a woodworking shop, all powered by a fourteen-foot overshot wheel. The main water source, Laurel Fork Creek, was barely adequate to power the mill [that and Mabry's land was nearly level], thus he built multiple flumes to bring in water from different sources. Power from the water wheel is transmitted to a small inner face gear of rack and pinion design. The grist mill has a single set of thirty-six-inch diameter stones, and the sawmill is a small rotary structure. Due to the constricted layout of the mill building, it was difficult to load logs onto the carriage and thus long logs could not be used. Mabry designed the woodworking shop mainly to build wagons. His blacksmith shop turned out metal parts. The sawmill is not operated today. Research by parkway seasonal historian Lewis McNeace Jr. indicates the grist mill was probably built in 1908, the blacksmith shop in 1910, the sawmill section in 1915, and woodworking shop in 1916. Mabry's extensive series of flumes and races to convey water from nearby hollows and branches, all feeding into one main race, led to the building of the original overshot wheel. Between 1905 and 1914, he purchased five additional tracts to acquire access to more water. Still, the supply was inadequate during dry weather. To solve this problem, he constructed a log dam across one of the streams, creating a reservoir to store water from rains and spring thaws. In or about 1915, Mabry built a two-story frame house adjacent to the mill, using lumber cut at his own milling facility. Mabry's second wife – Mintoria "Lizzie" DeHart Mabry (1867 – 1940) – often ran the gristmill while he attended the sawmill or blacksmith and woodworking shops. Mabry was an invalid and unable to maintain the flume network sometime around 1930. To continue operations, he installed an eight-horsepower kerosene engine to drive the two grist mills.

Edwin Mabry died on July 18, 1936, after which the mill continued to be operated by his widow; it was at this point, Abbott and Abbuehl were planning the route of the parkway through the area and they wanted to acquire the mill and preserve it as a cultural exhibit. Despite their intent, the state highway department almost razed the mill as it cleared away buildings on the parkway right-of-way. Parkway ranger Edwin Maxwell Dale drove by as the wrecking crew entered the mill. Dale called Samuel P. Weems, then project manager for the recreational parks, and Weems secured an order halting the state from demolishing the mill.[102] But then National Park Service historical technician Thor Borresen (1895 – 1946) visited the mill in 1940, and reported that he was "a little disappointed" in what he found. The mill was not particularly old, certainly not of the same age as the log cabins and other structures the parkway was planning to interpret; however, the structure was well-weathered and appeared much older. Borresen found the three separate roof-lines attractive, and believed its location only sixty feet from the parkway would make it a popular site. Still, Borresen thought it significant only in that it reflected "a man's ingenuity in creating machinery necessary to sustain life in those mountains," and in that the use of the same machinery

had continued until very recent times. Borresen was more attached to the Mabrys' house, which the miller had constructed from lumber he had prepared himself at the mill. The house, regrettably, was located in an area adjacent to the mill that the parkway planned to allocate for parking. Borresen urged the parkway staff to reconsider and locate the parking across the parkway from the mill, providing pedestrian access through a planned culvert or drainage structure that would serve as an outlet for the proposed mill pond. Borresen also urged the acquisition of an old log barn at the site. Despite Borresen's recommendation, the Mabry home was razed in April 1942. The mill was restored that year, a mill pond was excavated, and the flumes were reconstructed. Crews from CCC Camp NP-29 worked under parkway landscape architect Kenneth Carnes McCarter's supervision[103], completing the project in September. Alonzo Newton Hylton (1872 – 1957), a native of Burks Fork, Floyd County, Virginia, and local water wheel maker who had helped Mabry construct his wheels, supervised the reconstruction of the wheel for the park service. He was assisted by Charles Arthur Goad[104] (1897 – 1946), a native of Laurel Fork, Carroll County, Virginia, had worked on much of the original mill construction. In November 1944, the parkway made plans to turn over operation of the mill to National Park Concessions Inc., allowing the mill to grind and sell corn at the site. The company began operating the mill in June 1953, selling meal in two-pound souvenir sacks. The acting superintendent reported the sales were so successful, visitor demand exceeded supply. The mill's deteriorated wooden flumes were replaced in 1954 and again in the 1970s and the mid-1980s. The National Park Service has since made other changes at the site. The old log dam at the reservoir was replaced with a cement one, and the mill was fitted with a clutch which allows the mill to stop grinding without having to shut off the water supply.[105]

The log cabin built in 1869 near Galax by Samuel and Elizabeth Matthews was relocated to the mill area from Carroll County in 1956 and reconstructed on the site of the Mabry house. When it opened for visitors, the cabin housed a display of Simon Scot's tannery equipment and doubled for a while as a visitor information center. A cane mill or sorghum press, a mint still, a lumber drying rack, and a bark mill from Rocky Knob were installed on the grounds later in 1957. Mabry's blacksmith shop was relocated to a point nearer the mill in order to facilitate interpretation. But this is where Mabry Mill also serves as an example of authenticity gone sideways. While Mabry Mill remains the most popular attraction on the parkway, its integrity as an historic site is, at best, questionable, according to National Park Service documentation of the site. In an essay on the parkway's effect on local people, Kimberley Burnette put it bluntly: "Mabry Mill has been changed to fit the Blue Ridge Parkway's vision of Appalachia."[106] By replacing the historic Mabry home with the Matthews cabin, Burnette claimed the parkway was supporting an old stereotype, that mountain people lived in log cabins well into the 1930s. In the parkway's 1989 historic structures report for Mabry Mill, Barry Buxton stated that while the buildings on the site were historic, they represented "a contemporary creation by the National Park Service [...] a countryside museum which is antithetical to NPS defined strategies for preservation of cultural resources."[107]

Beyond Mabry Mill, there are many surviving examples of early Appalachian mountaineer structures that dot the Blue Ridge Parkway, also beginning in Virginia with the Humpback

Rocks Visitor Center [Milepost 5.8] and adjacent mountain farm exhibit. The collection of nineteenth century farm buildings opened in 2000 and represents the most complete effort by the park service to date to tell the story of the Blue Ridge region with stories about housing, community, folklife and how the people of this mountainous region moved in and around the topography. At the Peaks of Otter [Milepost 85.9] there is a trail leading to the restored mid-nineteenth century John Therone (1820–1901) and Mary Elizabeth Powell (1824–1895) Johnson Farm [Milepost 86] in which generations of the Johnson family lived and worked with other members of the now-vanished community for eighty-nine years. The Johnsons bought the land on Harkening Hill in 1852, where they raised sheep, grew potatoes and operated a distillery in a nearby hollow dubbed Stillhouse Stream and it was there that John Johnson made brandy from an orchard on the mountainside. The land was buffered by John's father Castleton Johnson's land and that of Benjamin Wilkes (1801–1886).[108] Another structure of interest here is early nineteenth century [Mary] Polly Wood's Ordinary[109] [Milepost 85.9], believed to be the oldest structure on the parkway, and representative of the early days of tourism trade in the region. Originally located in the low meadows of the Mons community that became Abbott Lake, Polly Wood's Ordinary was moved in 1965 from the site on which it had stood for over a century-and-a-half to its present Peaks of Otter location. Other interpretive structures on the parkway include the Trail Cabin [Milepost 154.6], Puckett Cabin [Milepost 189.9], Brinegar Cabin [Milepost 238.5], Caudill Cabin [Milepost 241], Sheets Cabin [Milepost 252.4], and Jesse Brown Farmstead [Milepost 272.5], all of which are nineteenth century log cabins illustrating the often-isolated existence of the mountain family and the efforts of the original park planners to save log structures as opposed to other types of larger farm houses they surveyed in the salad days of the Blue Ridge Parkway. The 1880s cabin built by farmer William Jefferson Trail (1855–1933), of Little River, Floyd County, Virginia, is located in the Virginia Piedmont's Smart View Recreation Area and is remarkable for its spectacular location.

From the Wildcat Rocks overlook in Alleghany County, North Carolina, the late nineteenth century Alfred Martin and Frances Janie Blevins Caudill one-room cabin sits one thousand five hundred feet below. This is the only view that parkway visitors get of the cabin, today located in Doughton Park, unless they take the three-and-a-half-mile hike to see it. The Caudill Cabin was called one of the finest examples of pioneer cabins on the parkway – and also one of the most isolated [there is no road to the cabin] – by Stanley Abbott. Alfred Martin Caudill (1874–1933) built the cabin in 1890 in Basin Cove and there he and Janie (1877–1933) raised a large family until a catastrophic landslide in 1916 forced the family to abandon the property. The National Park Service acquired the Caudill Cabin in 1938. The Puckett Cabin on Groundhog Mountain is a tribute to the extraordinary midwife Orlena Hawks Puckett (1837–1939), who delivered her last child in 1939 at the age of 102, also the same year she died at Fancy Gap, Carroll County, Virginia. Married at the age of sixteen to John Puckett, this Lambsburg, Carroll County native gave birth to twenty-four children of her own but none lived beyond infancy.[110] The Sheets Cabin, located between mile markers 251 and 252 in Laurel Springs, Ashe County, North Carolina [section 2-D of the parkway], was built in or about 1818 by Andrew Sheets (1774–1855).[111] Andrew and his wife, the former

Mary "Mollie" Shearer (1776 – 1855) raised ten children in this cabin – seven sons and three daughters. The Jesse Brown Farmstead [Milepost 272.5/section 2-E], located near Tomkins Knob [section 2-E of the parkway] in the North Carolina High Country, consists of a cabin, spring house, and the relocated Cool Springs Baptist Church, is believed to be pre-Civil War and contains interesting examples of early pioneer log construction. Tomkins Mountain, most of which is within the bounds of the Blue Ridge Parkway is near the community of Deep Gap and also marks the corner between Ashe, Watauga and Wilkes counties. Split along the Eastern Continental Divide, the mountain generates feeder streams to both the South Fork New River and the Yadkin River. Brown was a black preacher who led a small community of Baptists in the area. These are just a few of the sights to see along the Virginia and North Carolina Blue Ridge Parkway.

Once land was transferred by North Carolina and Virginia to the federal government for the Blue Ridge Parkway, notices like the one shown here were posted on the tract in clear view. This sign, which showed up in Ashe County, North Carolina, cautioned property owners and passersby to refrain from injuring shrubbery, trees or ferns, nor deface any of the natural features. The warning was published by the authority of National Park Service director Arno B. Cammerer. *Ashe County Public Library*

This sign marks the entrance to the north end of the southbound Blue Ridge Parkway at Rockfish Gap, Nelson County, Virginia. *Famartin*[112]

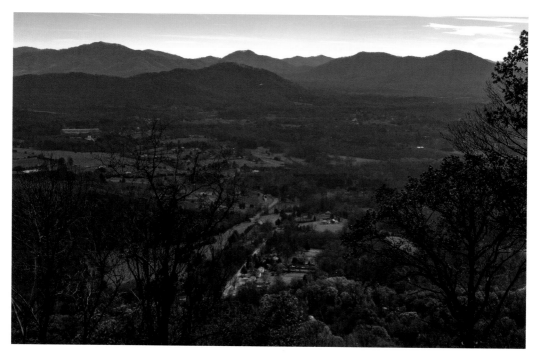

Rockfish Gap, at 1,900 feet elevation and at the southern end of Shenandoah National Park, is Milepost 0 on the Blue Ridge Parkway. This photograph, taken from the Rockfish Gap scenic overlook, just inside Nelson County, Virginia, was taken on November 25, 2017. *PumpkinSky*[113]

The original Humpback Rocks Visitor Center, located at the northern end of the Blue Ridge Parkway [Milepost 5.8], was constructed in 1955 and opened on May 19, 1956. After it was destroyed by arson in 1981, the visitor center was rebuilt as an expanded facility and opened the following year. In the foreground of this David Haas Historic American Engineering Record (HAER) photograph, taken in 1996/7, is a post-and-rail fence and a tower of truth [information sign]. In the background to the right is a buck – also called a "Yankee" – fence. The view is west-northwest. *Library of Congress*

From 1851 until the early twentieth century, wagoners hauling goods used the long-gone Howardsville Turnpike as they traveled between Howardsville and the Shenandoah Valley. Travelers frequently camped at Humpback Gap. Located nearby is the 795-acre Humpback Rocks [Milepost 5.8] Recreation Area. *Continued on next page*

Continued from previous page: Of note, there is a rock fence at this stopping off point that was purportedly constructed by the slaves of a plantation owner. The wall separates the gap and the Greenstone overlook [Milepost 8.8], placed on an outcrop of Catoctin Greenstone, a rock formed from a geologically ancient lava flow that inundated vast areas in Maryland and Northern Virginia; it is the most prevalent rock type over the first nineteen miles of the parkway. The sign for the Blue Ridge Parkway's Humpback Gap overlook and parking area [Milepost 6 and located at an elevation of 2,360 feet] in Augusta County, Virginia, is shown in this October 24, 2016 photograph. The Humpback Rocks area was one of the first planned as a recreational park along the parkway. The first plans were prepared for it in 1934, before the parkway was named. *Famartin*[114]

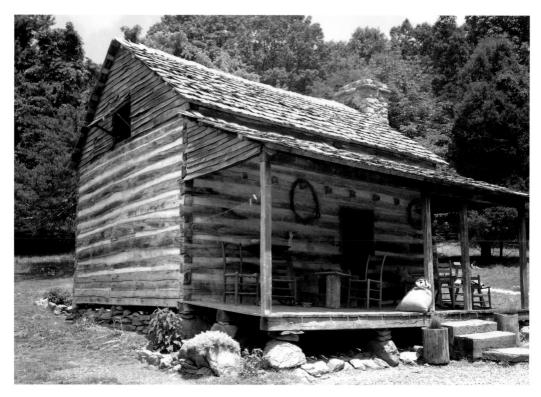

Situated at the northern end of the Blue Ridge Parkway at Milepost 5.8 in Virginia, Humpback Rocks is a gigantic rock outcropping that served as a major travel route across the narrow Blue Ridge until the advent of railroads that put down track through the mountain gaps. Here you'll find the mountain farm exhibit, which showcases the history of the settlers who populated the communities in and around this portion of the parkway. The early European settlers of the Appalachian Mountains forged a living from the native materials so abundant around them. Hickory, chestnut, and oak trees provided nuts for food, logs for building, and tannin for curing hides, while the rocks were put to use as foundations and chimneys and stone fences. The farm museum, adjacent to the Humpback Rocks Visitors Center, was the creation of parkway builders who took several historic buildings from the surrounding region and brought them to this location – including the single-room log cabin shown here – to tell the story of the people and places displaced by the construction of America's most scenic byway. Also on site are a series of outbuildings that represent elements of regional architecture of the late nineteenth century. Costumed interpreters provide demonstrations, including weaving, basket making and gardening. Of note, the Old Howardsville Turnpike begins at Humpback Gap parking area [Milepost 6] and descends three-and-a-half miles into Rockfish Valley. The turnpike was built between 1846 and 1851 to connect the trade markets of the Shenandoah Valley with the James River canal system. Original rock walls are still visible along this historic trace, but hiking this route is not recommended as the roadbed is not maintained. This picture of the farm's log cabin was taken on July 11, 2006. *Nationalparks*[115]

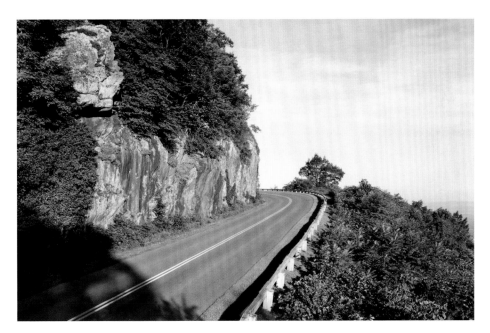

David Haas took this picture in 1996/7 of one of the many rock cuts necessary to build the parkway. The perspective, located at Milepost 6.5, is looking to the west-southwest. This stretch of road is in proximity of some of the parkway's best hiking opportunities, to include an intersection point with the Appalachian Trail at Humpback Gap parking area [Milepost 6]. *Library of Congress*

This view of the Whetstone Ridge [Milepost 29] gift shop and restaurant now used as park service district office space. The building is made of board and batten construction with a long integral shed porch across the front, a jerkinhead roof and stone chimney that reflect the Appalachian culture the parkway has endeavored to interpret. The view is looking toward the southwest. David Haas took the photograph in 1996/7 for the HAER study. *Library of Congress*

David Haas took these pictures of Yankee Horse Ridge [Milepost 34.4] in 1996/7 for the HAER report on the Blue Ridge Parkway. The first view, facing south, is of the trail crossing for the Yankee Horse Ridge reconstructed railroad bed, and the second is a close-up of the reconstructed railroad trestle, looking north. Much of the land that now buffers the Blue Ridge Parkway was being logged with the help of railroads before America's entry into the First World War. To get the logs out of the mountains, the lumber companies constructed narrow gauge railroads. This stop on the parkway showcases just a short section of what was originally the fifty-mile long narrow-gauge Irish Creek Railway that followed the same path seen here. Beyond the railroad exhibit is Wigwam Falls. The railroad exhibit and the falls are located along the Rockbridge County, Virginia leg of the parkway. *Library of Congress*

Viaducts are elevated roadway sections carrying the road high above dry ravines or across the shoulders of mountains where extensive and aesthetically unpleasing fill sections would otherwise be required. The earliest of these is the Rocky Mountain Viaduct, constructed in 1937, on the northern section of the parkway at Milepost 35. This steel girder structure is supported by arched stone piers and stone-faced abutments, and is the only viaduct to feature this treatment. Most other parkway viaducts are steel girder structures supported by reinforced concrete or steel piers. David Haas took this picture of the Rocky Mountain Viaduct in 1996/7 as part of the Historic American Engineering Record (HAER) of the parkway. *Library of Congress*

The area of lowest elevation along the Blue Ridge Parkway threads its way through the George Washington National Forest and is located where Otter Creek meets the James River. The James River has been a major transportation artery through Virginia for centuries. Although originally planned to provide a navigable waterway from Richmond's Great Falls to the Ohio River, the James River and Kanawha Canal was destined to extend no further west than Buchanan, Virginia. When completed in 1851, it was the primary commercial route in the state but the Civil War, floods and railroads ended the canal's relevancy. The Otter Creek Bridge [Milepost 59.8] shown here is part of that James River system. This view of the stone face elevation covering the concrete box culvert was taken by David Haas in 1996/7 for the HAER report. *Library of Congress*

Natural Bridge [Milepost 61.6] is a 215-foot-high, naturally-occurring, solid-rock geological formation with an arch span of ninety feet. Located in Rockbridge County, Virginia, it is situated in a gorge carved from the surrounding mountainous limestone terrain by Cedar Creek, a small tributary of the James River. Natural Bridge is the remains of the roof of a cave or tunnel through which Cedar Creek once flowed. The site has been designated a Virginia Historic Landmark and a National Historic Landmark. Since 2016, the bridge and its surrounding area have been managed by the commonwealth of Virginia as Natural Bridge State Park. The first photograph was taken by a Detroit Publishing Company photographer between 1900 and 1905. The contemporary photograph was taken by Carol M. Highsmith. *Library of Congress*

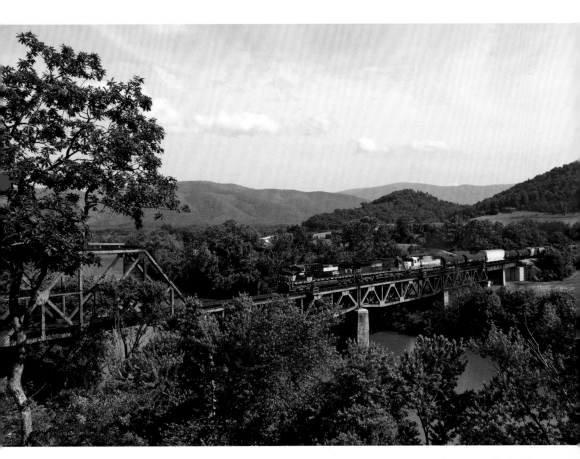

The railroad played a significant role in the development of Natural Bridge as a resort destination during the latter half of the nineteenth century. The newly formed Richmond and Alleghany Railroad arrived at Natural Bridge station in 1881 and the Shenandoah Valley Railroad followed two years later. Constructed on the vacated James River and Kanawha Canal towpath, the Richmond and Alleghany tracks ran along the James River for 220 miles from Richmond through Natural Bridge to Clifton Forge; the company merged with the Chesapeake and Ohio in 1890 and served as its James River Division. The Shenandoah Valley Railroad, which ran from Hagerstown, Maryland, to Roanoke, Virginia, later merged with the Norfolk and Western. Between these two railroads, there were twelve daily stops at the Natural Bridge station, where stagecoaches transported visitors to the Forest Inn, still the main hotel at that time. In this contemporary photograph, a Norfolk Southern Railroad freight train crosses the James River at Natural Bridge, Virginia. This is the Norfolk Southern H-line, which runs from Roanoke, Virginia, to Hagerstown, Maryland. The H-line crosses the CSX James River line that follows the river bank below and to the left in this photograph, taken on May 29, 2011. *J. P. Mueller*[116]

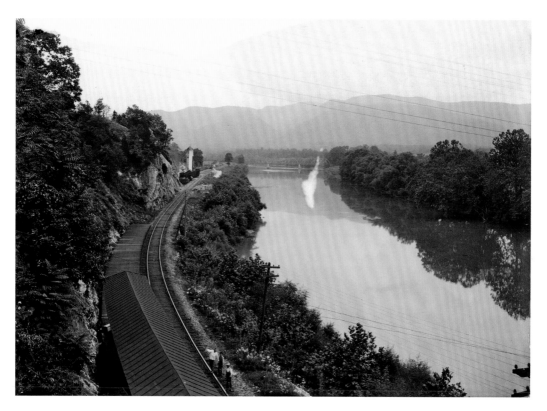

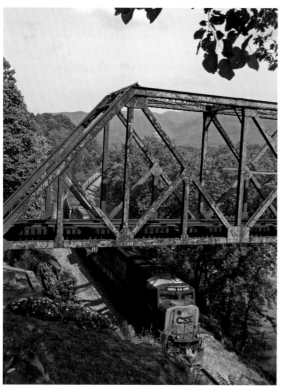

The first photograph (shown here) was taken between 1900 and 1915 by a Detroit Publishing Company photographer of the route originally laid down for the Richmond and Alleghany Railroad and running parallel to the James River near Natural Bridge. In the second photograph, a CSX train pulling empty coal hoppers heads west on the railroad's James River line in Natural Bridge, Virginia. The Norfolk Southern's bridge is shown above. This picture was taken also on May 29, 2011. *Library of Congress* (old) *J. P. Mueller*[117] (new)

Davis Haas took these photographs of the Otter Lake Dam [Milepost 63.1], located along the Blue Ridge Parkway in Amherst County near Big Island, in 1996/7 for a HAER report. The first view shows the rustic stone façade of the dam. The stepped face of the dam gives it the illusion of a natural cascade. The perspective is facing southeast. Looking east-northeast, the second view, shot from downstream, shows how the dam blends into its environment. *Library of Congress*

The James River Visitor Center [Milepost 63.6] first debuted as an open-air visitor center in 1962 but was enclosed and a heating system installed in 1984 to allow use through the cooler months and to help mitigate vandalism. The view shown here is looking northeast. The picture was taken by David Haas for the HAER report in 1996/7. *Library of Congress*

The Blue Ridge Parkway bridge over the James River at Big Island, Virginia, was named for and dedicated in 1985 to Berryville, Clarke County, Virginia native, former governor and United States senator Harry Flood Byrd (1887 – 1966). This view of the underslung pedestrian walkway of the Harry Flood Byrd Memorial Bridge [Milepost 63.6 and collocated with the visitor center] was taken by David Haas for the 1996/7 HAER report. The pedestrian bridge provides access between the visitor center and the James River and Kanawha Canal. The perspective is facing west-southwest. This is the largest prestressed concrete girder bridge on the parkway and is 1,040 feet long; it is also the first bridge of its type to be constructed in Virginia and the longest such overland bridge. The pedestrian footbridge slung under the five northern spans remains a unique feature; it also provides access to the restored segment of the James River and Kanawha Canal. *Library of Congress*

This August 17, 2007 photograph was taken from the pedestrian walkway of the Harry Flood Byrd Memorial Bridge running over the James River. The perspective is looking west toward the James River Gorge. *Thea Ganoe*[118]

The James River and Kanawha Canal locks [also at Milepost 63.6], which operated from 1835 to 1880, serves as the focal point of the area's interpretation. The Battery Creek lock was reconstructed between 1961 and 1965. Severe flooding in 1985 damaged the lock gates, which were later rebuilt in 1987/8. The view is looking to the south. The picture was taken by David Haas in 1996/7 for the HAER report. *Library of Congress*

The Peaks of Otter remains a major developed area on the Blue Ridge Parkway and is the most popular recreation area on the Virginia section of the highway. In the valley formed by Sharp Top and Flat Top Mountains, and Harkening Hill is a lodge and restaurant, visitor center, campground, picnic area and historic farm. Additionally, the area is almost totally surrounded by the Jefferson National Forest, which only adds to its appeal as a destination for parkway travelers. This view from Sharp Top Mountain provides a sweeping view, overlooking the Peaks of Otter lodge and manmade Abbott Lake. *Continued on next page*

The stone-faced Peaks of Otter Visitor Center [Milepost 85.9] was completed in 1957 with a comfort station added in the mid-1960s. The picture was taken by David Haas in 1996/7 for the HAER report. *Library of Congress*

Continued from previous page: The first inn opened in the Peaks of Otter area by 1834 and by the turn of the twentieth century, the Peaks of Otter had become a popular tourist destination. The photograph was taken by Gary Johnson in his capacity as a Blue Ridge Parkway landscape architect. Of note, for many years, Sharp Top Mountain was believed to be the highest peak in Virginia and drew many visitors hoping to climb the Old Dominion's loftiest point. *National Archives*

The Peaks of Otter gas station was one of only two remaining on the parkway at the time David Haas took this picture in 1996/7. *Library of Congress*

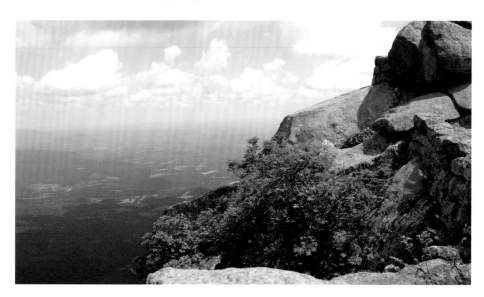

The summit of Sharp Top Mountain offers an impressive 360-degree view of the Peaks of Otter area, the Piedmont to the east, the Blue Ridge Mountains, and the Shenandoah Valley with the Alleghany Mountains to the west. Peaks of Otter is located at Milepost 86 off the Blue Ridge Parkway. This area has been traveled for more than eight thousand years. Native Americans passed through the area hunting, and the earliest European settlers began arriving in the middle of the eighteenth century. The picture shown here was taken on August 14, 2015. *Virginia State Parks*[119]

This picture of the Polly Wood's Ordinary [Milepost 85.9], believed to be the oldest structure on the parkway and dating to the early nineteenth century, is located in the Peaks of Otter area, moved from its original location. The small log cabin was run as an inn from in or about 1832 to the early part of the 1850s by Wood, the widow who owned it. Born Polly Dooley, she married Jeremiah Wood, the grandson of the original settler of the Peaks of Otter [Thomas Wood], in 1796. This was the first hostelry operated in the area. The cabin, originally built in the low meadows of the Mons community, was moved to its current location in 1965 to make way for what became the manmade Abbott Lake, named for landscape architect and first superintendent of the parkway Stanley W. Abbott. Parkway planners originally wanted to add the lake as an attraction in 1943 but Abbott stopped it. With a new Peaks of Otter Lodge completed in 1964, the lake was created one year later. This photograph was taken on May 8, 2016. *Laura A. Macaluso Ph.D.*[120]

Opposite above: The Boblett's Gap overlook [Milepost 93.1] is collocated with the William Robert "Will" Boblett[121] (1828 – 1906) family cemetery shown in this 1996/7 David Haas photograph for the Blue Ridge Parkway HAER report and surrounded by a post-and-rail fence. The view is looking to the southwest. Early mountain settlers like the Bobletts maintained their own family cemeteries. All headstones have been removed and while there is not much to see other than a few depressions in the ground that mark the sites of the seven Bobletts interred there, it remains an interesting stopping off point. A sign that once listed the names of the Boblett family members buried there is now also missing. The Bobletts were farmers who owned the land but they eventually moved to down to Buchanan in the valley, leaving behind this burial plot. From this stopover, travelers can also access the Appalachian Trail. *Library of Congress*

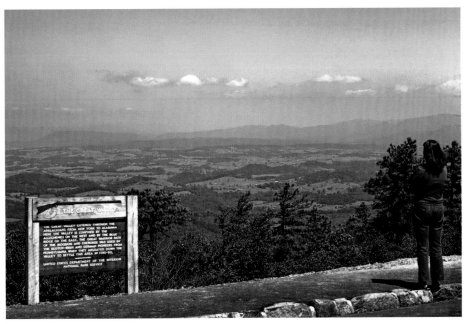

A visitor to the Blue Ridge Parkway stands at the Great Valley overlook [Milepost 99.6] to observe the entire valley spread out below in this contemporary photograph taken in or about 1995. The view here is looking westward. The Great Valley – in its entirety – extends through the Appalachians from New York to Alabama. But here the valley is confined by the Alleghenies on the west and by the Blue Ridge on the east. The Great Warrior Path of the Iroquois and Cherokee was used by the Scots-Irish and German pioneers from Pennsylvania when they migrated down the valley to settle this area between 1730 and 1750. The parkway runs above the Great Valley for one hundred miles south of Rockfish Gap. *National Archives*

Table Mountain pine [sp. *Pinus pungens*], also called hickory pine, prickly pine or mountain pine, is a small pine native to the Appalachian Mountains. The needles of this tree, a common site on the Blue Ridge Parkway (where this picture was taken), grow in bundles of two, sometimes three, and are fairly stout. The cones are very short-stalked, ovoid, pale pinkish to yellowish buff. This pine tree prefers dry conditions and is mostly found on rocky slops, preferring higher elevations from approximately 1,000 to 6,000 feet. The picture was taken on August 9, 2006. *Tim Menzies*[122]

OPPOSITE PAGE:

Above: The Roanoke River Bridge [Milepost 114.7] is a 1,028-foot six-span steel girder bridge built in 1963 and the longest of its type on the parkway. This view, photographed by David Haas in 1996/7, is of its west elevation. *Library of Congress*

Below: The Sweet Annie Hollow Trail [Milepost 138.8], located in Floyd County, Virginia, at the crest of the Blue Ridge Mountains, sits at an elevation of 2,889 feet. David Haas photographed the trail as it ran under the concrete box culvert faced with rusticated stone arch, a good example of the rigid frame bridges found along the parkway, in 1996/7. The view is looking north-northeast. *Library of Congress*

The Kelley School, located just off the Blue Ridge Parkway [Milepost 149.1] in Floyd County, Virginia, is an example of early education in this mountain area. In 1877, the Locust Grove trustees bought land for a school from the Kelley family for fifteen dollars and built a one-room school. The school had no running water or electricity and did not get an outhouse until 1917. Due to growing enrollment, a two-room schoolhouse was built on the lot, and it is this structure that now stands just out of sight along the parkway. The school was still in operation when the parkway was built. *Continued on next page.*

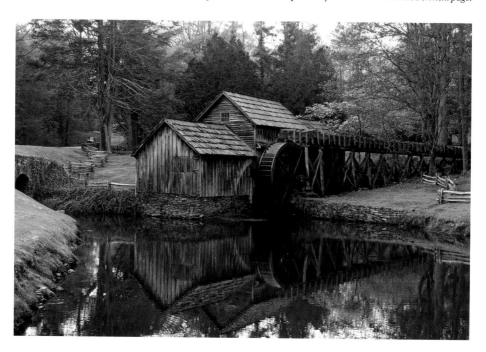

Continued from previous page: It closed in 1939 when the school system was consolidated. Shortly after, Virgie Pate (1899 – 1977) bought the building at auction and it became the Locust Grove residence and grocery store for Pate and her son, Herman Jewel Pate, both of who were former students of the Kelley School. The Pates added electricity and living quarters. They sold the store in 1972 and it operated as Ye Old Country Store until the building was sold to the parkway in 1984. This view of the school in unrestored condition serves as an example of the many cultural resources to be found along the parkway. The view is looking southeast. David Haas took the picture in 1996/7 as part of the parkway HAER. *Library of Congress*

The Mayberry Presbyterian Church is located on the Blue Ridge Parkway southwest of Meadows of Dan in Patrick County, Virginia. Built in 1925, it is listed on the National Register of Historic Places. The Mayberry church is located adjacent to Blue Ridge Parkway Milepost 180.1. The rock churches were founded by the Reverend Robert Walter Childress (1890 – 1956) in the early 1920s. Childress, born in hills below Buffalo Mountain, Patrick County, Virginia, came back to the Virginia mountain community in June 1926 with his family. Over the years he would sometimes travel more than one hundred miles each Sunday, preaching as many as five sermons in five different churches and as time went on he would expand that ministry, traveling some forty thousand miles a year and preaching as many as fourteen sermons a week. Mayberry Presbyterian is one of the five historic rock churches located in the tri-county area of Carroll, Floyd and Patrick counties in southwestern Virginia he established and built in the shadow of Buffalo Mountain. This picture of Mayberry Presbyterian Church (shown here) from the front and eastern elevation was taken on May 13, 2017. *Nyttend*[124]

Opposite below: Historic Mabry Mill [Milepost 176], near Meadows of Dan, Virginia, is shown in this May 8, 2015 photograph. Mabry Mill is the most popular – and most photographed – attraction on the Blue Ridge Parkway. Nearly three million people visit it each year. Of interest, in 1941 and 1942 the parkway began providing visitors with storyboards recounting tales, legends and historical lore at various points along the parkway. Stanley W. Abbott stressed that the signs would express the "lived-in quality of the mountains" rather than political history. The first four of these signs were prepared for the Trail Cabin at Smart View, Mabry Mill, the Puckett Cabin, and the Brinegar Cabin. At the same time, the parkway began to design signs for the overlooks. Trail signs were also installed at the Cascades and Flat Rock trails, though these original signs no longer exist. *Niagara66*[123]

This view of the Groundhog Mountain fire lookout tower, constructed by the Virginia state forest service in the summer of 1942 in Carroll County, Virginia, and built to resemble an old tobacco barn, was taken by David Haas for the HAER in 1996/7. The elevation at Groundhog Mountain is 3,035 feet. This location is located north of Interstate 77 [Fancy Gap Exit] at Milepost 188.8. Just south of the Groundhog Mountain picnic area, within walking distance of this tower, is the Pilot Mountain scenic overlook. Carroll County offers thirty miles of the Blue Ridge Parkway. A buck or Yankee fence crosses the foreground with a snake fence in the background. Civilian Public Service employees began erecting the rail fences in April 1939. The perspective is looking north-northeast. *Library of Congress*

The Fraser magnolia [sp. *magnolia fraseri*], known also as the mountain magnolia, earleaf cucumber tree and mountain oread, is a species of magnolia native to the southeastern United States in the southern Appalachian Mountains and adjacent Atlantic and Gulf Coastal Plain from West Virginia south to northern Florida and west to east Texas. The Appalachian variety is classified as *Magnolia fraseri* var. *fraseri*, and the coastal plant as *Magnolia fraseri* var. *pyramidata*. This is a small, deciduous tree named for the Scottish botanist John Fraser (1750 – 1811), who collected extensively in the Appalachian Mountains. The picture was taken on May 9, 2011. *Becky Cortino*[125]

IV

FOLKLIFE LEGACY

"Life in the Blue Ridge is richly complex and cannot be described as simple or culturally uniform," wrote Alan Jabbour, director of the American Folklife Center, after a recently concluded study of Blue Ridge Parkway communities in the late 1970s. "There are no 'pure folk communities' here – or, for that matter, anywhere else in the United States." He would go on to offer this observation. "Folklife sometimes seems far away and quaint, covered by a patina of history."[126] The folklife that Jabbour opined was gone was once very much alive in and around the reaches of the parkway, to include the rich tradition of music, dance and handicrafts that were the calling card of the mountaineer life. As folklorists acknowledged now decades ago and what others who came before them got to see in purer form, it was still there to be photographed and documented when the architects of the Shenandoah and Great Smoky Mountains national parks and the Blue Ridge Parkway drafted their plans in the early 1930s.

Notably, Blue Ridge Parkway superintendent Stanley W. Abbott had always considered regional crafts an important part of Southern Highland culture and proposed promoting handicrafts by encouraging mountain people along the road to produce crafts that might be sold to visitors in various outlets established by the park service. With mixed success, the program was implemented and visitors can still view and purchase authentic mountain crafts in several outlets run by cooperating associations. In 1940, Roy Edgar Appleman (1904 – 1993), National Park Service regional supervisor of historic sites, and Thor Borresen, assistant historical technician, filed a report delineating how the parkway might promote regional handicrafts. Seeking a consistent source of supply from genuine mountain craft workers, they visited the Allanstand Shop in Asheville, the principal outlet of the Southern Highland Handicraft Guild. Allanstand Cottage Industries had been established in 1895 by Frances Louisa "Fannie" Goodrich (1856 – 1944), a social worker with the Board of Home Missions of the Presbyterian Church, for the marketing of traditional mountain crafts. The shop dissolved

in 1931 and its surplus stock was turned over to what was then called the Southern Mountain Handicraft Guild, organized in 1928 as a larger consortium of craft-producing centers. Appleman and Borresen found products there from several potteries and wood-working shops, along with textiles, baskets, dolls and other work, but were critical of what they saw, declaring a large portion of it was "not truly handiwork." They visited several other shops and potteries, and met with Allen Hendershott Eaton (1878 – 1962), author of *Handicrafts of the Southern Highlands*, published in 1937, and a champion of Craft Revival. Eaton was interested in the parkway's plans to promote handicraft sales and told the two planners that he already intended to approach the National Park Service about a concession contract for the sale of handicraft work at adjacent Shenandoah National Park.[127]

The Appleman and Borresen report proposed that the parkway encourage artisans to locate shops along the route. This would have two advantages: visitor interest in the journey would be enhanced, and those engaged in handicraft work would have a readymade outlet for their work, which would further encourage the preservation of traditional arts. If guilds or other associations of artists and craft work producers were permitted to sell their members' work, then the parkway should make a special effort to promote the sale of crafts from the immediate region: Virginia crafts in Virginia, Carolina and Tennessee crafts on the southern sections. Appleman expressed the importance of preserving the handicrafts of the mountain people observing: "This way of life has all but disappeared. To preserve some fragments of this cultural past will be rendering a service to posterity and will be just as truly historical preservation as to perpetuate physical remains in the forms of various structures."[128] Abbott also wanted artisans from the region to produce items for sale at concession operations. At Mabry Mill, for instance, he intended for a local blacksmith to manufacture handcrafted pieces for sale in the various gift shops that were planned. By providing places for the sale of these articles, he hoped to encourage the preservation of traditional skills.

Instructions issued to parkway concessionaires in this period spotlighted the parkway staff's interest in having parkway venues market only handicrafts and products native to the Blue Ridge. In addition to discouraging the "ordinary run of five and ten cent store souvenirs," the instructions also prohibited "spurious or specious" articles sold "under the guise of handicraft fakery." The instructions urged operators to consider handling non-perishable agriculture produce from the area such as sorghum molasses, sourwood honey, preserves, chinquapins, and aromatic herbs. Potted native trees and plants would also be popular, and might reduce the amount of visitor vandalism in the form of removing plants along the parkway, which had already become a problem. The report also urged concessionaires to utilize Southern Highland artisans who might practice their crafts in restored parkway structures and sell their wares at the various concessions outlets. Above all, it urged the concessionaires to work with handicraft guilds and local artists to provide the public with appropriate and worthwhile items that reflected the character of the mountain people.[129]

Following the donation of the Moses H. Cone estate at Blowing Rock, Superintendent Samuel P. Weems asked the Penland School of Handicrafts to operate Cone's mansion, Flat Top Manor, as a handicraft center. School officials were enthusiastic about the proposal and reorganized as the Southern Highland Handicraft Guild, entered into a contract to operate a

"parkway craft center" at the house. Weems was enthusiastic about the arrangement, which would not only help maintain the manor house, but provide what he estimated just then would be millions of parkway visitors an opportunity to learn about the variety and beauty of handicrafts produced in the region. In August 1952, the guild began operating the craft center under a concession agreement with the parkway. The agreement authorized the guild to produce and sell handicraft articles, operate a museum of handicraft arts, and conduct demonstrations. Interest in the programs was attested to the first year by substantial sales and good attendance at programs. The Francis L. Goodrich handicrafts collection formed the nucleus of the museum.

To showcase the crafts of the northwestern North Carolina counties, the parkway authorized the establishment of the Northwest Trading Post, described as a country store that offered mountain crafts and, for a while, produce, from this particularly isolated region. After receiving a concessions contract in 1958, the not-for-profit board organized to operate and fund construction of the frame store located in Ashe County at Milepost 258.6 fronting the parkway. The fact that the store was built in plain view of the parkway meant that it had to conform to scenic landscaping to protect the viewshed. Today, the Northwest Trading Post-turned-Sally Mae's on the Parkway continues to offer crafts produced in the seven-county area, along with regional foods such as chess pies and country ham biscuits. Some non-craft items are offered as souvenirs, but are labeled to distinguish them from the work of mountain artisans. All parkway concessionaires were cautioned three years after the Northwest Trading Post first opened to the keep the quality of their merchandise high and they were further advised to carry "authentic, meaningful" handicraft items associated with the Blue Ridge Parkway and the Southern Highlands region. The "less expensive souvenir items that many visitors want" were to be kept separate if space allowed.

The success of the parkway folk art center at Moses Cone's Flat Top Manor led the Southern Highland Handicraft Guild, headquartered in Asheville, North Carolina, to propose the establishment of an "Americana Village" on the grounds of the estate. The chief proponent was Robert Ward Gray[130] (1916 – 2007), who became director of the guild, also in 1961. Gray had been associated with Old Sturbridge and the Worcester Craft Center [now the Worcester Center for Crafts], both in Massachusetts, and thought a similar village development at Cone Park would enhance the guild's income. Americana Village would have been the largest visitor exhibit on the parkway, encompassing a virtual town made up of an old country store, village church, and one-room schoolhouse, together with a working farm and two water-powered mills. A visitor center and amphitheater, to be located near the Cone manor house, would handle the expected surge in visitation. Artisans and demonstrators would be lodged in multi-unit residences, and the Cone estate apple barn would become a workshop and warehouse for crafts produced on the site.

Gray's project was enthusiastically supported by the guild, and an advisory board, including Weems, former National Park Service director Conrad L. Wirth, conservationist Michael Frome (1920 – 2016), and Evelyn Hazen Hanes (1885 – 1975), wife of the underwear magnate Pleasant Huber Hanes (1880 – 1967), was formed to offer business experience to the organization. The Advisory Council on National Parks, Historic Sites and Monuments also endorsed the

project. Everything seemed on track at that point. But then planners eventually determined that the Cone estate was not suited for such an ambitious development, and a new concept plan shifted the location to adjacent Julian Price Memorial Park. By this point, the proposed project had escalated to $3.2 million. This came at a time when expanded funding from the park service's Mission 66 program, a ten-year-program intended to dramatically expand visitor services by 1966, was coming to an end and the parkway was being directed to plan for the extension of the motor road to a point near Atlanta, Georgia [this did not happen]. The 1971 announcement of a tentatively named "Appalachian Heritage Center" to be built at Asheville by local boosters spelled the death knell for Gray's handicraft village; three years later, the Americana Village proposal was quietly abandoned. The Asheville project would evolve beyond the notion of another craft village to the present Folk Art Center, which has since become the focal point for handicraft programs on the parkway.

In the late 1960s, the Southern Highland Handicraft Guild proposed the establishment of a major folk art center on the parkway at Asheville. The park service agreed to the concept, and when it obtained some land at Oteen on the outskirts of Asheville from the Veterans Administration in 1969, it made the tract available for an art center, though it insisted that it be funded privately. Just a few years later, in 1976, the guild received a $1.5 million grant from the Appalachian Regional Commission, along with several smaller grants from National Endowment for the Arts, private foundations, and the North Carolina Arts Council. The park service kicked in an additional $119,000 for planning costs. Some of the grants required matching funds, and the guild raised these from local industries and interested parties. A ground-breaking was held in June 1977 at a ceremony attended by Joan Mondale, the wife of Vice President of the United States Walter Mondale. Following its construction, the guild donated the structure to the parkway, which leased it back to the guild but agreed to maintain the grounds. The center was dedicated on April 17, 1980, again by Joan Mondale. The $2.2 million, 30,500-square-foot Folk Art Center was constructed of concrete faced in native stone and wood. It contains a museum and exhibition area, a large sales room, a reference library, and a small outlet for interpretive publications operated by the Eastern National Park and Monument Association.

In the same time frame that the Folk Art Center was going up, there was an equally important multiple-year study undertaken to document the folk cultural traditions, including the quilters [many of them shown in this chapter], along a one hundred-mile stretch of the Blue Ridge Parkway. The Library of Congress' American Folklife Center's folklorists gathered audio and video recordings, photographs, publications, ephemera, and accompanying manuscript materials to preserve snapshots of life where neighboring farms, communities and churches readily met the road. The study covered parts of Grayson, Carroll, Floyd, and Patrick counties in Virginia, and Alleghany, Wilkes, and Surry counties in North Carolina. The project spanned the three-year-period from 1978 to 1981, and had the cooperation of the National Park Service and included such popular sites as Rocky Knob in Virginia and Doughton Park in North Carolina. The fieldwork took place primarily during August and September 1978 and was conducted by ten folklorists and photographers; Charles Keith Wolfe Ph.D.[131] (1943-2006), of Middle Tennessee State University, and Carl Fleischhauer, folklife specialist,

American Folklife Center, Library of Congress, were field coordinators. The fieldwork also included an intern program designed to train selected park service employees in folklife study. What they found was a region bound together by invisible networks of shared feelings and behavior, by a sense of community that was reflected in the stories like Ruth Holbrook's tale of how the rural Wilkes County community of Traphill got its name:

> A drummer got drunk on pea liquor and the hotel or the building where they kept boarders, they called it 'hotel,' was just across the road on top of the hill over here. And he started up to spend the night and he couldn't make it. And so they set a chicken coop over him, or a turkey trap it was. And he waked up, why he named it 'Traphill.' And they had a meeting then, the next night, and officially named it 'Traphill.'[132]

The study observed that a crossroads hamlet like Laurel Fork, an unincorporated town in Carroll County, Virginia, like Traphill, becomes home for people with common backgrounds and shared values. Patterns that reflect these values, they observed, are present everywhere in the community, from the look of a store or restaurant, in the form of stories or seating arrangements at the barbershop or quilting bee, or in the types of music and movement at a dance. "Dance is the very metaphor for community, both in the way dancers join in pattern expression and in the kaleidoscope movement of dancers within the pattern," project folklorists wrote. With the quilters their values are symbolized by decoration: a flower garden quilt pattern wrought by women in a church basement defined largely by their common family and community bonds, their age and experience and skill level. At events like the Galax fiddler's convention, an event the project covered and that drew in some forty thousand visitors just then, the Blue Ridge both expressed itself as part of the upper South and shared the nation's perception of it as a region. The old-time music that was developed in the communities of the Southern Appalachian Mountains, down in the foothills and hollows, has its roots in the European and African musical traditions that continued to ripple through the daily rhythm of mountaineer life for generations. This music nearly always spotlights the fiddle. But other instruments include the banjo, guitar, mandolin, harmonica and dulcimer, to include also the jug, washboard and spoons. We are reminded, in the spirit of that unique old-time music, of the faith and family that binds together the communities that front the Blue Ridge Parkway.

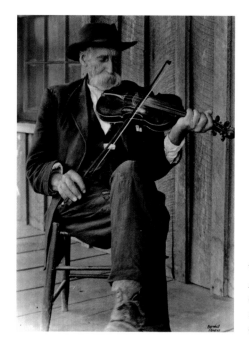

William Augustus Barnhill (1889 – 1987), of Asheville, North Carolina, took this photograph of an unidentified mountain fiddler. The accompanying information with the photograph dates it to July 15, 1920. *New York Public Library*

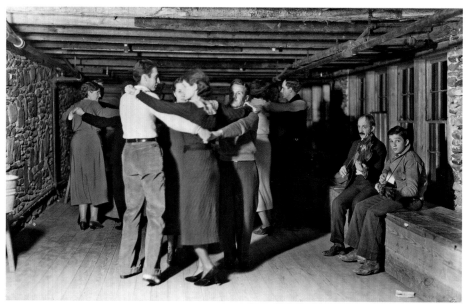

Bayard Morgan Wootten took this picture of a dance held at Penland community's Bailey's Peak during the Great Depression. History informs that the Penland and Bailey families lived in and around what is now Mitchell County from the period of first settlement by European immigrants and their descendants. The Bailey family is documented as early as the 1790s with family members settling throughout the region in communities such as Deer Park, Grassy Creek, Red Hill, Bakersville, and Burnsville in the nineteenth century. The Penlands trace their roots back to Milton Pinckney Penland[133] (1813 – 1880), a native of Burke County, whose interests in minerals and land acquisition from the mid-nineteenth century brought him to Yancey and Mitchell counties. These families became central players in the development of the region, but most especially the Penland community. *University of North Carolina Chapel Hill*

Bailey's Peak, visible from the current Penland community, was named for patriarch John Wesley "Yellow Jacket" Bailey (1798 – 1880) whose extended family lived in the area in or about 1850, according to information filed with the National Register of Historic Places. Bayard Morgan Wootten also photographed Bailey's Peak (shown here). *University of North Carolina Chapel Hill*

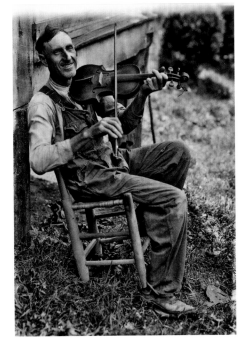

Bayard Morgan Wootten took this picture of balladeer Dock ("Doc") Walter Hoppas (1883 – 1945), a self-taught musician and folksong composer, playing his favorite fiddle. He was born in poverty in Mitchell County, North Carolina, as the seventh and last son of James Alison and Nancy Creson Hoppas. While still a small child, his father deserted the family for another woman and moved away to Jennings County, Indiana. He was raised by his mother. The picture was taken in the vicinity of Penland, located in Mitchell County, during the Great Depression. *University of North Carolina Chapel Hill*

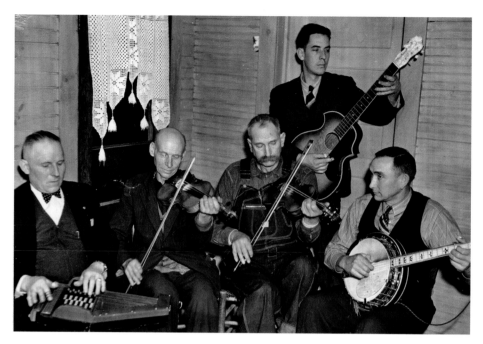

Western North Carolina and southwest Virginia are known internationally for their traditional old-time stringband music, ballad singing and bluegrass. Traditional music can be heard throughout the region – from hometown oprys and informal jam sessions to concert stages. Festivals and old-time music conventions, some dating back nearly a century, provide parkway visitors the opportunity to enjoy traditional music and dance in family-friendly settings. In this photograph, the Ballard Branch Bogtrotters were photographed at Galax, Virginia, in 1937. Included (left to right) are Doc Davis (autoharp), Alexander W. "Uncle Eck" Dunford (fiddle), Crockett Ward (fiddle), Wade Ward[134] (banjo), and Fields Ward (standing) (guitar). The picture was taken by a CBS photographer during the Alan Lomax School of the Air Broadcast, also located in Galax. *Library of Congress*

The southern folk musical instruments shown in this 1934 period photograph and part of the Lomax Collection include homemade horns, a drum and washboard. The collection includes four hundred photographs made in the course of sound recording expeditions carried out by John Avery Lomax (1867 – 1948), a folklorist and pioneering musicologist; his wife, Ruby Terrill Lomax (1886 – 1961), and his son, Alan Lomax (1915 – 2002), an ethnomusicologist, from 1934 to in or about 1950 for the Archive of American Folk-Song. *Library of Congress*

Musician, folklorist and festival organizer Bascom Lamar Lunsford (left) (1882 – 1973) and two so-called "Alabama visitors" visited during the Mountain Dance and Music Festival held at Asheville, North Carolina, during the 1930s. Lunsford was born in Madison County, North Carolina. His father was a Confederate veteran from East Tennessee, and his mother, a ballad singer, hailed from Buncombe and Madison counties. Lunsford's family included fiddlers and other musicians. When he and his brother Blackwell were children, they learned to play the fiddle, and then as teen-agers took up the banjo, which would become Lunsford's primary instrument. Lunsford worked in many different professions in his adult years. He was a fruit tree and honey salesman, lawyer, publisher, teacher, and reading clerk in the North Carolina House of Representatives. It was in his work as a fruit tree salesman that Lunsford developed his vast repertoire of traditional songs and tunes. The job required him to travel throughout the mountains, staying with customers, and it was on his trips that he would learn music from the people he met. The songs and tunes that he knew from memory numbered over 300, and the files that he kept included 3,000 pieces of music. In 1927 the Asheville Chamber of Commerce asked Lunsford to organize a festival. The Mountain Dance and Folk Festival has been in existence since, occurring every August in Asheville. *Library of Congress*

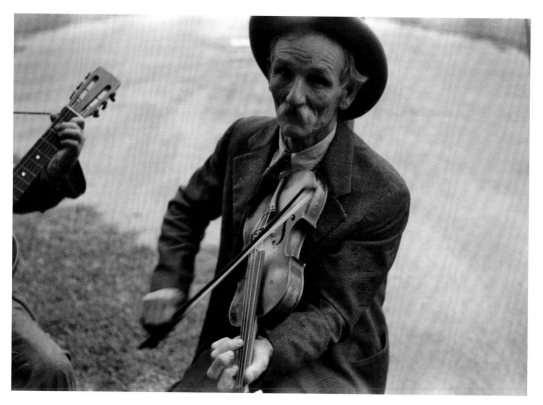

Ben Shahn (1898 – 1969), a photographer for the United States Resettlement Administration, took the picture of William Andy "Fiddlin' Bill" Hensley (1873 – 1960) [seated], a mountain fiddler, of Asheville, North Carolina, in 1937. The second photograph of Fiddlin' Bill (left) was taken at the Mountain Dance and Music Festival held at Asheville, in or about 1938. Hensley was born in Hot Springs, Madison County, North Carolina, the son of Jesse and Nancy Ann Tittle Hensley, but moved to Buncombe County, where he spent sixty years of his life. Hensley's obituary would inform that he had played before presidents and royalty, and while he had worked as a railroad man, machinist, a cabinetmaker and farmer, his principal interest was in fiddling. His last spoken words were about his fiddle, which he called "Old Calico." *Library of Congress*

The Soco Gap Junior Square Dance Group from Waynesville, North Carolina, danced at the Mountain Dance and Music Festival held in Asheville, North Carolina, in the 1940s. *Library of Congress*

These Soco Gap, Haywood County, North Carolina square dancers were photographed in or about the waning years of the Great Depression. The county boasts forty-six of the most scenic miles of the Blue Ridge Parkway and remains a hub of the Old North State's Appalachian history, culture and Nature's splendor. Of note, Haywood County's Cataloochee Valley is ground zero for the reintroduction of the elk population in the Great Smoky Mountains. *University of North Carolina Chapel Hill*

Bayard Morgan Wootten took this picture of Mae Gouge [later Huskins] (1911–1984) at the loom in Lucy Calista Morgan's weaving cabin at the Penland School of Handicrafts, located in Mitchell County. Morgan (1889–1981) founded the community handicraft program in 1924. The school celebrated the traditional crafts of the North Carolina mountain people, reviving skills such as weaving, metalwork, wood carving, jewelry and pottery making that had nearly disappeared. Before the start of the Second World War, there were more than sixty looms operating at Penland. *University of North Carolina Chapel Hill*

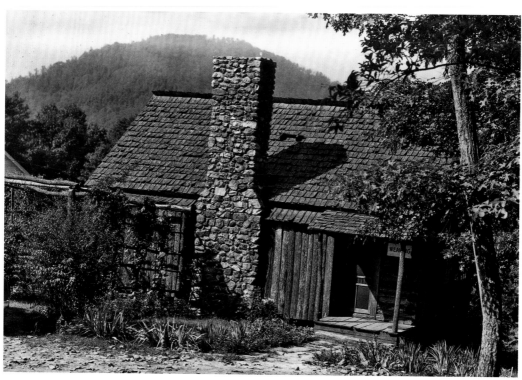

Lucy Morgan's earliest attempt to establish Penland School of Handicrafts began with a series of simple log cabins, photographed by Bayard Morgan Wootten. The weaving cabin is shown here. *University of North Carolina Chapel Hill*

The Penland School of Handicrafts memorialized Chicago educator and pioneer in the manual education movement in the United States Edward Francis Worst (1866 – 1949) for his contribution to craft revival in western North Carolina and his annual summer weaving institute at the school, starting in August 1928 and that continued until his death, with a studio in his honor. Worst was the nation's leading expert in hand weaving. Lucy Morgan was Worst's western North Carolina connection. Construction of the Edward F. Worst Craft House began in May 1935. Morgan called it "a mansion in the sky." This four-story fifty-by-eighty-foot national laboratory for weaving was built of logs and remains today a focal point of the Penland School of Crafts. The notchers were hard at work in the construction of the building when this picture was taken. *University of North Carolina Chapel Hill*

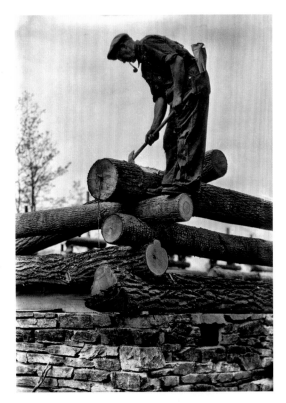

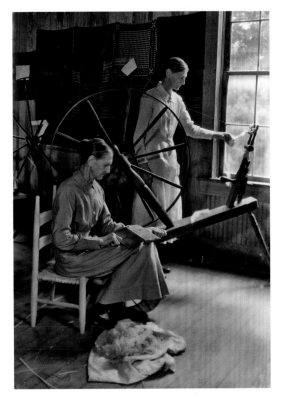

Penland women are shown carding and spinning in this Bayard Morgan Wootten photograph, taken during the height of the Great Depression. *University of North Carolina Chapel Hill*

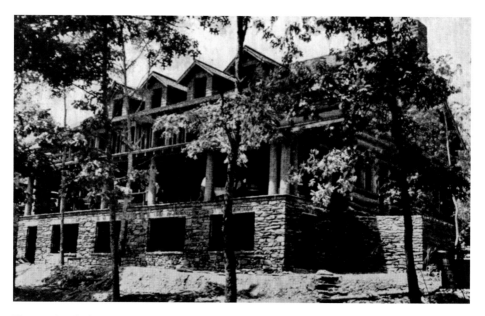

The completed Edward F. Worst Craft House at the Penland School of Handicrafts [now Penland School of Crafts], located near Burnsville, in the heart of North Carolina's Blue Ridge Mountains, was just completed when Bayard Morgan Wootten took this photograph of the building. *University of North Carolina Chapel Hill*

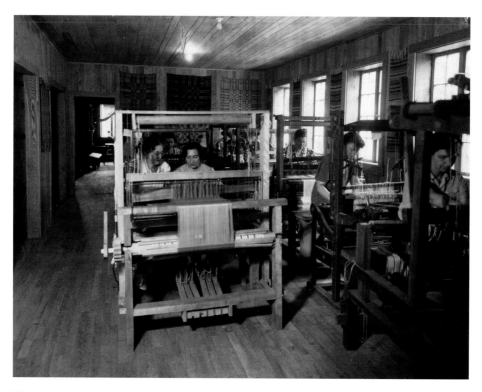

Weaving students took instruction from Lucy Morgan (shown left, first loom) in the Pittsburgh Room of Penland's Edward F. Worst Crafts House, built in 1935 as a national laboratory of weaving. This picture was taken by Bayard Morgan Wootten shortly after that opening. *University of North Carolina Chapel Hill*

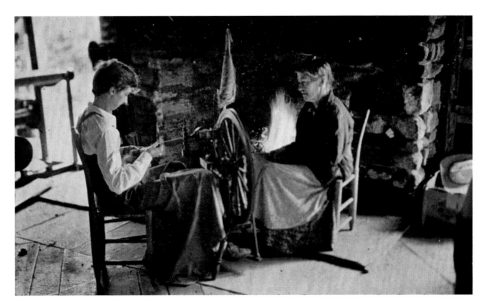

This postcard depicts two women spinning flax in front of the fireplace in the newly constructed Edward F. Worst Craft House adjacent to the campus of the Penland School of Handicrafts in Penland, North Carolina, in or about 1935. The older woman seated to the right is Harriet "Aunt Harriet" Conley (1855-1940), a western North Carolina native who taught flax spinning at the school during the 1930s. The woman seated on the left is either Harriet Byram Turnball (1900 – 1992) or Janet Duncan Turnball (1903 – 1985), sisters from Casanova, located in Fauquier County, Virginia, who were students in Penland's summer weaving institutes. The photograph for this postcard was taken by Bayard Wootten. From 1923 to 1938 the Appalachian school served as the umbrella institution under which the Penland weavers and potters were organized and the Penland School of Handicrafts [now Penland School of Crafts] was established. *University of North Carolina Chapel Hill*

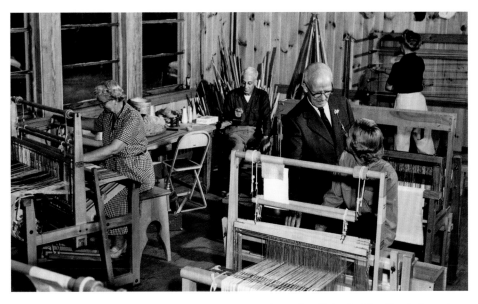

Sebastian C. Sommer took this photograph of weaving at the Penland School of Handicrafts in or about 1960. *University of North Carolina Chapel Hill*

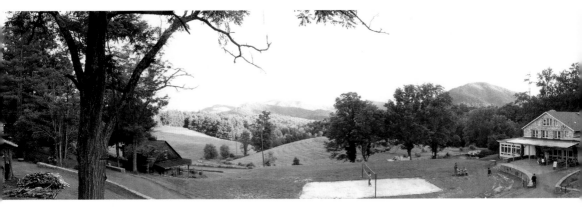

Today, Penland School of Crafts is the largest and oldest professional crafts school in the United States. The school offers courses in all of the major craft media and many fine arts fields, bringing thousands of students and prominent instructors together every year. Nine of North Carolina's seventeen Living Treasures live within a five-mile radius of Penland. This panoramic photograph of the Penland School of Crafts was taken on July 15, 2009. *Ungenda*[135]

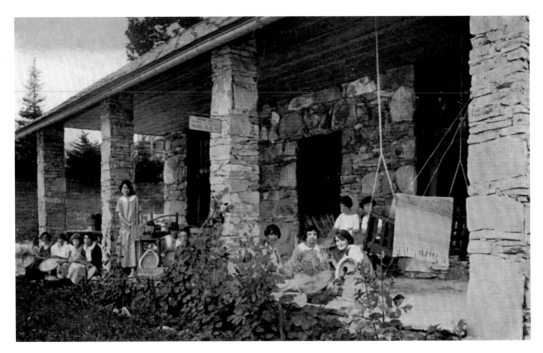

Lees–McRae College was founded in Banner Elk, Avery County, as an all-female high school in 1899 by Reverend Edgar Tufts (1869 – 1923), a Presbyterian minister and educator. In 1900, he named the school the Elizabeth McRae Institute after a well-respected teacher. School benefactor Suzanna Lees' name was added in 1903 and the institution's name became the Lees-McRae Institute when was chartered by the state in 1907. An all-male branch was founded during 1907 in Plumtree, North Carolina. The Plumtree facility was destroyed in a 1927 fire, leading the two campuses to merge at the Banner Elk site. After the merger, the high school program was phased out and the institute was renamed in 1931 to Lees–McRae College, an accredited, coeducational junior college. The Southern Association of Colleges and Schools granted Lees-McRae status as a four-year college in 1990. The photograph on this white border postcard was taken of a basketry class being taught at the Lees-McRae Institute in or about 1925. *University of North Carolina Chapel Hill*

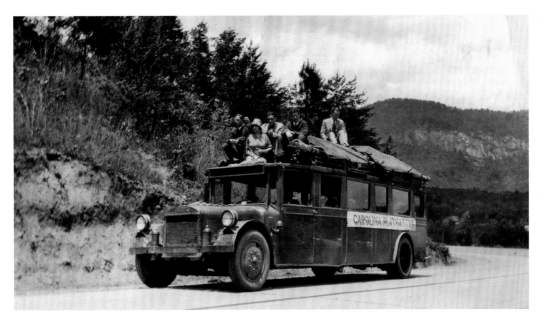

The Carolina Playmakers, the theater company in residence at the University of North Carolina at Chapel Hill, were on their seventeenth tour, this one in the western North Carolina and Virginia mountains, when this picture was taken in May 1927. The Playmakers began touring North Carolina in 1922 and had expanded to Virginia by the time the picture was taken. According to the company's history, a number of successful writers and actors honed their craft in the Playmakers, including novelist Thomas Wolfe (1900 – 1938), who wrote and acted in several plays as a University of North Carolina student. There was also Betty Wehner Smith (1896 – 1972), who would later write *A Tree Grows in Brooklyn* from her Chapel Hill home, who first came to Chapel Hill in 1936 as part of the WPA Federal Theater Project, and wrote many plays for the company. In the late 1940s, of course, there was actor Andy Griffith (1926 – 2012), another Chapel Hill graduate who had featured roles in several Playmakers performances. Other writers associated with the Playmakers were Paul Eliot Green (1894 – 1981), Josefina Niggli (1910 – 1983), Kermit Hunter (1910 – 2001), Margaret Bland (1898 – 1996), John Patric (1902 – 1985) and Jonathan Worth Daniels (1902 – 1981). *University of North Carolina Chapel Hill*

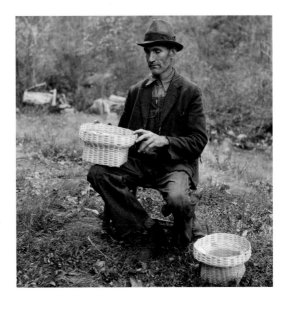

John Taylor Nicholson (1894 – 1961), of Nicholson Hollow, in what is today Virginia's Shenandoah National Park, is shown with some of his baskets in this Arthur Rothstein (1915 – 1985) photograph published in October 1935. Nicholson and Charles Washington "Buck" Corbin were gifted basket weavers and continued to make them even after they left the hollows. *Library of Congress*

The Nicholson Hollow mountain people made and sold their baskets to tourists, putting them up on the fence posts near the closest roadside. Arthur Rothstein took these pictures of some of the baskets out for sale. The picture was published in October 1935 as part of Rothstein's collection of photographs from his trip to the Virginia mountains. *Library of Congress*

Opposite above: The son of a Corbin Hollow squatter is shown in the doorway of a cabin with his guitar. The picture was taken in the fall of 1935 by Arthur Rothstein. Residents of Corbin Hollow were relocated during the Great Depression when Shenandoah National Park was developed from more than three thousand tracts of land, purchased and condemned by the commonwealth of Virginia and ceded to the federal government. *Library of Congress*

Above: James Martin Brinegar (1856–1925) and his young bride, the former Mary Caroline Joines (1861–1942), settled on the property shown here in or about 1880. The site of their homestead was on a tract at an elevation of 3,500 feet in the Blue Ridge Mountains of Alleghany County, North Carolina, today located at Milepost 238.5 on the Blue Ridge Parkway. Construction of the cabin and several outbuildings took Martin Brinegar five years to complete. Remarkably, it is known that except for placing of the heavy logs of the cabin, he did all of the work himself. In addition to farming, Martin was a cobbler. He attended and was clerk of the Pleasant Grove Baptist Church. Martin died in 1925, and Caroline continued to live on the property for a decade until it was purchased by the state of North Carolina, which conveyed it to the National Park Service in 1937. This picture of the rear elevation of the cabin was taken during documentation of the structures on the Brinegar property, to include survey work completed in October 1941 and measured drawings that were not finished until after World War II in April 1947. *Library of Congress*

The site of the Brinegar Cabin was so remote that fifty-five years later, when the Blue Ridge Parkway was started, there was no road to the homesite. The nearest outlet was a half-mile away. When Caroline Joines Brinegar was first approached about selling her land for the parkway, she just laughed, according to the May 27, 1959 report of Edward H. Abbuehl, supervising National Park Service landscape architect, and said it was not possible for modern road to go right in front of her door where there had not been a road all those years. In this cabin, Caroline wove cloth for the family on an old four-poster loom, similar to the one later used to demonstrate the technique for parkway visitors. The storehouse on the property (shown here) was photographed from the rear view during the National Park Service's documentation of the Brinegar property. *Library of Congress*

Brinegar Cabin is typical of pioneer mountain dwellings found in the Blue Ridge. It is a surviving trace of a culture that lasted a century or more, little changed, until roads and automobiles brought the twentieth century to "their front door." When Edward Abbuehl wrote his report, he observed just then that "the homespun arts and manners of the mountaineer are disappearing from the scene." Like the cabin, the storehouse (viewed from the east elevation and shown here) harked to a time and place that is now relegated to history. *Library of Congress*

Four decades after the Penland School of Handicrafts was established, students from all over the world traveled to it to learn the various textile techniques. In this photograph, Leila Mae Cox Woody (third from the left) (1909 – 1975) showed and explained her coverlet to Penland's foreign students. Woody wove the coverlet from looper clips, a waste product from the hosiery mills. *University of North Carolina Chapel Hill*

The Parkway Playhouse, located in Burnsville, Yancey County, North Carolina, is the oldest continually operated summer theater in North Carolina. Located near the parkway in one of its most beautiful and curviest sections, it was established in 1947 by William Raymond Taylor Ph.D. (1895 – 1976), a professor of drama at Woman's College of Greensboro, now the University of North Carolina Greensboro. *Continued on next page.*

Continued from previous page: The Parkway Playhouse was operated for many years as a summer stock venue and a sponsored extension of the drama departments at the University of North Carolina Greensboro and the University of Miami. In the 1990s the Parkway Playhouse became an independent theater company, and is now operated as a small professional theater company serving the mountain region of western North Carolina. The playhouse's mission is to tell stories that reflect how the people in the community in and around Burnsville, Yancey County, and in a larger sense, the people who live in western North Carolina and the parkway, live. The playhouse is shown in this photograph, taken shortly after it opened. *University of North Carolina Chapel Hill*

 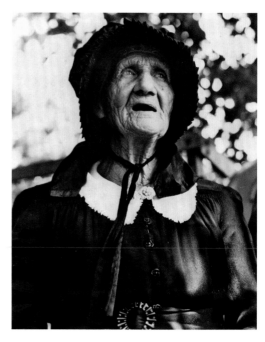

Above left: Joe Larkin "Uncle Joe" Hartley, of Linville, North Carolina, founder and chairman of "Singing on the Mountain," an all-day gospel singalong and fellowship held at MacRae Meadows at Grandfather Mountain, welcomed thousands on June 27, 1965, for some old-time religion. The ninety-four-year-old mountaineer started the gathering in 1924 and it has continued to present. Hartley started the event – held the fourth Sunday in June – as a family reunion of his parents' families attended by one hundred and fifty people. He was born on September 29, 1870, in Blue Ridge, Watauga County, North Carolina, to Elbert Joshua and Nancy Cook Hartley. Eight months after this picture was taken, Hartley died on February 28, 1966. According to his obituary in the *Winston-Salem Journal*, Hartley was "a farmer, a fire warden, and a philosopher." *Amy Waters Yarsinske*

Above right: The memory of "those old black-bonneted women"[136] who preached and sang at the "Singing on the Mountain" stayed with event founder Joe Larkin Hartley. In this photograph, taken on August 29, 1946, elder songstress Rebecca Sophronia "Aunt Becky" Tester (1855 – 1954), of Sugar Grove, Watauga County, North Carolina, joined in with the rest in singing the old religious favorites of the mountains. At age ninety-one, she and others reprised old gospel songs, forgotten by the books. Over 20,000 people were attending "The Sing" by that time. She was the daughter of Jacob Sands and Myra Norris Cook, and the wife of Benjamin Franklin Tester (1853 – 1905). *Amy Waters Yarsinske*

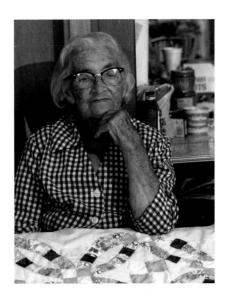

Bertha Atkins Marion (1904 – 1981) was working on her double wedding ring quilt when photographer Terry Eiler took this picture on August 1, 1978, at her home in Galax, Virginia, the gateway to the Blue Ridge Parkway. *Library of Congress*

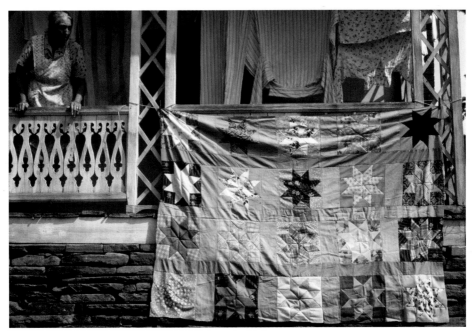

Carrie Miller Severt (1912 – 2002) (left), the wife of Edd Raymond Severt (1909 – 1988), was photographed on September 1, 1978, by Lyntha Scott Eiler, who took many pictures of Severt's quilts, to include her star quilt, attached to the porch rail to show her fine handiwork. The Severts' home was located in Ennice, an unincorporated community on North Carolina Highway 18 [N.C. 18], a little over seven-and-a-half miles east-northeast of Sparta, in Alleghany County, North Carolina. The couple, who raised cattle on the farm they rented just then, told Eiler they liked their one-hundred-year-old house, including the hand-dressed lumber in the ceiling. The Severts, both raised in Ashe County, also produced, like so many Blue Ridge families, most of the food they consumed. They walked long distances, they told Eiler, to the old Boggs schoolhouse there, usually going barefoot until Thanksgiving "when Daddy sold his turkeys." But they also had fun. Edd Severt told Eiler that during the winter they went sledding on homemade locust runners. "We was crackjacks then," he chuckled. Carrie Severt died at the age of ninety. *Library of Congress*

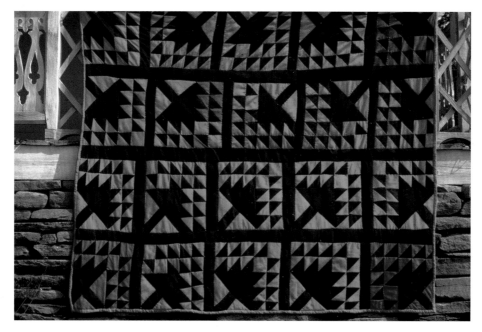

Carrie Miller Severt was a master quilter and it was, as she told Lyntha Eiler, her favorite pastime. "I'd just as soon quilt as to eat and I ain't kidding," she said then. Severt started quilting after Christmas and continued until the gardening season began in April. One winter she and her daughter pieced forty quilt tops, including some of her favorite patterns: the Wheel, the Lone Star, and the Tree. She used blankets from the Chatham Blanket Factory as the filler and once, she told Eiler, her daughter sewed together tiny tobacco sacks to make a quilt lining. Most of the excess quilt tops she shared with the needy or with her family. Hung from her front porch railing for Lyntha Scott Eiler to photograph on September 1, 1978, was Severt's pine tree quilt with its dramatic red and blue pattern, and her double X quilt, complex and beautiful just the same. *Library of Congress*

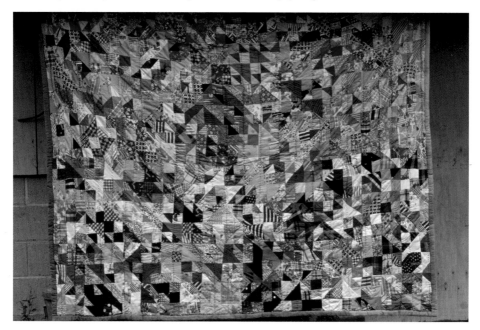

Litha Lowe (1902 – 1987) was photographed on September 1, 1978, by Lyntha Scott Eiler as she pieced a quilt top at her Franklin, Surry County, North Carolina home. Franklin is a small unincorporated community in the county's Mounty Surry Township, located on the outskirts of the city of Mounty Airy. Lowe also made the quilt and quilted pillows shown left of the bed in the second photograph. *Library of Congress*

Crystal Williams Cruise (1910 – 1999) was photographed piecing a flower garden quilt on September 6, 1978. Geraldine Niva Johnson (1940 – 2016) took this and other photographs of Cruise at her home in the unincorporated southwest Virginia community of Vesta, located in Patrick County on U.S. Route 58, seven-and-a-half miles northwest of Stuart. This area of Virginia is known as the Blue Ridge Highlands. *Library of Congress*

Mamie Lee Joyner Bryan (1898 – 1994), of Sparta, Alleghany County, North Carolina, showed her quilts to documentarian Geraldine "Gerri" Niven Johnson. Lyntha Scott Eiler took the picture on September 10, 1978. *Library of Congress*

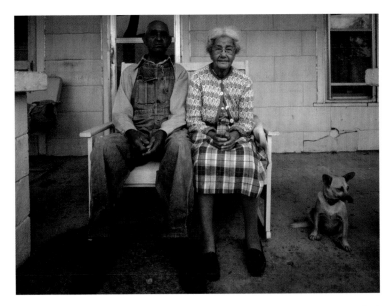

During Geraldine Johnson's Sparta, North Carolina visit, Terry Eiler photographed Mamie Bryan and husband Leonard Lucio Bryan (1888 – 1985) on the porch of their home. Johnson discovered, in the search to document fabric-based crafts of the Blue Ridge Parkway area, that there were far more quilts than rugs in the homes she visited. Project folklorists discovered many exquisite examples of them, just a few of which are shown herein, to include those pieced and sewn together by Mamie Bryan. *Library of Congress*

Terry Eiler took this picture of a Meadows of Dan Baptist Church quilting group on September 16, 1978. [Left to right] Edna Eunice Yeatts McAlexander (1909 – 1990), Lora Ruth King (1904 – 2001) and Crystal Williams Cruise are shown working on the side of the quilt frame. The church, organized in 1855 and located in Meadows of Dan, an unincorporated community in Patrick County where the Blue Ridge Parkway crosses U.S. Route 58, was destroyed by fire on March 5, 2015. *Library of Congress*

Ila Frances Hale Patton (1905–2001) was photographed by Geraldine Niva Johnson in front of her nine-patch quilt on September 23, 1978. *Library of Congress*

The Galax, Virginia home of Ila Frances Hale Patton is shown in this Geraldine Niva Johnson photograph also taken on September 23, 1978. *Library of Congress*

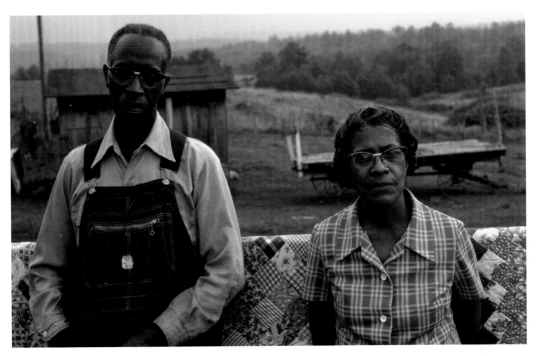

Sabe (1910–1989) and Donna Choate (1908–1986) were photographed in front of a quilt she made, shown here draped on a fence. The picture was taken at their home in Cherry Lane, Alleghany County, North Carolina, taken on September 25, 1978 by photographer Geraldine Niva Johnson. *Library of Congress*

The Cherry Lane, North Carolina home of the Choates is shown in this September 25, 1978 picture, taken by Gerrie Johnson. *Library of Congress*

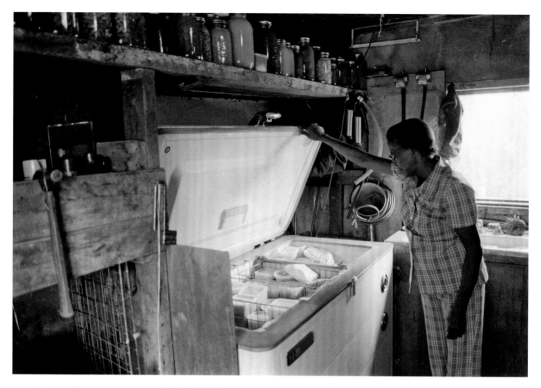

Donna Choate was photographed by Geraldine Niva Johnson looking over her canned and frozen foods, one of a series of photographs taken of Choate during Johnson's visit on September 25, 1978. *Library of Congress*

OPPOSITE PAGE:

Maggie Cochran Shockley (1913 – 2011), a prolific quilter from Hillsville, Virginia, told documentarian Geraldine Niva Johnson that her mother, Sybilla Vashti Cochran (1883 – 1988), had made thousands of quilts and quilt tops. "She quilted for everyone in the neighborhood." From Johnson's notes, Shockley learned to quilt as a child and went on to make numerous quilts for her family in addition to selling quilt tops at a local flea market. She spoke extensively in the interview about her mother and remarked that she also had her mother's collection of quilt blocks. Though not addressed in the interview, these blocks probably served as a reference collection, to remind the maker of how the block went together. This interview was particularly interesting for Shockley's detailed memory of the activities of an earlier quilting generation and because of her poignant comments about her realization that quilts were her mother's legacy. Among Shockley's prized pieces was this Kansas trouble quilt. The photograph of Shockley and the quilt were taken by Johnson on September 28, 1978. The town of Hillsville is the county seat of Carroll County, which is bisected by the Blue Ridge Parkway. *Library of Congress*

"You know, I've never done any of the, of the fancier quilting," Maggie Shockley told Gerri Johnson. "By the piece, by whatever pattern the quilt is pieced. The fact is, I think most of us mountain people always quilted, that, that was the type of quilting that most of the people around did, was just the fan, or the diagonal, or quilted it by the block rather than, I know, in late years, you know, since quilting has become quite a fad, that, a lot of it is done more or less with the fancy scrolls and so on." Johnson also took this photograph of Maggie Shockley's carpenter's wheel (left) and sunflower quilts. *Library of Congress*

A seated portrait of Lura Elizabeth Branscome Stanley (1906 – 1984) was taken by Geraldine Niva Johnson in the backyard of Stanley's Laurel Fork, Virginia home on September 28, 1978. Stanley grew up on a farm and learned to quilt as a child, worked as a school teacher and at the time she was interviewed by Johnson, was making quilts for herself and her family. Laurel Fork is an unincorporated community in Carroll County in southwest Virginia, located on U.S. Route 58 in the Blue Ridge Highlands. Johnson described Stanley's quilts as "truly exquisite." *Library of Congress*

This magnificent crazy quilt photographed by Terry Eiler on September 28, 1978, was purchased by Lura Stanley at an auction. Of this quilt and another of the same type in her collection, Stanley explained that they were pieced out of dress material. "I'd say, back in the early nineteen hundreds or before then." She told Johnson that the maker of the quilt used old material and then added the beautifully wrought embroidered elements. *Library of Congress*

Gerri Johnson (right) chatted with Lura Stanley while Terry Eiler photographed Stanley's quilts in background. The picture was taken on September 28, 1978, by Lyntha Scott Eiler. "I would not sell a quilt," Stanley told Johnson just then. "I don't have any desire to. I give my quilts. [There's] too much time and effort put in a quilt for met to sell it. I'd have to have more than people would give for my quilts. They're large. They're large enough for spreads and there's so much time in 'em that I don't think people would pay me what I'd have to have for my quilts. So, I just give them." *Library of Congress*

When asked by Gerri Johnson what time of year she preferred to quilt, Lura Stanley responded: "Quilt in the wintertime. I never quilt in the summertime. I, I like to garden, and travel, and do different [things]. I'm an outdoors person. And so, I don't quilt in the summer. Winter, when you have to stay in, when the roads are bad and the weather's bad. That's when I do, do my quilting." Stanley made this drunkard's path quilt, also photographed by Johnson during her September 28, 1978 visit. *Library of Congress*

Arthel Lane "Doc" Watson[137], legendary guitarist, songwriter and singer of bluegrass, folk, country, blues and gospel music player, was born on March 3, 1923, in Deep Gap, the unincorporated little community off the Blue Ridge Parkway in Watauga County, where he lived until his death at age eighty-nine on May 29, 2012. According to Watson's 2002 three-compact disc biographical recording *Legacy* (High Windy Audio), he got his famous nickname during a live radio broadcast when the announcer remarked that his given name Arthel was odd and he needed a name easier on the ear. A fan in the crowd shouted "Call him Doc!" presumably in reference to the literary character Sherlock Holmes' sidekick Doctor Watson. The name stuck. Watson, who lost his sight to an eye infection before his first birthday, is shown here at the North Carolina Folk Heritage Awards, held in Raleigh, North Carolina, in 1994. *State Archives of North Carolina*

V

MAGNIFICENT MOUNT MITCHELL

The North Carolina Division of Parks and Recreation backstory of the Black Mountains that serve as the setting for magnificent Mount Mitchell informs that they were formed more than a billion years ago. This mighty range of peaks once stood lofty and rugged. But over millions of years, wind, water and other forces wore down the pinnacles to their rounded, more subdued profile of today. Only the erosion-resistant igneous and metamorphic rocks allowed Mount Mitchell to retain its dramatic height of 6,684 feet. Due to the relatively even elevation of its ridgeline, the Black Mountain range was referred to as a single mountain until the late 1850s. Of the separate peaks that have since been designated, six are among the ten highest in the eastern United States. Although the Black Mountain range is higher, its length and breadth do not equal that of the nearby Blue Ridge or Great Smoky mountains. From the air, the range bears the shape of the letter J, and the distance between its end points—Yeates Knob and Celo Knob—is just fifteen miles. Of note, the climate of the Black Mountains is more like that of Canada than North Carolina. Extremely cold temperatures during the Pleistocene Era allowed the plants and animals of more northern latitudes to extend their ranges to the south, but as warmer climates returned, these cold-adapted species became restricted to the highest peaks and thus many of the plants and animals of Mount Mitchell are much like those native to more northern alpine environments.[138]

Long before explorers left Europe in search of the New World, various Native American tribes inhabited the area surrounding the Black Mountains. In the mid-eighteenth century, the tribes were joined by settlers primarily of Scots-Irish and English origin. According to the North Carolina parks system, French botanist Andre Michaux journeyed to the Black Mountains in 1787 to seek the region's most valuable plants so the French government could cultivate them on their royal plantations. On his botanical excursions to the area, Michaux collected more than 2,500 specimens of trees, shrubs and other plants. About the same

time that his French counterpart explored the area, Scotsman John Fraser collected plants from the region to introduce to his native land and it was for this botanical explorer that the most abundant tree along the crest of the Black Mountains—the Fraser fir—was named. Though botany was the first discipline to be explored in the Black Mountains, it was physical geography, particularly the measuring of mountains, that had the greatest impact on the history of Mount Mitchell, previously known as Black Dome, for its rounded shape. Elisha Mitchell D.D., a science professor at the University of North Carolina, made an excursion to the area in 1835 to measure the mountain elevations. Grandfather Mountain was, just then, assumed to be the highest point in the region, but previous trips to the area had persuaded Mitchell that the Black Mountains were higher. Through the use of barometric pressure readings and mathematical formulas, Mitchell figured the highest elevation of the range to be 6,476 feet, higher than that of Grandfather Mountain. Subsequent visits to the Black Mountains in 1838 and 1844 led Mitchell to calculate the height of the peak at 6,672 feet—amazingly, only a mere 12 feet in error of modern calculations. When controversy arose about which peak in the range was the highest again nearly two decades later, Thomas Lanier Clingman (1812 – 1897), a former student of Mitchell's, and a United States senator, set the elevation of the highest peak at 6,941 feet and insisted that Mitchell had measured another peak. Mitchell returned to the Black Mountains in 1857 to verify his measurements and to support his claim. While hiking across the mountain, he fell from a cliff above a purported forty-foot waterfall. Knocked unconscious by the fall, Mitchell drowned in the water below. In honor of his work, the highest peak in the Black Mountain range was given his name a year later. Though originally buried in Asheville, Mitchell's body was reburied atop Mount Mitchell in 1859.[139]

Mitchell had died trying to make his way around unchartered trails on the mountain. Eugene Alby, a Winston-Salem resident, described in a letter published in a September 6, 1860 Asheville newspaper and preserved in a scrapbook of the late colonel, lawyer and pioneering community leader Virgil Stuart "Tollie" Lusk (1836 – 1929), of Asheville, host of the outing: "At the solicitation of friends, I will ask a short space in the columns of your paper to give an account of a recent trip to Mitchell's Peak. On Tuesday, August 31 [1860], we accepted the kind invitation of Colonel V. S. Lusk and his most inimitable lady to accompany them on a trip to the Black Mountains, of which Mitchell is the highest. It being the most elevated point east of the Rocky Mountains causes it to bear quite an historical name. Our party consisted," he continued, "of the Colonel and lady, Miss Maude Brent, of Greensboro, and Miss Addie Holman, of Lancaster, Massachusetts. None of us had ever visited the Black Mountains and, of course, all were wild with anticipated pleasure."[140] Alby described leaving Asheville at an early hour in a two-horse wagon driven by Joe "Old Black Joe" Penland, holding the reins. "We were soon speeding up the beautiful valley of the Swannanoa. Coming to a beautiful spring on the roadside, twelve miles from our starting point, we alighted to partake our dinner [...]." The trip was halted by heavy rains twelve miles short of their destination, Alby's party waited until that Friday, when sunshine got them on their way again. William Glass, with thirty years' experience guiding travelers over the rugged heights, gave Alby confidence they would reach the summit of Mount Mitchell without incident. "Onward we

journeyed through wild and dense forest, deep and dark ravines, where to all appearances, save the narrow path, had never been trodden by the foot of man. Sometimes," he observed, "perched upon the edge of the precipices, we could gaze down into distances seemingly immeasurable. We reached the mountain house where in former years lived Mr. William Patton[141], but who has long since passed to his final accounting; the house has decayed and fallen in and scarcely any sign of it remains. Here we rested and gathered ferns while our mules grazed. Once more in the saddle," he wrote, "our cavalcade moved on to Clingman's Park [Dome], named in honor of General Thomas L[anier] Clingman[142]. Reaching the summit, we dismounted and climbed to a huge stone which lifts itself full ten feet from the earth, and found the height, 6,597 feet, cut into the granite."[143]

Alby's party was two miles from Mitchell's Peak with some of the most difficult terrain yet to cover. "[W]e were compelled to travel slowly and cautiously. Here we came to a timber altogether unknown except upon the highest peaks of the Black Mountains, known as balsam. It somewhat resembles our pine, but is more hardy and is the only tree that will resist the intense cold of the peak. It grows," he noted, "very thick and the branches crowding so closely to the ground, it appears as if it were almost impenetrable, even by the smallest of animals." The group arrived safely at the top of the peak and to all of them it was "a sight of which for grandeur and sublimity has never been excelled. We stood by the grave of the lamented Professor Mitchell, who gave his life for his state while proving that within the bounds of old Carolina lay the highest peak east of the Rocky Mountains, and well did he establish this fact, winning for the mountains of the old North State a worldwide name."[144] Alby clarified that it was Mitchell's students in Asheville who carried his body to the top, where they laid away his ashes to repose in peace. "No one can stand upon that mountain top," he observed, "[...] and gaze out upon the broad expanse of hills and vales without a feeling of awe. The scene is too grand and sublime for description."

Until the end of the nineteenth century the Black Mountains remained largely in a wilderness state and certainly difficult to access. The only apparent influence of man upon the environment was a reduced animal population caused by increased settlement and hunting. This lack of exploitation of natural resources did not last. By the early twentieth century, extensive logging operations had denuded much of the Black Mountain range. Logging activity had expanded rapidly by 1913 and citizens began to voice their alarm about the destruction of the forest. At the third annual convention of the North Carolina Forestry Association, held in Raleigh on January 16, 1913, a resolution was adopted requesting the state legislature pass a bill to make a state park and demonstration forest area including the top of Mount Mitchell. A bill was introduced into the North Carolina General Assembly, then in session, by state senator Zebulon Vance of Buncombe County, but it failed to pass. The so-called development of the spruce and balsam forests in the Black Mountains of Yancey County had been started in 1912 and by the summer of 1914 the desolation caused by lumbering followed by fire had reached the slopes of Mount Mitchell.

In the early summer of 1914, an exceptionally destructive fire occurred, taking with it many acres of live timber in what is now part of Mount Mitchell State Park. The forester of the North Carolina Geological and Economic Survey, precursor of the North Carolina Division

of Parks and Recreation, was requested to investigate, which was done. That summer, Locke Craig, governor of North Carolina from 1913 to 1917, accepted an invitation from the lumber company to take a trip over their logging railroad. Craig was shocked by the destruction that was taking place and from what he saw that day, determined going forward that at least some of the remaining virgin forest must be saved. "After these balsams are mowed down and the trunks removed, everything is cut away down to four inches, and the ground is left covered with a thick mat of leaves and moss, which gets to be so inflammable that anything will light it," Craig told the forestry convention that followed his trip. "Fire started in this material burns up everything; all the little trees that happen to be left are destroyed; even animals get burned. Nothing can escape in one of these fires, and where they have burned there is no more sign of life than there is on that table." Craig later provided this summary of his trip: "Last year I was invited up to celebrate the opening of the twenty-mile logging railroad from Black Mountain station to Mount Mitchell as a great enterprise. But when I looked all around," he opined, "where I had been bear hunting as a boy, and saw this vast desolation all below, I told them they had gotten the wrong man to come up and celebrate the opening of their railroad. I felt like a man that stood amidst the ruins of his home after the conflagration had destroyed it. I tell you," he iterated, "the lumbermen – I am not criticizing them, but us – the lumbermen are destroying North Carolina. We cannot expect them to sacrifice their business for the public good. They have bought that timber. They are entitled to every stick of it. If the people of North Carolina want to save it they must do so. They cannot expect the lumbermen to save it; they must save it themselves. They must save it from the fire that follows the lumberman."[145]

In 1912/3, a narrow-gauge railroad had been built to reach the spruce forests in Yancey County from the Black Mountain station, where a large sawmill was built. The line reached to within less than a mile of the top of Mount Mitchell. Roughly one thousand acres of spruce had already been cut for lumber while smaller trees were shipped out for pulp. Repeated fires had burned over these cut-over lands, often reaching nearby timber stands. Erosion of the hillsides had already begun. The Asheville Board of Trade summed up the situation very well in a resolution that members endorsed at the end of 1914 reiterating that recent lumbering operations had resulted in the cutting off of the magnificent spruce and balsam forests from a large area on Clingman's Peak and such operations had now been extended to the slopes of Mount Mitchell, which operations included the cutting off of all spruce and balsam down to four inches in diameter, denuding the entire surface of the mountain's sides, which cutover area was then subject to forest fires and the wash of the heavy mountain rains. The board of trade noted that the slopes of Mount Mitchell and other nearby peaks "are the sources of streams which affect the conditions and life of hundreds of thousands of people living along the valleys."[146] The Asheville Board of Trade requested the governor and the legislature, in the upcoming session, take up protection of Mount Mitchell and surrounding mountain peaks to conserve these treasured resources for the people of North Carolina. This callout was followed by Craig's remarks to the North Carolina Forestry Association on January 13, 1915, and as the result of the governor sounding the alarm, state senator and later congressman Zebulon Weaver[147](1872 – 1948) again introduced a bill into the legislature

in 1915, and with the strong backing of Craig, the state geological and economic survey, the North Carolina Forestry Association, the Asheville Board of Trade and many influential individuals, the bill was enacted providing for appointment of a commission to acquire the land, and an appropriation of $20,000 to pay for the land.

While state government and civic organizations moved to acquire and protect Mount Mitchell and surrounding peaks and forests, Neptune Uranus Buckner (1873 – 1944), the Asheville Board of Trade's secretary, who had done more than anyone up to that time to raise the public awareness to preservation of the forests also made it clear that there had been other problems up on Mount Mitchell. "A man is up on the mountain now making pictures of the ruins of the monument, erected to Dr. Mitchell, which was blown up with dynamite some time ago. He will also make pictures of the burnt over area and of the lumbering which is being done." Buckner considered the forest fires and lumbering "a crime against the people of the Eastern section of the United States." In addressing various views of the destroyed monument to Dr. Mitchell, and the scenes of the fire-swept cutover areas on Clingman's Peak and Mount Mitchell, Buckner offered that they stood to tell the story "better than any tongue or pen."[148]

When Mount Mitchell State Park was established by the North Carolina legislature on March 3, 1915, it became North Carolina's first state park and in its creation, also established the North Carolina State Parks system in the same legislation. On March 31, 1915, Governor Locke Craig announced the appointment of the following men to the Mitchell Peak Park Commission: Thomas Edgar Blackstock (1878 – 1939), a lumberman, of Asheville, Buncombe County; Gaston Penley Deyton (1857 – 1925), a teacher and farmer, of Green Mountain, Yancey County; Elbert Franklin Watson (1868 – 1961), a lawyer, of Burnsville, Yancey County; Murray Cornelius Arcemus Honeycutt (1869 – 1936), farmer, banker and sheriff, also of Burnsville, and Wilson McWilliam Hensley (1839 – 1919), a farmer, of Bald Creek, Yancey County. At the commission's first meeting, held at Burnsville on April 10, 1915, Blackstock was elected chairman and Honeycutt, secretary. The commission acquired the first 524 acres, including the summit of Mount Mitchell, and reported its action to the governor. Another 700 acres of cut-over land all along the western and northern boundaries was also bought, bringing the total acreage up to 1,224 acres. Later, more land was acquired to reach the 1,996 acres of the present-day state park. Though Craig recommended to the general assembly in 1917 that it appoint a commission for the protection and management of the park, no such action was taken just then. Two years later, in 1919, the legislature did create the Mount Mitchell Park Commission to administer the park.

When the first North Carolina game refuge was opened on Mount Mitchell on November 1, 1927, the only wildlife that could be found within the 16,000-acre boundary were a few bears, wildcats, hawks, owls, snakes and kingfishers. There were a small number of game fowl, and the streams were thinly populated with trout. In the state's effort to repopulate western North Carolina with game and fish, the department of conservation and development obtained the cooperation of officials of the Pisgah National Forest. Following the opening of the Mount Mitchell refuge, which included a game-breeding farm that got its start when part of the breeding stock from an earlier Asheboro breeding farm was moved there, the state

opened a second game refuge on Wayah Bald, a high-altitude treeless open area in Nantahala National Forest, near Franklin, Macon County, on February 1, 1928. This refuge began with a 10,000-acre boundary. The third refuge, Daniel Boone, in Avery and Caldwell counties, was opened on August 1, 1929, and contained 16,000 acres when it was first established. The hunting distances around the three refuges were Mount Mitchell, thirty-nine miles; Wayah Bald, twenty-four miles, and Daniel Boone, thirty-seven miles. In addition to the refuge proper, 272,000 acres of national forest land in Pisgah and Nantahala forests surrounding the three refuges were all public conservation and hunting grounds for the replenishment of game in the mountains.

These early mountain refuges – within their boundaries – included eighty-one miles of trout fishing waters, to include thirty-five miles in the Mount Mitchell refuge, thirty-seven in Daniel Boone and nine miles in Wayah Bald. A hatchery on Mount Mitchell had a capacity of 400,000 rainbow and speckled trout fingerlings. The refuge was only open four days a month during the regular fishing season. In an undated early press report on the state of wildlife, published a handful of years after the first refuge opened, Superintendent Curnel Nelson Mease (1893 – 1972) observed that there were believed to be 600 deer, 12 elk, 60 bears, 800 opossums, 100 minks, 60 muskrats, 40 wild turkeys, 1,500 ruffed grouse, 500 quail, 150 pheasants, 900 raccoons and 1,600 squirrels, including boomers [red squirrels], in the refuges. "The wild turkey at present are all on the Wayah Bald refuge," Mease offered, "but the next project of the department is to start a wild turkey ranch on the Mount Mitchell refuge to raise wild turkeys to ship to all parts of the state. Raising wild turkey is not very easy; the birds show too much tendency to become tame." Other animals present included groundhogs [whistle pigs], small skunks [civet cats], and several species of mice and rats. An occasional report of a panther in the surrounding area informed wardens at that time that there was the distinct possibility that they were active in the Mount Mitchell reserve. Rough grouse [pheasants] and the Carolina junco [snow bird] were found present in the park while robins, wrens and song sparrows were just summer inhabitants. Two species of owls were heard at night. Of note, it was observed that there were no beaver colonies on the Mount Mitchell refuge when the state first opened it but a pair was released there during the first years of its development. After that release the rangers lost track of the beaver pair. Superintendent Mease and the seven rangers in his employ could also not track the other wildlife in the refuges at that time. "We have only a single strand of wire around the refuges so there is no impediment at all to the animals if they stray," he noted. "Of course, that is the eventual object of the whole program, to have a constant new supply of game filtering from the refuges into the whole mountain country."

Mount Mitchell State Park benefitted in several ways from the Blue Ridge Parkway and from federal work programs initiated by President Roosevelt in the 1930s. First, much of the initial park development was done by the Civilian Conservation Corps (CCC). CCC workers planted seedlings and built trails, a water system, fire breaks, and a concession stand. This work continued until the outbreak of the Second World War. Second, as sections of the Blue Ridge Parkway were completed, visitation in the region steadily increased. By 1946, the parkway's annual visitation had reached one million. Mount Mitchell, however, did not

begin to have large visitation growth until a public road was built from the parkway to the park. Accessing Mount Mitchell was made possible by improvement of the section of the old Mount Mitchell toll road [today's North Carolina Highway 128 (N.C. 128)] from the Blue Ridge Parkway [Milepost 355] on the border of Yancey and Buncombe counties. The road up to Mount Mitchell existed as a toll road on a 1936 county map and was given its current designation in or about 1947; North Carolina Highway 128 [N.C. 128] was designated part of the Mount Mitchell Scenic Drive, a fifty-two-mile byway from the Interstate 26 [I-26] exit 9 to the top of Mount Mitchell, via U.S. Highway 19 [U.S. 19], U.S. Highway 19 East [U.S. 19E], North Carolina Highway 80 [N.C. 80], and the Blue Ridge Parkway. Stanley Abbott, the first resident landscape architect and planner of the Blue Ridge Parkway and acting parkway superintendent just then, wrote to Romanus Getty Browning, senior locating and claim engineer for the North Carolina State Highway and Public Works Commission, on August 30, 1940, urging strongly further consideration of the Mount Mitchell vehicular approach from Balsam Gap. "I am sure," he wrote, "that for my part I would fight the construction of a highway up the face of Potato Knob, the face of which is very important as seen from the Parkway. I feel certain that we should never be able to erase the scar nor would we be forgiven for locating an approach to Mount Mitchell in this manner. I do not feel," Abbott continued, "that a location by way of Steppes Gap to Swannanoa Gap directly would be a great deal better, but at least it has possibilities of being far less objectionable." Abbott encouraged further a study of the Balsam Gap approach. "The side slopes being flatter here, less scar would result in our opinion, and of course the roadway would not be fully in sight from the Blue Ridge Parkway nor in turn the Parkway from it, which I consider an equally important consideration," he advised. Abbott copied Thomas Wallace Morse[149], superintendent of state parks, on his letter. Eight years later, in 1948, Morse wrote in his report summarizing the year's accomplishments: "Now that the connecting road between the park and the Blue Ridge Parkway has been completed, [Mount Mitchell State Park] has so far this summer received the heaviest attendance in its history. A new service has been provided for the public at this park with the opening of the refreshment stand near the top of the mountain."[150] Reaching an elevation of over 6,400 feet, it is the highest (of any) road or highway east of the Mississippi River. Before the improvements streamlined the trip, visitors from Asheville took U.S. Route 70 [U.S. 70] to the Curtis Creek [Forest Service] graveled road, two miles east of Old Fort, or continued to paved North Carolina Highway 104 [N.C. 104], which turned north toward the parkway, five miles west of Marion. These old scenic, public roads connected with the Blue Ridge Parkway at Big Laurel Gap and Buck Creek Gap, respectively. From these parkway intersections, motorists could travel westward along the parkway to Swannanoa Gap, where there was a new "free" road. Back in the early days of the parkway, the toll road to the mountain was still in operation.[151]

From today's Mount Mitchell parking area, visitors hike up to Mount Mitchell's summit [6,684 feet]. The grave of Elisha Mitchell, the University of North Carolina professor who first documented the mountain's height, is located at the base of the observation platform at the summit. The old observation deck was razed in early October 2006. The trail leading up to the summit has been paved and a new observation platform constructed and opened

to the public in January 2009. In addition to Mount Mitchell, the park also includes several other peaks that top out over 6,000 feet, including Mounts Hallback [6,391 feet]; Mount Craig [the second highest peak east of the Mississippi (6,647 feet)], named for Norfolk Carolina governor Craig; Big Tom [6,580 feet and named for Thomas Wilson, the guide who found Elisha Mitchell's body], and Balsam Cone [6,611 feet]. Another popular destination within the park, reachable by a hiking trail, is Camp Alice, located at an elevation of 5,800 feet south of the Mount Mitchell summit. This historic site is the location of a logging and, later, Civilian Conservation Corps (CCC) [NC-SP-2] tourist camp at the end of the old Mount Mitchell toll road. Lower Creek, one of the highest elevation perennial streams in the Appalachians, tracks across the main trail at this point, flowing through the spruce-fir forest.

This mid- to late-nineteenth century hand-colored print depicts travelers cooking their dinner outside a log cabin located on the summit of Mount Mitchell. *University of North Carolina Chapel Hill*

Elisha Mitchell D.D. was born in Litchfield County, Connecticut, on August 19, 1793. He graduated from Yale College in 1815 and was appointed professor of mathematics and natural philosophy at the University of North Carolina at Chapel Hill in 1817. Mitchell was married in 1819 and ordained by the Presbytery of Orange in 1821. Four years later, in 1825, Mitchell transferred to a professorship of chemistry, mineralogy and geology and was honored with a doctorate of divinity by the University of Alabama in 1840. Five years earlier, in 1835, he had been named bursar of the University of North Carolina at Chapel Hill. He died on June 27, 1857. By measurement, Mitchell established in 1835 and again in 1844 that "The Black" [also called Black Dome and later renamed Mount Mitchell] was the highest mountain in the United States east of the Rocky Mountains, being measured just then at 6,476 feet above sea level [it was later adjusted higher], and forty-eight feet higher than Mount Washington, New Hampshire. *University of North Carolina Chapel Hill*

The watch belonging to Elisha Mitchell, which broke during his fatal fall, shows the exact time of his death. The object, located in the North Carolina Collection, Wilson Special Collections Library, University of North Carolina at Chapel Hill, was photographed in 2012. *University of North Carolina Chapel Hill*

Above left: After making various surveys, Elisha Mitchell D.D. attempted to go down to Yancey County by himself along a familiar trail when a rainstorm and night overtook him. While passing a precipice and waterfall on Sugar Camp Creek, he lost his balance, went over the falls and eleven days after his departure for Yancey, he was found in the limpid pool below, in a state of perfect preservation, and was, by superhuman exertions, carried on men's shoulders up the mountain for three miles and then to Asheville, where he was first interred on July 10, 1857. Mitchell Falls, shown in this December 24, 1857 lithograph published by Oscar M. Lewis, of New York, was documented just then at forty-four feet in height, the pool below fourteen feet in depth. The figure (left) and highest up, is on the point where Mitchell lost his foothold and fell; the persons at the head of the falls represent those who searched for the body and those at the pool below, the men who were first to discover the body, which lay at the end of a fallen tree, standing (right) of the pool. Mitchell's "ghost" is shown standing in the foreground (left). Mitchell's tragic death occurred in furtherance of his research of the mountain that now bears his name. Of note, Mitchell Falls is actually just twenty-five feet high and in many historical narratives and depictions, it is misidentified or exaggerated in height [such is the case with the Lewis lithograph, which makes the waterfall appear higher and more foreboding than it is, even in his time, and has been accompanied by an inaccurate narrative]. *University of North Carolina Chapel Hill*

Above right: This late nineteenth century cabinet card featured an early view of Mount Mitchell. *University of North Carolina Chapel Hill*

After initial burial at Asheville, Elisha Mitchell D.D.'s family consented to reburial at the pinnacle of "The Black," shown in this late nineteenth century cabinet card. Commensurate with this reburial, a site was secured and funds raised to erect a suitable monument to Mitchell and his Christian faith. Mitchell wrote the following singularly prophetic words after a visit to the Black Mountain that now bears his name, either in reference to the spot where he lost his life or to another close by: "The ascent to the highest peak of the Black was the hardest day's work I ever performed! It was over one high mountain spur, and again into a deep valley, crawling through laurels, with two barometers, one a common mountain, and the other a Gay-Lussac's[152], in hand. And when about noon," he continued, "I passed under a high shelving rock, where the ground was bestrewn with clean dry leaves beneath, and a clear rushing stream close by, I could not help thinking what a comfortable place it would be to die in. When the necessary observations had been made, at four o'clock in the evening, and we began to descend, the clouds were gathering, and soon the rain poured down in torrents. We came to a tributary of Caney river, and my companions could find no better way of getting along, than that of springing from rock to rock along the channel of the stream." *University of North Carolina Chapel Hill*

Bear hunter and mountain man Thomas David "Big Tom" Wilson (1825–1908), (shown here) was the famous Black Mountains guide and Pensacola, Yancey County resident who found the body of Elisha Mitchell on July 7, 1857. Big Tom summit, located at 6,580 feet and near Mount Mitchell, is named for him. *University of North Carolina Chapel Hill*

On August 18, 1888, University of North Carolina alumni erected a twelve-foot obelisk at the gravesite of Elisha Mitchell D.D. on top of Mount Mitchell to honor his life's work. The first cabinet card shows the monument not too many years after it was erected. The second shows the monument after high winds toppled it onto Mitchell's gravesite in or about 1900. *University of North Carolina Chapel Hill*

This group of foragers is shown bringing galax out of the Blue Ridge Mountains near Mount Mitchell in Yancey County in or about 1910. Galax is a small, cool weather plant with remarkable broad, waxy, heart-shaped leaves that has been prized as a base plant in floral arrangements because the leaves hold their color for several weeks after being picked. The best – and largest leaf – tetraploid galax is found only along the Blue Ridge escarpment in the eastern range of the southern Appalachian chain. According to the September 26, 2012 *Smoky Mountain News*, the United States Fish and Wildlife Service estimated that as many as three billion galax leaves are harvested each year from this area and while some of this harvest is taken with a valid permit, much of it is illegally poached. The article also noted that North Carolina alone accounts for approximately ninety-nine percent of the national galax harvest. Around nine galax dealers in North Carolina dominate the trade, shipping most of what is harvested across the country and worldwide, from Japan to Holland. The *News* further documents that the Blue Ridge Parkway runs right along the escarpment, making the parkway a hotspot for galax poachers.[153]

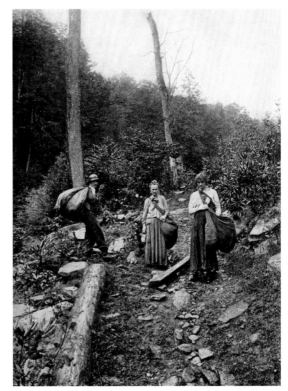

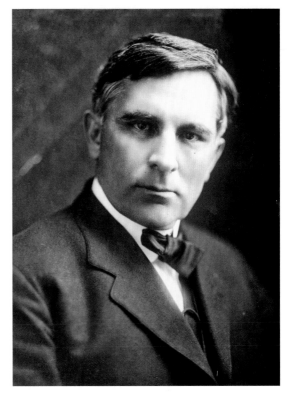

Locke Craig (1860 – 1924), the governor of North Carolina from 1913 to 1917, and instrumental in the creation of what became Mount Mitchell State Park, is shown in this Bain News Service photograph taken between 1910 and 1915. *Library of Congress*

This plaque, located at the summit of Mount Craig, altitude 6,663 feet [it is actually 6,647 feet], is dedicated to North Carolina governor Locke Craig. The photograph was taken on July 29, 2002. *State Archives of North Carolina*

State senator and later congressman Zebulon Weaver was the Buncombe County lawyer and politician who introduced the legislation in the North Carolina state senate that created Mount Mitchell State Park. The legislation, dated February 19, 1915, passed on March 3. *Library of Congress*

Opposite above: The original photograph from which this postcard was printed dated to in or about 1910 and had been black and white. The fifteen-foot-tall makeshift platform shown here, located at the top of Mount Mitchell, was precarious at best. The state of North Carolina later built a new covered wood platform (also shown herein) of roughly the same height after Mount Mitchell was designated a state park in 1915. *University of North Carolina Chapel Hill*

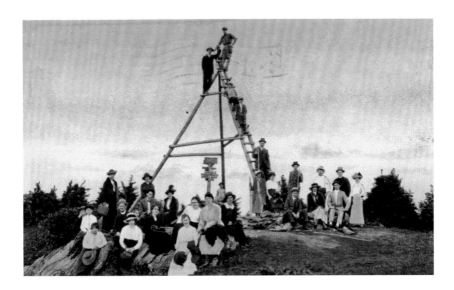

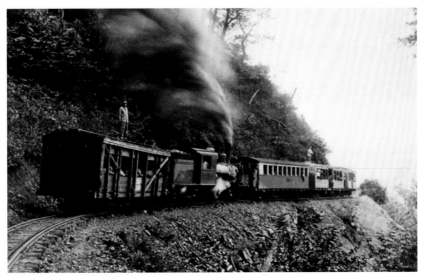

The Mount Mitchell Railroad, opened in the Black Mountains for the purpose of logging and tourism, was fully operational just four years. Built between 1911 and 1914, it became one of the state of North Carolina's most popular tourist attractions. Sources inform that the narrow-gauge line was extended and improved by lumbermen Frederic "Fred" Allen Perley (1876–1955), also a civil engineer, and William Henry "Bert" Crockett (1864–1952), who bought out originators Dickey and Campbell Company, owned by Clarence A. Dickey and Joseph C. Campbell, on September 27, 1913. It originated near Black Mountain in the Swannanoa Valley and traveled over some twenty-one miles, ascending more than 3,500 feet to Camp Alice, just below Mount Mitchell's summit. Perley and Crockett intended that it be used to move spruce and other commercial timber but by 1914 the owners had built passenger cars to go up the mountain. With the help of Greater Western North Carolina Association tourism promoter Colonel Sanford Hopkins Cohen (1851–1925), the lumbermen opened the Mount Mitchell Railroad to passenger traffic in July 1915.[154] This photograph of the train was taken before passenger service was suspended in June 1919. From the time it opened for passenger traffic until service ended, Cohen was the general passenger agent for the Mount Mitchell Railroad. After it suspended service, he became the traffic manager of the Mount Mitchell Motor Road, a position he held until just before his death. *University of North Carolina Chapel Hill*

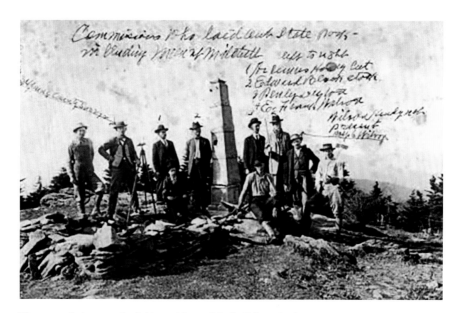

The commissioners who laid out Mount Mitchell State Park are shown in this 1915 period photograph (left to right): Troy Lyda Young (1895–1975), Joseph Young's son; Joseph Richmond Young (1856–1931), Yancey County surveyor; Murray Cornelius Arcemus Honeycutt; Reece Honeycutt (1900–1973), Murray Honeycutt's son; Thomas Edgar Blackstock; Gaston Penley Deyton; Wilson Hensley (seated); Elbert Frank Watson; Adolphus Augustus "Dolph" Wilson (1883–1962), a farmer, of South Toe, Yancey County, and Roy Davenport Horton (1898–1963), of Paint Gap, Yancey County. *Continued on next page.*

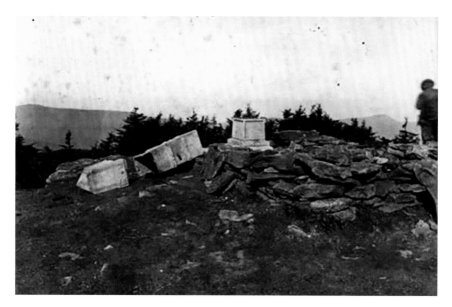

The University of North Carolina alumni monument to Elisha Mitchell was reportedly destroyed by high winds on January 1, 1915. But a report provided by Neptune Uranus Buckner, the Asheville Board of Trade's secretary just then, indicates that it was vandalized just before the end of 1914, blown up by dynamite. Buckner suspected lumbermen had done it. The monument was pieced back together in the interim, then taken down. *State Archives of North Carolina*

Continued from previous page. The men are standing around the burial site of Elisha Mitchell D.D. and the monument in his honor. Established in 1915 by the state legislature, Mount Mitchell became the first state park of North Carolina. By doing so, it also established the North Carolina State Parks system within the same bill. That May, members of the commission spent sixteen days completing a survey of the area and it is during this spring visit that this picture was taken. *State Archives of North Carolina*

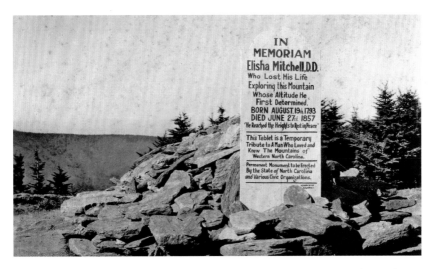

After the first monument to Elisha Mitchell was vandalized, this tablet was erected in its place as a temporary tribute to "a man who loved and knew the mountains of western North Carolina." As indicated on the marker, a permanent monument was to be erected by the state of North Carolina and various civic organizations on the site. This area, which also played host to a lumber operation billeted at Camp Alice just then, was photographed in or about 1920. The tablet was replaced eight years later – in 1928 – by the first funeral cairn and plaque that would mark his tomb. *University of North Carolina Chapel Hill* [above] and *State Archives of North Carolina* [below]

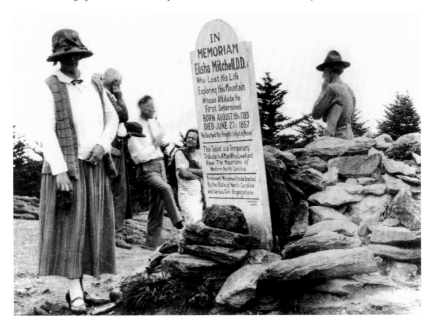

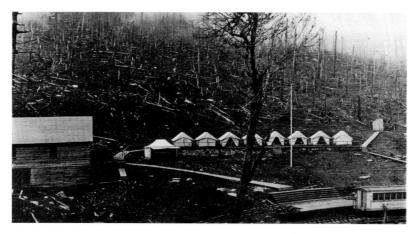

A popular destination reachable by trail within Mount Mitchell State Park is the former location of Camp Alice[155], at an elevation of 5,800 feet south of the summit of Mount Mitchell. This historic site is the location of a logging and, later, tourist camp at the terminus of the old Mount Mitchell toll road. Lower Creek flows across the main trail at this point and it is one of the highest elevation perennial streams in the Appalachians, flowing through the spruce-fir forest. Openings here in the forest are surrounded by evergreens that closely resemble the tree line in higher mountain ranges. Camp Alice is shown on this real picture postcard that dates to in or about 1915. Note the platform tents for overnight campers. *University of North Carolina Chapel Hill*

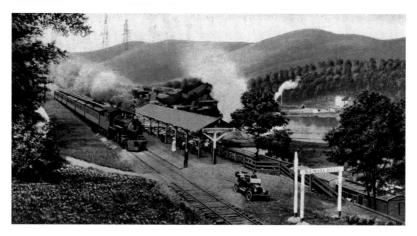

The Mount Mitchell Railroad Station, which officially opened on the Southern Railway right-of-way on August 3, 1915, is pictured on this white border postcard postmarked January 8, 1918. The postcard shows a train pulling up to the platform with passengers and an automobile waiting. The backdrop is the Perley and Crockett Lumber Company[156] [formerly owned by Dickey and Campbell Company] sawmill and yard. While it shared the rail with logging trains, according to the history, the Mount Mitchell Railroad expanded service and in 1916 carried more than ten thousand passengers to Camp Alice, which had been built between 1914 and 1915 specifically for the tourist trade. Dickey and Campbell Company, prior owner of the lumber company bought by Perley and Crockett and which also leased additional Southern Railway track, on April 4, 1916, had ten special passenger cars built for the excursion to Mount Mitchell. The railroad formally opened to passenger traffic on July 16, 1915. *University of North Carolina Chapel Hill*

This picture of Camp Alice was taken in or about 1925. The camp included a large rustic dining hall and other amenities from the time it was first built. There was also a one-mile trail that ascended Mount Mitchell's summit. Though it was quite popular, the passenger rail service was stopped in June 1919 to allow the railroad to be used for timber removal only. Of note, once logging operations depleted timber resources on Mount Mitchell, the tracks and ties were removed and the old railroad bed served as the foundation for the Mount Mitchell Motor Road, which first opened for automobiles like the ones shown here in June 1922.[157] *University of North Carolina Chapel Hill*

The first observation tower at the pinnacle of Mount Mitchell and adjacent to Elisha Mitchell's gravesite was built by the Dickey and Campbell Company, which initiated construction of it on April 5, 1916, and is shown in this photograph taken in or about 1925, roughly two years before this tower was replaced with more impressive one made of stone. *University of North Carolina Chapel Hill.*

The Old Log Cabin on Summit Mt. Mitchell. N.C.

The old log cabin (shown here) was built near the summit of Mount Mitchell and used by the state park warden until it was replaced. The picture was taken about 1925. This cabin was in a state of disrepair that made it inadequate quarters not only for the warden but also poor shelter for campers and visitors from sudden storms. The North Carolina state geologist's biennial report for 1924/5 opined that a new cabin should not occupy the site of the one in this photograph, which spoiled one of the most attractive natural features of the summit – the long-used Camper's Cave, which is seen arcing above the small building to the left of the large cabin (right). Two privately owned toll roads, one from Black Mountain and the other from Pensacola, provided access to Mount Mitchell. The Old Mitchell Trail from the north fork of the Swannanoa River was by far the most popular route. *University of North Carolina Chapel Hill*

This view of twenty-five-foot Mitchell Falls was taken by photographer Walter Bingham Gragg (1883 – 1964) in 1928. The waterfall is located on the slope of Mount Mitchell in Yancey County. Elisha Mitchell did, indeed, topple over a rock outcropping above the falls to his death on June 27, 1857. The falls are located on private property set aside as a hunting reserve. Mitchell Falls is closest to Milepost 350 in section 2-N of the Blue Ridge Parkway. *University of North Carolina Chapel Hill*

Photographer Walter Bingham Gragg took this picture in 1928 of the trail in the "deer and elk corral" in the Mount Mitchell State Park game refuge. The warden's cabin[158], constructed by what was then called the North Carolina Department of Conservation and Development in the fall of 1928, is visible in the distance. This was the home of the park warden for eleven months of the year; no one was stationed on top of the mountain during the month of January. The United States Weather Bureau cooperative station, maintained on top of Mount Mitchell and of which the warden was in charge, on New Year's Eve 1928, registered the temperature as twenty-five degrees below zero (unofficial). The park warden also acted as a fire lookout for the United States Forest Service and state forest service. *University of North Carolina Chapel Hill*

This view of two cars climbing the unpaved and tolled Mount Mitchell Motor Road was printed on a white border postcard in or about 1930. Several of the men are wearing dress shirts and neck ties in the first open car. The road was one-way up from eight o'clock in the morning to one o'clock in the afternoon and then reversed going down from half past three to half past five in the afternoon. There is a camp set up alongside the road with several tents. *University of North Carolina Chapel Hill*

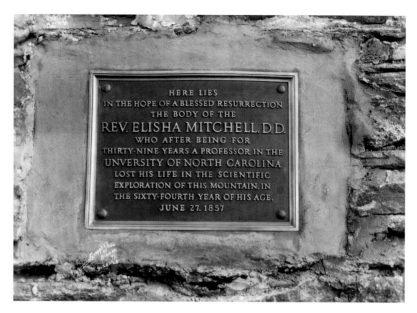

Affixed to the Elisha Mitchell burial site is this plaque, which reads: "Here lies in the hope of a blessed resurrection the body of the Rev. Elisha Mitchell, D.D., who after being for thirty-nine years a professor in the University of North Carolina lost his life in the scientific exploration of this mountain, in the sixty-fourth year of his age. June 27, 1857." The word "University" is misspelled on the plaque. The picture was taken just after construction of the memorial stone tower and new mortared-stone burial site had been completed. The site as it appears today has been completely reimagined for visitors but the plaque remains the same. *University of North Carolina Chapel Hill*

The grave of Elisha Mitchell (foreground) is shown at the base of the stone tower at Mount Mitchell State Park given in 1926 by Colonel Charles Joseph Harris (1853 – 1944), of Dillsboro, Jackson County, North Carolina, "for the benefit of the state and the permanent protection of the forests of the region." The twenty-four-foot tower was dedicated on June 17, 1927 [about the time frame this picture was taken], and cost roughly $25,000 to build. Harris, born and raised in Connecticut, was a capitalist who came to the mountains of western North Carolina at the turn of the twentieth century, where he opened a manufacturing facility that made locust pins for high-tension power and, later, telephone lines – and made his fortune. *University of North Carolina Chapel Hill*

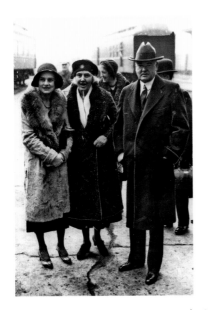

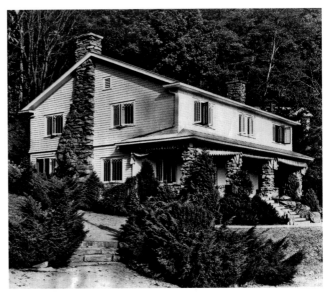

President Herbert Clark Hoover (right) (1874–1964) accompanied by first lady Lou Henry Hoover (1874–1944) (center), were met at the Asheville train station by daughter-in-law Margaret Eva Watson Hoover, during a heavy snow storm on March 9, 1931. The Hoovers' son, Herbert Charles Hoover[159], was in the western North Carolina mountains near Asheville recovering from tuberculosis and the president and first lady were there to pay a visit. Of note, from the late-nineteenth century through the end of the 1930s, Asheville and the surrounding mountains had become well known as a curative place for tuberculosis patients. More than 130 boarding houses and sanitaria – namely such facilities as The Villa and the Mountain Sanitarium for Pulmonary Diseases and Saint Joseph's Hospital – opened in Asheville for the treatment of tuberculosis at first for purely medical purposes and, later, during the Great Depression, for the financial opportunities that treating the disease brought to the community. Asheville's reputation as a center for the treatment of pulmonary disease was, in fact, what drew George Washington Vanderbilt (1862–1914) to Asheville. Vanderbilt's mother, Maria Louisa Kissam Vanderbilt, and millionaire and Asheville visionary Edwin Wiley Grove (1850–1927) had both come to Asheville to be treated for non-tubercular pulmonary problems – and George Vanderbilt and Edwin Grove fell immediately in love with the town. Asheville would be transformed by Vanderbilt's Biltmore Estate and Grove's Grove Park Inn and Grove Arcade. The second photograph, taken on October 27, 1930, shows Blue Briar Cottage where Herbert Charles Hoover stayed during his fight against tuberculosis. The Arts and Crafts-style cottage dates to 1906 and sits three hundred feet above the city of Asheville. *Amy Waters Yarsinske*

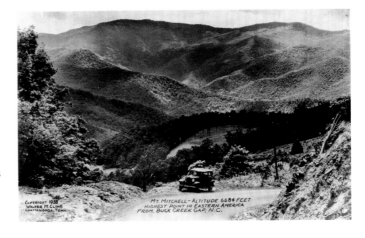

This view of Mount Mitchell – altitude 6,684 feet – is shown from Buck Creek Gap in this 1938 Walter Matson Cline photograph. The elder Cline, later joined by his son, Walter Matson Cline Jr. (1914–1984)[160], owned Cline's Studios in Chattanooga, Tennessee. *University of North Carolina Chapel Hill*

Above: The Civilian Conservation Corps (CCC) constructed the picnic shelter shown in this July 29, 2002 photograph at Mount Mitchell State Park. Members of CCC companies assigned to the western North Carolina region were engaged in forest protection and preservation, road construction, park projects such as construction of recreational facilities, soil erosion and wildlife conservation. There was a Black Mountain CCC Camp SP-2, twenty-three miles north of Mount Mitchell, established on May 11, 1937. A monument to the members of Companies 413 and 2410, who worked from Camp SP-2 is located near the summit of Mount Mitchell. *State Archives of North Carolina*

On November 4, 1948, Thomas Wallace Morse (1906 – 1986), superintendent of state parks, wrote Samuel P. Weems, a civil engineer and superintendent of the Blue Ridge Parkway, to inform him that his office had begun studies for a hotel and restaurant for Mount Mitchell State Park. "We have been working pretty much in the dark," he informed Weems, "because we don't know how many people to plan for. We have no data on which to base such decisions as dining room capacity, number of guests that will need to be accommodated, etc." He asked Weems if he had made any studies of what kind of demand there might be for a possible hotel and restaurant along the Mount Mitchell section of the parkway. This early photograph of the Mount Mitchell State Park restaurant, located midway between the park office and the summit area on North Carolina Highway 128, which is accessible from the Blue Ridge Parkway at Milepost 355, was taken in or about 1950. *University of North Carolina Chapel Hill*

Opposite below: Located in the Black Mountain campground, just off the Blue Ridge Parkway near Burnsville, Yancey County, in Pisgah National Forest and in the shadow of Mount Mitchell, is this dilapidated former Civilian Conservation Corps (CCC) information shed. The picture was taken on October 13, 2017. In North Carolina the CCC had sixty-six camps, employing 13,600 men, in forty-seven counties. One of the earliest (the first by some accounts) was Camp Pisgah Forest, assigned the number F-1 and occupied on May 18, 1933. In early 1934 the named was changed to Camp John Rock for a nearby rock formation. Plans were laid for the installation of this camp as early as April 20, 1933, and men began arriving from Fort Bragg on May 5 to construct barracks and other buildings. Eventually, 220 workers were assigned to the unit. Major projects included fish and fawn rearing, road building and maintenance, trail improvement, reforestation, and forest conservation. Their work is evident today throughout Pisgah National Forest. The camp closed in 1936 and the CCC program was abolished by Congress in 1942.[161] *Bobistraveling*[162]

Elisha Mitchell's tomb on Mount Mitchell, the highest point in eastern North America, is shown here, the new observation platform in the background. The picture was taken on October 1, 2011. *KudzuVine*[163]

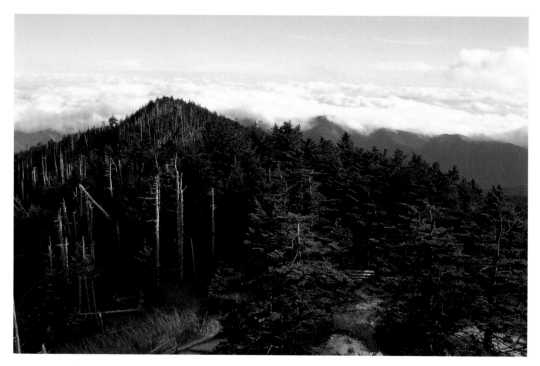

The Fraser fir [sp. *Abies fraseri*] forest at the Mount Mitchell summit was photographed on November 4, 2003. *United States Department of Agriculture National Resources Conservation Service*

This view is looking southwest from the observation tower on top of Mount Mitchell on July 22, 2006. *Ken Thomas*[164]

The entrance to Mount Mitchell State Park, located on North Carolina 128, in Yancey County, is shown in this July 6, 2014 photograph. *Washuotaku*[165]

VI

WHERE CONSTRUCTION BEGAN AND THE PARKWAY ENDS – NORTH CAROLINA

Although much had been accomplished in the first six years of the Blue Ridge Parkway's construction, the outbreak of the Second World War brought the work to a grinding halt. Even before the December 7, 1941 Japanese attack on Pearl Harbor, the possibility that the fighting in Europe might spread to the United States and its potential impact on parkway construction was discussed. In early 1941, parkway staff were queried about the possible "defense value" of the parkway. Although Stanley Abbott insisted its "first value" was recreation, he admitted that in a national emergency it might provide a "relief route" for the valley highway and possibly serve as point of control for the various east-west highways which crossed the limited gaps in the mountains. As the year went on and the possibility of war grew closer, the pace of construction slowed. Then came the presidential order of September 1, 1941, that impounded $4 million in construction funds already appropriated by Congress for the parkway's construction. By the time the war broke out, over $20.4 million had been spent to build significant parts of America's premier scenic highway. Some one hundred-and-seventy miles were open to travel and another one hundred and sixty miles were in various stages of construction, of which one hundred-and-twenty-three miles had received preliminary surfacing of crushed stone and were open to travel on a temporary basis. National Park Service records indicate that an estimated 965,000 visitors traveled over parts of the parkway in 1941.[166]

The war's immediate effect – beyond slowed to no construction and suspended maintenance – on the parkway was the reduction of the speed limit to forty miles per hour, a speed-lowering measure instituted by Interior Secretary Harold Ickes for all national parks and parkways as a means of saving rubber. In late spring 1942, the parkway closed sixty-six miles of the motor road for which no final surfacing had been applied because maintenance costs for these dead-end sections was higher than for paved segments. The one hundred-and-forty-mile paved section between Adney Gap in Virginia and Deep Gap in North Carolina remained open to travel. But that fall, all major parkway construction was stopped. Whatever projects contractors could not finish were abandoned and heavy equipment was moved out, often to

war jobs. When construction ended in November 1942, there were 171 miles of paved parkway, and another 162 miles graded, leaving 144 miles left to be started when the war was over.

The Second World War necessitated a drastic reduction in the National Park Service and Public Roads Administration staff assigned to the Blue Ridge Parkway. Between July 1942 and July 1943, the parkway administrative staff lost fifteen of its forty-four positions. Five positions were terminated in April 1943 when the parkway's allotted positions were set at twenty-nine. Most of those leaving joined the armed forces and several took jobs with defense industries. The limited number of maintenance workers left behind to tend to the parkway did their best to keep the road and road-related facilities from deteriorating. In January 1944, Stanley Abbott was called into the army, temporarily depriving the parkway of its guiding figure. Samuel P. Weems was appointed as acting parkway superintendent in his place, and Kenneth Carnes McCarter became the parkway's designated resident landscape architect.[167]

Restrictions on critical materials effectively terminated work on the recreational areas, and the greatly-reduced Civilian Conservation Corps (CCC) forces concentrated mostly on landscape development work. As material for this work was similarly limited, and because of a wartime policy mandating only landscape work that would lead to an immediate reduction in maintenance costs, planting of trees and shrubs for scenic effect, vista clearing, and related programs were abandoned. Crews focused on slope work and erosion control. The agricultural lease program, which promised to reduce government expenditures on maintenance, was expanded, all of this documented by the park service. Most construction projects already underway were pushed to completion, but two grading projects, in the Great Craggies and on the Cherokee Indian Reservation, were shut down by the War Production Board for the duration. No new projects were authorized during the war years. Maintenance also suffered, as road surfacing repairs and drainage clearing by the Public Roads Administration was canceled due to materials and labor shortages. In his 1942 annual report, Abbott expressed concerns that large investments in the parkway were liable to damage from seasonal storms and washouts. While the work was halted, planning was not. Parkway officials used the wartime period to continue with plans and surveys, and the states of Virginia and North Carolina continued right-of-way acquisition.

As the war marched on, the federal government suspended New Deal public works programs. The loss of the CCC jeopardized fire protection since many of the young men on the crews formed the backbone of the parkway's firefighting capability. To offset this loss during the war years, the parkway ranger force organized firefighting crews from parkway neighbors, and local high school and college students. Landscape improvement work and development of parkway recreational areas was severely cut back, also absent CCC crews and the availability of parkway staff. With the war also came a significant drop in visitation – fifty-eight percent in the first six months of 1942 – most of them out-of-state travelers. When Virginia imposed a ban on pleasure driving in May 1942, the parkway closed the Smart View and Rocky Knob recreational areas. The ban was lifted in August 1943, and the parks were reopened, but visitation remained light due to gasoline and tire rationing. Then, in December 1942, the parkway began allowing loaded trucks to use the road in order to save gasoline and tires. Trucks were limited to a speed of twenty-miles-per hour or thirty-miles-per hour if empty or

carrying a light load. Truckers wishing to use the parkway had to show that gas or tires would be saved and pay a five-dollar fee for a four-month period in order to offset wear and tear on the parkway pavement, which was designed for light passenger vehicles. During the first six months of the program, the park service estimated that ninety trucks were issued permits to carry farm and forest products, and about six hundred dollars in fees were collected. By the end of the war, nearly 550 permits had been approved for truckers using the parkway.[168]

Although the war delayed construction of the parkway and disrupted the lives of many of its employees, it had one beneficial effect. Three conscientious objector camps were assigned to the parkway project, thus there was a ready source of labor to carry on some of the work of the recently disbanded Civilian Conservation Corps. The Civilian Public Service (CPS) program allowed conscientious objectors to perform "public service to humanity" instead of serving in the military; the participants served without wages and paid thirty-five dollars a month to live in the camps. Three CPS camps, which were paid for and supported by historically pacifist churches, the Brethren, Mennonites, and Quakers, were located at former CCC camps near Waynesboro and Galax in Virginia and Marion in North Carolina. The CPS crews were trained in fire control but spent most of their time grading and seeding road slopes to prevent erosion and also improved fields and pastures. Two of the camps were transferred from the parkway in May 1943. The Galax camp was sent to Sequoia National Park, and the Buck Creek Camp was transferred to the Great Smoky Mountains.[169]

High wartime prices for tanning extract wood led to numerous requests from the leather tanning industry for dead chestnut on parkway lands. In late 1942, the Interior Department authorized the sale of a large amount of dead chestnut on Flat Top Mountain in the Peaks of Otter as an experiment to collect data for purposes of future sales of other wood. In May 1943, the National Park Service, agreeing to a request by the War Production Board, authorized the Holston Land Company to construct temporary access roads to the parkway from their woodlots on Humpback Mountain. This marked the first time an exception was made to the policy of denying privileges for new access roads once land title was accepted from the states. The Civilian Public Service camp at Bedford, Virginia, which was assigned to work at Peaks of Otter, was put to work harvesting some of the dead chestnut for the tannic acid program. The last of the public works projects, CPS Camp NP-121, located at Bedford, Virginia, closed in May 1946 and the parkway lost a valuable source of inexpensive labor – this was the last of the major public works projects involved with the Blue Ridge Parkway.

More exemptions for access roads to the parkway were granted to several North Carolina concerns in 1943 and 1944 to provide access to mica and feldspar mines for war production. The War Production Board was anxious to stimulate production of mica to replace foreign sources, which were either no longer available or greatly restricted. The United States Geological Survey investigated deposits north and south of Mount Mitchell, and in areas west of Asheville. Some mica mines had operated in earlier years along the parkway corridor; these works are noted by two overlooks, Glassmine Falls ["Glass" being a shortening of isinglass, a common name for mica] [Milepost 361.2], and Grassy Ridge Mine [Milepost 436.8]. Of note, too, the agricultural leasing program was expanded during those tenuous war years, both to decrease maintenance demands, especially for roadside mowing and to contribute

to the nation's need for greater food production. The resumption of farming also added to the scenic effect, especially along the Virginia highlands section where the parkway crossed the greatest amount of agricultural land.

When the war ended, the parkway's transition back to peacetime functions was a rocky one. Furloughed personnel returned slowly. Parkway staff resumed planning for the completion of the road. Stanley Abbott returned as resident landscape architect, but Sam Weems remained acting superintendent. Abbott would stay only three years under this arrangement.[170] Weems was thereafter formally appointed Blue Ridge Parkway superintendent. Much of the parkway's equipment had been declared surplus and turned over to the military for the war effort, leaving returning staff short of cars, trucks and maintenance equipment. Office space was inadequate, though this was resolved in the fall of 1945 when the central offices relocated to a new building in Roanoke, Virginia. Permits that had been issued for commercial hauling over the parkway were officially canceled effective November 30, 1945. While United States Forest Service contractors, dairy interests, and other parties protested, they were quickly reminded that the parkway had been constructed for pleasure travel, not to facilitate commercial enterprise. School buses were allowed to continue using the parkway for the remainder of the school year because state and county road maintenance had also incurred setbacks during wartime.

Deferred maintenance during the war had left portions of the parkway in severely deteriorated condition. Visitors often asked rangers one question more than any other: "Is this road this rough all the way?" Acting superintendent Weems lamented that the parkway pamphlets showed visitors a "ribbon smooth" road surface but the sections that had only been covered with crushed stone were in very poor condition. Further, there were places damaged by rock slides and improper drainage. Even before new construction could resume, it would first be necessary to devote considerable resources to restoring those damaged sections. Beginning in mid-summer 1946, contracts were awarded for repaving the worst sections. Even though the parkway was in somewhat rough shape, visitation increased rapidly with the lifting of gasoline and tire rationing. In the first quarter of 1946, visitation was sixty-five percent higher than the same period the previous year. Weems reported in his February monthly report that even though the staff was collectively gratified by the increase in visitation, many were reluctant to publicize the parkway while it remained in such poor condition. Like his staff, Weems knew that sizeable appropriations would be required for repairs and to push work on the parkway over the finish line. The 1944 Federal Aid Highway Act earmarked $10 million in postwar funds for national parkways, but the Blue Ridge Parkway would only receive a portion of that, the rest of the appropriation going to the Natchez Trace and other projects. The Blue Ridge Parkway staff wanted to use the appropriation they did receive for work that would open up as much of the parkway as possible to the public. Weems announced that the main priorities would be completion of the parkway link over the James River and sections around Roanoke, and the final work on a five-mile section between Mount Mitchell and Craggy Gardens. Completion of the latter project would enable motorists to travel mostly by parkway from Roanoke to Asheville. Other sections would be completed as additional funds became available.[171]

In 1946, the parkway staff proposed establishing six to eight force account units to carry on the work that prior to the war had been done through the Emergency Relief Administration (ERA) and CCC programs. Such work fell into two general categories: landscape work and the construction of minor roads, trails, buildings, and utility systems in the recreational parks. The parkway requested an initial appropriation of just over quarter-million dollars to start three such units in fiscal 1947 for projects at Peaks of Otter, Bluffs Park and Crabtree Meadows. New construction had just resumed when nine months later, in August 1946, President Harry S. Truman issued an executive order halting federal construction. Two paving contracts in the process of being awarded were suspended, and other planned projects were put in abeyance. Work already underway continued, but the suspension disrupted hopes that much-needed parkway improvements would be completed as scheduled. Ever hopeful, Weems submitted a three-year program to resume work on critical sections to the Public Roads Administration. Under it, a grading contract was issued for a five-mile section extending north from U.S. Highway 460 at Roanoke. Another contract was let for paving the section between Linville, North Carolina, and Mount Mitchell. Bids were also advertised for repaving the southernmost thirty-five miles of parkway in Virginia, which had fallen into poor condition during the war. But the bids received were too high and the contract was again advertised. Bids were also invited for three new structures. The bids once more proved too high and parkway staff recommended waiting for construction prices to level off.[172]

The National Park Service assumed responsibility for maintenance for the one-hundred-forty-mile section between Adney Gap, Virginia, and Deep Gap, North Carolina, from the Public Roads Administration (PRA) on May 1, 1946, organizing maintenance crews to do its work from stations at Rocky Knob and The Bluffs. The PRA retained maintenance responsibilities on all other completed sections. Because some of the roadway did not have a final surfacing, maintenance costs were high and Weems requested additional funds for this work pending reconstruction and final surfacing on these segments. Over the decades that followed, the park service took over maintenance of other completed sections. In July 1949, the Public Roads Administration relinquished control over sections I-A through I-G-1, the first sixty-one miles between Jarman Gap and U.S. Highway 60. Continued high prices and another presidential no-construction order in 1947 further constrained the work with only one grading contract for a minor four-mile section, a twenty-seven-mile paving contract, and a seventeen-mile surface repair contract were awarded that year. Remarkably, the pace of construction increased the following year. Five new contracts were awarded, including two grading projects, two paving projects and a contract for the construction of a superstructure for a viaduct on section 2-F near Blowing Rock. Bids were invited on two additional projects, a paving contract for section 1-M and construction of two grade separation structures on 2-E. The total cost of all work in various stages of construction, including carry-over projects, exceeded $3 million in June 1948. In July, the parkway assumed maintenance of sections 2-J through 2-M in North Carolina. Work on this forty-eight-mile segment was carried out from the maintenance yard at Gillespie Gap. A year later, the parkway assumed maintenance for the forty-five miles between Rockfish Gap and U.S. Highway 60 from the newly completed Montebello maintenance station. When the parkway took over the forty-two-mile section

between the James River and U.S. Highway 460 near Roanoke in 1952, the total mileage under maintenance by parkway staff reached 315 miles.[173]

President Truman signed the bill authorizing the exchange of lands between the Eastern Band of Cherokee Indians (EBCI) and the National Park Service in October 1949, making possible the construction of section 2-Y northwest from Soco Gap. Construction also got underway on the 3.59-mile Heintooga Spur Road into the southeastern corner of Great Smoky Mountains National Park where it connected with the park's Round Bottom Road. The spur road was completed in 1951 at a cost of just over $278,000, according to park service documentation. Of note, in 1949, as the parkway segment between Mount Mitchell and Asheville neared completion, North Carolina and Asheville tourist interests proposed a dedication ceremony for the parkway. Superintendent Weems endorsed the proposal and asked the National Park Service's regional office to push ahead construction on that section so that a ceremony could be held the next year. In June 1950, a delegation consisting of Secretary of the Interior Oscar Littleton Chapman (1896–1978), National Park Service director Newton Bishop Drury[174] (1889–1978) and associate director Arthur E. Demaray, Congressman Robert L. Doughton, Superintendent Weems and other officials visited the White House and asked President Truman to speak at a ceremony marking the dedication of the parkway. Truman accepted the invitation and planning for the event got underway, a moment that was intended to celebrate the remarkable opening of the parkway from the James River in Virginia to Asheville, North Carolina. This segment was substantially complete, and only four short bypasses over public highways would be required for through-travel. The ceremonies were planned by the Blue Ridge Parkway Associated Chambers of Commerce, who chose Doughton Park as the site for the festivities. The dedication was set for August 12, but the outbreak of the Korean conflict forced Truman to cancel his attendance. The associated chambers then decided to postpone the dedication until the following June, anticipating that the hostilities would soon be over. When it became clear that fighting on the Korean Peninsula would go on, the delay grew longer. Truman's term in office expired, in fact, before the dedication could be held and the committee decided to invite President Dwight D. Eisenhower, his successor. Senator Harry Flood Byrd extended the invitation in February 1954, asking him to attend a ceremony that spring, but Eisenhower declined, citing a heavy schedule. The committee put off the ceremony for another year, allowing Eisenhower to choose the date. But as circumstances unfolded, no dedication would be held until the 1980s.[175]

By the mid-1950s, only about a third of the Blue Ridge Parkway had been completed and opened to travel. Much of the remaining work involved difficult construction in more rugged terrain than earlier sections. While work had resumed following the Second World War, meager appropriations limited the extension of the road. The impetus for the completion of most of the remaining sections was a multi-year National Park Service development program known as Mission 66. The Mission 66 program was announced in February 1955 by Conrad L. Wirth, who had succeeded Newton Drury as director of the National Park Service in 1951. Wirth had inherited a park system crippled by inadequate funding, indifferent maintenance and threatened natural and cultural resources. Seeing a need to attract the attention of Congress in order to secure assistance in upgrading and expanding park programs, he proposed a

ten-year program which ostensibly would meet the demands visitors would place on the parks by the fiftieth anniversary of the National Park Service in 1966. This "comprehensive and integrated program of use and protection" was largely a response to the needs of the automotive tourist and projects such as the completion of the Blue Ridge Parkway were given priority. In his memorandum to parks personnel announcing the program, Wirth set forth the underlying goals of the undertaking.

> The purpose of MISSION 66 is to make an intensive study of the problems of protection, public use, interpretation, development, staffing, legislation, financing, and all other phases of park operation, and to produce a comprehensive and integrated program of use and protection that is in harmony with the obligations of the National Park Service under the Act of 1916.[176]

The actual mission statement justified a new series of road construction projects, noting that:

> Construction is, of course, an important element in the program. Modern roads, well-planned trails, utilities, camp and picnic grounds, and many kinds of structures used for public use or administration, to meet the requirements of an expected eighty million visitors in 1966, are necessary; but they are simply one of the means by which "enjoyment-without impairment" is to be provided.[177]

Blue Ridge Parkway supporters were of course enthusiastic about the potential for jumpstarting the project under the impetus of Mission 66. Per the park service backstory, Sam Weems greeted the announcement of the program as "a real opportunity for new thinking about old problems." The park service announced, in August 1956, a set of priority projects to be carried out on the Blue Ridge Parkway under the Mission 66 program. These included the construction of Sections 2-F-1 near Blowing Rock, North Carolina, 2-X between Balsam and Soco Gaps, and 2-Y and 2-Z, the southern terminal sections of the parkway, all in North Carolina. The state of North Carolina was further pressed to turn over deeds for the remaining rights-of-way so construction could get underway promptly. Once construction of these sections was completed, the National Park Service vowed to program the completion of the remaining sections, provided the state was able to turn over the necessary land. Certainly, under the Mission 66 program, the pace of construction accelerated. Within the first two years projects totaling $16 million were in progress, an all-time record for the parkway. In addition to work on the mainline parkway segments carried out under the program, the Heintooga Spur Road from Wolf Laurel Gap to Black Camp Gap was completed in 1956, along with an extension within Great Smoky Mountains National Park to the Heintooga overlook.[178]

Visitation passed the five-million-mark in 1956. To deal with the additional pressures from the increased visitor load, the parkway sought to hire more staff. By 1962, a total of one hundred-and-fifty-six permanent positions had been approved and budgeted, a far cry from the days a few landscape architects huddled around Stanley Abbott's dining room table. With the new staff on board, the administrative structure of the parkway was reorganized. Maintenance activities were divided into four districts rather than eight, and

the protection division was reorganized into six districts, with plans to reduce these to four. The forest service transferred the right-of-way over its lands for the remaining sections of the parkway in 1957. The parkway received the right-of-way for the section between Wagon Road Gap and Beech Gap from the Pisgah National Forest and surveys were made for the section between Robinson Gap and James River in the George Washington National Forest. Three years later, in 1960, the forest service transferred 1,443 acres from this forest for section 1-G. In addition to the roadway construction work, new buildings and facilities were built with Mission 66 funds. A new maintenance and office complex at Oteen, on the parkway just west of Asheville, opened in 1957. The property was transferred to the parkway by the Veterans Administration. Employee housing was another major priority. Plans were prepared in 1958 for twenty-five residences, mostly in pairs at maintenance areas but including three at Roanoke and four in Asheville. The houses were completed the following year. All remain in use, though several have been converted to ranger offices.[179]

Many of the remaining gaps on the parkway were closed during the Mission 66 program. The park service informs that in 1960, the sixteen-mile Virginia section between U.S. Highway 60 near Buena Vista and Milepost 105 near Roanoke was opened following the completion of the James River Bridge. South of Roanoke, the 14.6-mile section between U.S. Highway 220 and Adney Gap opened later in the year. With the completion of these two sections, only the 15.6 miles bypassing Roanoke remained incomplete in Virginia. In North Carolina, the four miles through Julian Price Memorial Park opened in June. This completed the North Carolina segment between the state line and Asheville with the exception of a five-mile contested stretch around Grandfather Mountain. South of Asheville, the 12.6-mile segment between Balsam Gap and Soco Gap opened in the fall. Another 3.5-mile stretch between Wagon Road Gap and Mount Pisgah was completed in 1962. In 1963, a 19.7-mile section between Beech Gap and Balsam Gap opened. This project made available a 60.7-mile segment between Great Smoky Mountains National Park and Mount Pisgah, the highest and one of the most dramatic sections of the parkway. Only 16.7 miles remained incomplete in North Carolina at that point.

In 1961, the federal government announced four new interstate highway crossings for the Blue Ridge Parkway. There was some uncertainty about the location of two crossings. Interstate 64 [I-64] between Staunton and Richmond was planned to cross Rockfish Gap, though Jarman Gap [then Milepost 1 of the parkway] and Mills Gap, five miles south of Rockfish, were considered possibilities. Studies for Interstate 77 [I-77] suggested crossings at either Piper's Gap or Low Gap near the state line. The parkway opposed the Low Gap location because of likely damage to the viewshed at Cumberland Knob. In the end, I-64 was routed through Rockfish Gap, and I-77 passed near Fancy Gap, well to the northeast of the two preliminary locations. In the Asheville area, interstates 40 and 26 would cross beneath the parkway. The Bureau of Public Roads pledged to construct bridges to carry the parkway over the interstates. As a matter of policy, the parkway staff opposed providing interchanges between the interstate system and the parkway, though the road is easily accessible by state routes connecting to the interstates. At the request of the city of Roanoke, the National Park Service agreed to construct a two-and-a-half-mile spur road between the parkway and the city's Mill Mountain Park [home to the Mill Mountain Star, also called the Roanoke Star], and

to construct a campground along the road. A master plan for the project was approved in 1962. Though the city sought state help in acquiring the right-of-way to the campground, it had to purchase the site without federal assistance. In 1963, the city also offered to purchased lands for a scenic spur road up Yellow [Roanoke] Mountain. The National Park Service agreed and built the two roads along with parking overlooks, the campground and a trail system.[180]

A milestone was reached on June 15, 1965, when the fifteen-mile section of the parkway around the city of Roanoke opened to travel, marking the completion of the two hundred-seventeen miles of the Blue Ridge Parkway in Virginia. Formal dedication ceremonies were held at the Roanoke River Bridge on June 17, with National Park Service associate director Albert Clark Stratton Jr. (1913 – 1970) delivering the keynote address. Contracts for the final section around Asheville were also awarded that year. Five major structures were included on this section, including a bridge over Interstate 26 [I-26] to be constructed by the state of North Carolina. When this section was opened to the public in late 1966, all of the parkway had been constructed except for a problematic 7.7-mile section around Grandfather Mountain. While Mission 66 has often been criticized for emphasizing development over protection of park values, the program was vital toward completion of the Blue Ridge Parkway as originally intended. More than seventy-five percent of the entire cost of the parkway was expended under the program. At its conclusion, only the short remaining link around Grandfather Mountain still awaited construction.[181] Of note, Sam Weems, parkway superintendent since 1944, left in 1966, at the end of the Mission 66 program.

By the end of February 1968, parkway superintendent Granville Brinkman Liles[182] (1913 – 1991) and his staff were working from offices in Asheville, North Carolina, largely to assist the assistant superintendent with the development and operations of the parkway in North Carolina. The superintendent and the remaining central parkway offices moved from Roanoke to Asheville in January 1972 while planning was underway for the extension of the parkway into North Georgia. Asheville would have proved a more central location for the administration of the parkway had the extension been constructed. Relocation was also prompted by the assignment of the parkway to the new National Park Service Southeast Region. The new headquarters was located in leased space in the Northwestern National Bank Building [later the Branch Banking and Trust Company (BB & T) Building] on Pack Square in downtown Asheville. An office for the Virginia unit manager remained in Roanoke. By the early 1980s, problems with the downtown Asheville headquarters Branch Banking and Trust Building space prompted studies for a permanent parkway headquarters facility. Leased space in the bank building was costly and inadequate, and some functions (such as the library and storage facilities) had to be located off-site. Parking for staff and government vehicles was an additional expense and free parking for visitors was difficult to find. Parkway staff spent considerable time in transit between downtown and the other facilities at Oteen, seven miles away on the parkway.

In 1981, a number of sites were evaluated for a new parkway headquarters facility and Hemphill Knob on the southeastern outskirts of the city of Asheville was selected as the most appropriate site. The tract, located at Milepost 384, was easily accessible from interstates 40 and 240 and from U.S. Highway 74, major access points for parkway visitors. But no funding

was available just then for the purchase. Circumstances had changed four years later when, on October 4, 1985, Blue Ridge Parkway superintendent Gary Eugene Everhardt announced that the parkway planned to buy the tract Hemphill Knob tract for the construction of the parkway's first permanent headquarters. North Carolina congressman William Martin "Bill" Hendon stated that $639,000 in unspent federal Land and Water Conservation Fund monies would be used to acquire the 81.66-acre parcel. In making the announcement, Everhardt[183] said the parkway hoped the facility would include a visitor center in addition to administrative offices. A development concept plan for the new facilities was prepared in 1987. But groundbreaking for the parkway's new headquarters would not take place until July 15, 1997. More than two hundred people were in attendance to hear remarks by Congressman Charles Taylor, Asheville mayor Russell Martin, Hugh Morton of Grandfather Mountain, and Everhardt. Authorized more than a decade before, the $9.8 million Blue Ridge Parkway Visitor Center [Milepost 384], which features an award-winning film – *The Blue Ridge Parkway – America's Favorite Journey* – and exhibits that spotlight the natural and cultural heritage, economic traditions, and recreational opportunities found in western North Carolina and the Blue Ridge Parkway, opened on December 17, 2007.

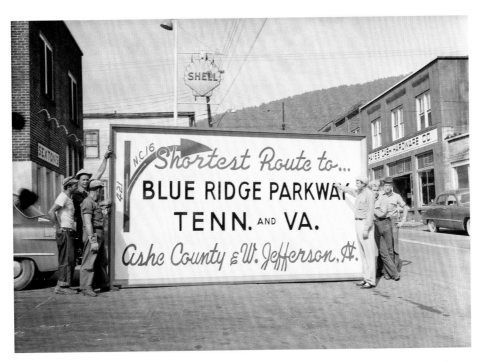

The sign being held up by a West Jefferson, Ashe County Shell gasoline station owner and his employees promoted U.S. Route 421 to N.C. Highway 16 as the shortest route to the Blue Ridge Parkway, Tennessee and Virginia. West Jefferson, tucked in the Blue Ridge Mountains in the northwestern region of North Carolina, developed primarily around the Virginia-Carolina Railroad [best known as the "Virginia Creeper"] depot and was incorporated in 1909. West Jefferson is today an important part of the Blue Ridge National Heritage Area. The picture dates to 1951. *Ashe County Public Library*

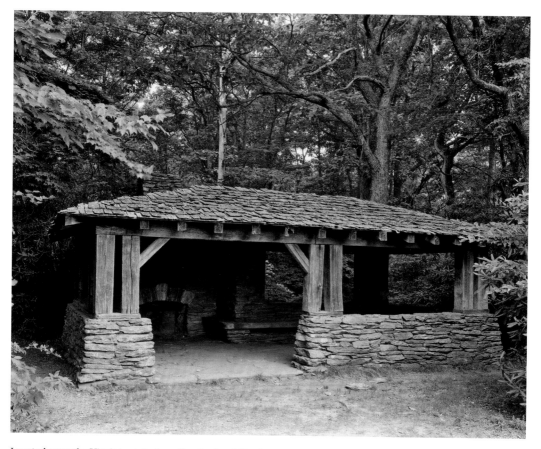

Located near the Virginia state line, Cumberland Knob was the site where construction of the Blue Ridge Parkway started in 1935 as a part of President Franklin D. Roosevelt's Civilian Conservation Corps (CCC) program. Thus, it would also be the first recreation area opened to the public, and is still a favorite destination point for both local residents and parkway visitors. The Cumberland Knob Recreation Area [Milepost 217.5] originally opened in 1941. This David Haas photograph of the historic chestnut timber and stone trail shelter, looking to the north, was taken in 1996/7 for the HAER report. *Library of Congress*

OPPOSITE PAGE:

Built in 1937, the Pine Creek Bridge [Milepost 225] was the earliest steel girder bridge built on the parkway. The first view of it is looking east-northeast. In the second view, taken from underneath and looking northeast, it is the only parkway bridge with steel arch piers and the only one in which the piers are attached to its foundations with steel pins allowing it to flex without damaging the structure. David Haas took both photographs in 1996/7 for the HAER study. *Library of Congress*

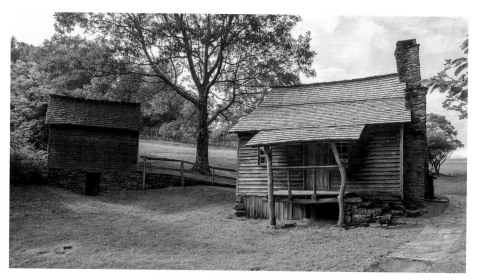

The Brinegar Cabin landscape is located at Milepost 238.5 on the Blue Ridge Parkway in North Carolina. Originally built as a family farmstead in the late nineteenth century, the property functions as a roadside interpretive site. It contains four wooden buildings and several features that reflect the farming period, as well as many design elements added during development of the Blue Ridge Parkway. The cabin, located in the vicinity of Whitehead in Alleghany County, North Carolina, was photographed by Harold Blackwood. The cabin also houses a display of mountain crafts and weaving. *National Park Service*

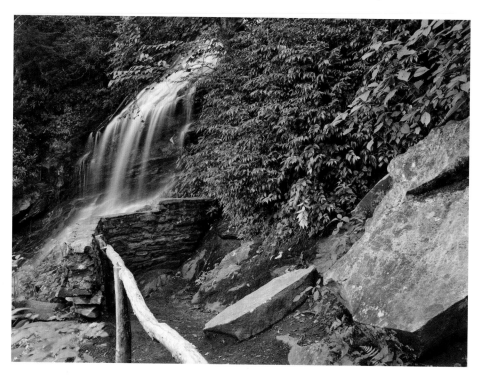

This view of the stone-walled pedestrian overlook at the Cascades [Milepost 271.9], a waterfall on Falls Creek and inside the E. B. Jeffress Recreation Area, was documented by David Haas for the 1996/7 HAER report. The view is looking southwest. *Library of Congress*

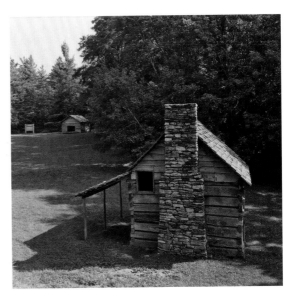

Located at the E. B. Jeffress Recreation Area is the Cool Springs Baptist Church (left) and the Jesse Brown Cabin (foreground). When the National Park Service acquired the property, the church was being used as a barn. David Haas took the photograph in 1996/7 looking south-southwest.
Library of Congress

The rosebay rhododendron [sp. *Rhododendron maximum*], commonly known as the great laurel, was blooming along the edge of the Blue Ridge Parkway at Deep Gap, an unincorporated community located in Watauga County, North Carolina, when it was photographed on July 25, 2016. This species of rhododendron is native to and the dominant species of this evergreen shrub in the Appalachians of eastern North America, from Alabama north to coastal Nova Scotia. Roughly twelve thousand square miles of the southern Appalachians are blanketed with this rhododendron species. Deep Gap takes its name from the natural depth of the gap, located at Fire Scale Mountain where the parkway crosses over U.S. Route 421 [Milepost 276.4]. *Famartin*[184]

Three female white-tailed deer [sp. *Odocoileus virginianus*] were photographed hiding in the forest along the Blue Ridge Parkway in Caldwell County, North Carolina, on November 16, 2008. *Ken Thomas*[185]

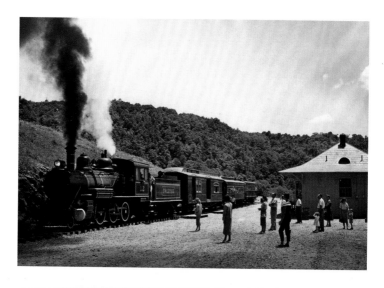

The Tweetsie Railroad, accessible from the Blue Ridge Parkway exit at Milepost 291, is the centerpiece of a wild west theme park located between Boone and Blowing Rock, North Carolina. The park's railroad first acquired the only surviving narrow-gauge coal-fired engine of the East Tennessee and Western North Carolina Railroad [the ET & WNC], which ceased operations in 1950. As explanation, the ET & WNC sold the locomotive to the Shenandoah Central Railroad. The engine eventually came to the park via Grover Cleveland Robbins (1886–1956), a Blowing Rock entrepreneur, who bought out cowboy actor and singer Gene Autry's interest in the locomotive in August 1955. Autry had purchased the engine from the defunct Shenandoah Central after rains from Hurricane Hazel washed out the railroad's track in October 1954. The legendary crooner had intended to move the locomotive to California as a movie prop but the expense of moving and restoring it quashed that plan. Robbins moved the number twelve locomotive back to its native Blue Ridge Mountains as the centerpiece of his Tweetsie Railroad tourist attraction. One mile of narrow-gauge track was constructed near Blowing Rock, North Carolina, for the train to run on, and on July 4, 1957, the locomotive made its first public trip over the line, an event that coincided with the park's opening. One year later, in 1958, the track was extended to the three-mile loop around the mountain, and the trains at Tweetsie have traveled that loop ever since. *Continued on next page*

Continued from previous page: Grover Robbins' brothers, Harry and Spencer, were also involved with the operation of Tweetsie Railroad, and the park is still operated by the Robbins family. In 1960, Tweetsie acquired another coal-fired steam locomotive, United States Army Transportation Corps (USATC) S118 Class 2-8-2 number 190 (shown in this contemporary Carol M. Highsmith photograph and painted in the Tweetsie Railroad colors). The latter locomotive was formerly the *Yukon Queen* from Alaska's White Pass and Yukon route. Built by Baldwin Locomotive Works in 1943 for the United States Army, the engine was part of an eleven-locomotive fleet of MacArthur 2-8-2s originally purchased for use overseas but which instead saw service in Alaska. Today, the Tweetsie Railroad is recognized as North Carolina's first theme park. The black-and-white photographs shown here were taken between 1957 and 1960. *University of North Carolina Chapel Hill* (black-and-whites) and *Library of Congress* (contemporary)

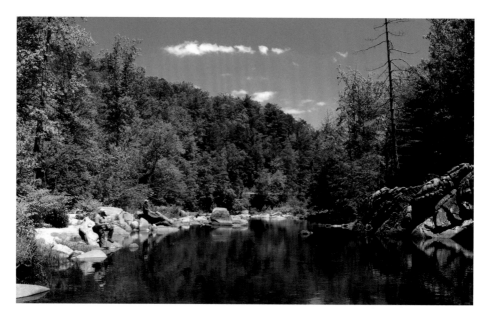

Wilson Creek, which also features an overlook at Milepost 303.6, was added to North Carolina's wild and scenic river system on August 18, 2000. The headwaters of Wilson Creek originate at Grandfather Mountain and flow twenty-three miles down through the Pisgah National Forest and eventually terminate into John's River in Caldwell County. The Wilson Creek Wilderness Area is a large recreation area for hikers, climbers, kayakers, mountain bikers, and fishermen. The addition of the creek to the wild and scenic river system purposefully strives to balance river development with permanent protection for the country's – in this case North Carolina's – most outstanding free-flowing rivers. This designation prohibits federal support for actions, such as the construction of dams or other instream activities, that would diminish the river's free flow or outstanding resource values. Designation neither prohibits development nor gives the federal government control over private property. The river, a popular destination for kayakers and trout fishermen (shown in the first photograph), was photographed on May 17, 2008. The second photograph was taken six months later, on November 2, 2008, from a different point of the river. *Ken Thomas*[186]

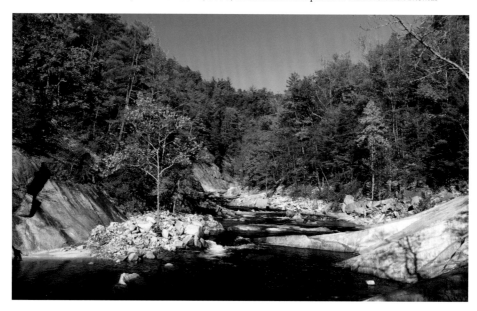

This is the so-called "Great Wall of China," a large stone retaining wall built to support the parkway around Grandfather Mountain's Rough Ridge. Linn Cove Viaduct is visible in the distance. David Haas took the picture as part of the HAER study in 1996/7. The view is looking west-northeast. *Library of Congress*

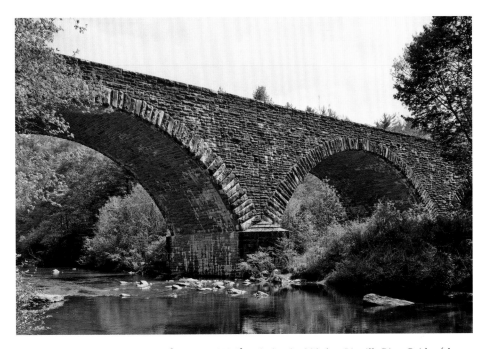

The Linville Falls Recreation Area [Milepost 316.6] includes the 309-foot Linville River Bridge (shown here), the parkway's largest stone-faced bridge. This triple span bridge, built in 1940, is an example of a spandrel arch bridge with Roman arches. The view here, taken by David Haas in 1996/7 for the HAER, is looking south. *Library of Congress*

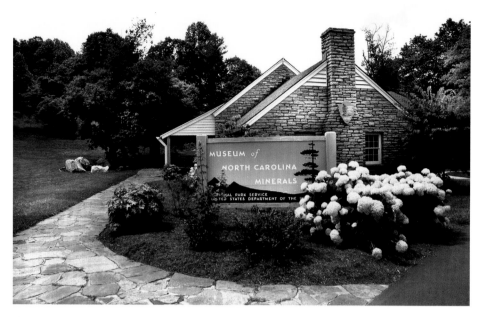

The mountains near Spruce Pine, North Carolina, are among the richest in minerals and gems in the United States. More than 300 varieties are showcased in the Museum of North Carolina Minerals (shown in this photograph), located on the Blue Ridge Parkway at Gillespie Gap [Milepost 316.4]. Due to the parkway's popularity, the museum may introduce more people to minerals and gems that any other such facility in the country. The Museum of North Carolina Minerals features interactive displays about the minerals and gems found in the region as well as the historical importance of the mining industry to the local economy. Gillespie Gap, a low notch in the mountains, is also significant for other reasons. *Continued on next page.*

The Little Switzerland Tunnel [Milepost 333.4], 547 feet in length, is located in Mitchell County. The picture was taken on November 16, 2008. *Ken Thomas*[187]

Continued from previous page: Late in the Revolutionary War, frontiersmen from the mountains known as the "Overmountain Men" crossed the Blue Ridge here on their way to a decisive engagement at Kings Mountain, South Carolina, one of the war's pivotal victories over the British. Today this trek is marked through Virginia, Tennessee, and North and South Carolina by the Overmountain Victory National Historic Trail. *National Park Service*

Crabtree Falls in located in the Crabtree Falls and Meadows Recreation Area [Milepost 339.5] on the Blue Ridge Parkway, roughly three miles from Little Switzerland and about forty-five miles from Asheville, North Carolina. There are two woodland hiking trails available to reach the seventy-foot waterfall. Both photographs of Crabtree Falls were taken on July 3, 2008. *J.D. Shepard*[188]

The Twin Tunnels [north and south], like the Grassy Knob Tunnel, are located on the Blue Ridge Parkway near Asheville, Buncombe County, North Carolina. Tunnels remain an iconic feature of the parkway and, in fact, thirty-six percent of all road tunnels found in national parks in the United States are located on the Blue Ridge Parkway. This view of the south portal of the north tunnel [Milepost 344.5] from inside the finished north portal of the south tunnel [Milepost 344.7] looking north was photographed by David Haas in 1996/7 for the Historic American Engineering Report of the parkway. The north tunnel is 300 feet in length and the south tunnel 401 feet. The tunnel interiors shown here have retained their natural rock surface but have been fitted with smooth concrete liners near the portal extensions to preclude avalanches from above. *Library of Congress*

When David Haas took this close-up view of the south portal of the north tunnel of the Twin Tunnels near Asheville, North Carolina, in 1996/7, it was one of the few left with a natural rock face. The perspective is looking north. *Library of Congress*

Carol M. Highsmith took this contemporary photograph of Haw Creek Valley from the parkway overlook [Milepost 380], nestled in the Black Mountains. The Blacks are the highest mountains in the eastern United States. The range takes its name from the dark appearance of the red spruce and Fraser fir trees that form a spruce-fir forest on the upper slopes that contrast with the brown during winter and lighter green (typical of the growing season) of the deciduous trees at lower elevations. The Eastern Continental Divide, which runs along the eastern Blue Ridge crest, intersects the southern tip of the Black Mountain range. The Black Mountains are home to Mount Mitchell State Park, which protects the range's highest summit and adjacent summits in the north-central section of the range. The valley view is more often than not obscured by the rich tree canopy. Highsmith took her photograph in the fall, when the loss of tree foliage permitted a better view to the valley floor. *Library of Congress*

There are twenty-six vehicular tunnels constructed along the 469-mile Blue Ridge Parkway. One – the Bluff Mountain Tunnel – is in Virginia and twenty-five are in North Carolina [most of them near Asheville]. Design standards specified minimum impact on the land thus vehicular tunnels were often constructed to reduce excessive landscape scarring that open cuts would have produced. *Continued on next page.*

Continued from previous page: Tunnels were also executed in areas of steep terrain where ridges ran perpendicular to the roadway alignment. North Carolina's terrain, more rugged than that found in Virginia, required the majority of the tunnels be built there. Solid concrete linings were added to strengthen the interior of the tunnels. The stone masonry portals such as the one shown in this contemporaneous view of Grassy Knob Tunnel taken by Carol M. Highsmith are generally not part of the original Civilian Conservation Corps (CCC) construction. Grassy Knob Tunnel, located at Milepost 397.1 near Asheville [in Buncombe County], is 770 feet in length. *Library of Congress*

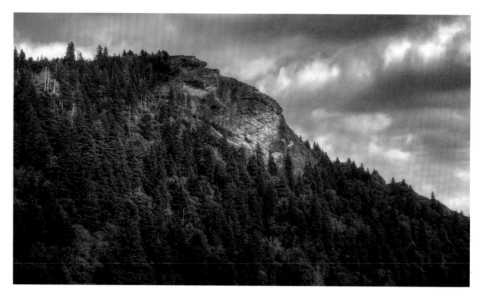

Devil's Courthouse (shown here) is a 5,720-foot mountain found at the western edge of the Pisgah National Forest and about ten miles northwest of Brevard and twenty-eight miles southwest of Asheville. Located at Milepost 422.4 of the Blue Ridge Parkway, the Devil's Courthouse has an associated moderate to strenuous hiking trail climbing a half mile to its peak with panoramic views. Folk tales inform us that the devil holds court in the chambers of the cave collocated here. The photograph was taken on January 1, 2013. *Kadokal*[189]

Opposite below: The Richland Balsam Mountain summit, located at an elevation of 6,410 feet, is shown in this October 10, 2016 photograph. There are two overlooks for Richland Balsam, one of which is just forty-five minutes from downtown Asheville and located near Milepost 431. Of note, the Richland Balsam is ground zero in the woolly adelgids destruction of the mountain's Fraser fir trees. The adelgid was accidentally introduced into the United States in or about 1900 and first showed up on Richland Balsam roughly seven decades later. The trees die once infested, leaving what looks like gray "snags." *Thomson200*[190]

Waterrock Knob [Milepost 451.2] includes a parking overlook, visitor information center, comfort station and the last hiking trail on the parkway before reaching the Great Smoky Mountains National Park. The peak at this pullover is 6,292 feet and is the sixteenth highest mountain in the eastern United States and the fifteenth highest of the forty mountains in North Carolina over 6,000 feet. The four-state-view at this location includes a panorama of the Great Smoky Mountains. These pictures of the Waterrock Knob summit and hiking trail were taken on May 20, 2017. *Thomson200*[191]

The Soco Gap, a mountain pass between the Plott Balsam Range to the south and Balsam Mountain to the north, was a strategic location for the Cherokee as the primary route for entering their land through the eighteenth century from the north and east. The Cherokee maintained an outpost here to protect from the Shawnee and early European settlers. To the Cherokee, the gap is known as Ahalunun'yi, meaning "ambush place" or Uni'halu'na, meaning "where they ambushed." The gap is the eastern point of the Qualla Boundary that marks the territory held as a land trust for the federally organized Eastern Band of Cherokee Indians and which was part of the 1876 federal survey. The gap also separates North Carolina's Haywood and Jackson counties (shown here) and also the French Broad and Little Tennessee river basins. Soco Gap is traversed by U.S. Route 19 [U.S. 19], making it twelve miles west to Cherokee and five miles east to Maggie Valley. The photograph of the Qualla Boundary historic marker and county boundary line was taken on July 6, 2014. *Washuotaku*[193]

Opposite page:

Above: Catawba rhododendron [sp. *Rhododendron catawbiense*], also known as Catawba rosebay and mountain rosebay, were photographed near the Waterrock Knob visitor center, just below the summit, on June 7, 2009. *Brian Stansberry*[192]

Below: This view of tourist attractions off the parkway at Soco Gap [Milepost 455.7 at elevation 4,340 feet] overlooking Maggie Valley was taken by David Haas facing west-northwest in 1996/7. *Library of Congress*

The Heintooga Spur [Ridge] Road (shown here) starts at Milepost 458.2, eleven miles from the south end of the Blue Ridge Parkway and provides ready access to Balsam Mountain. The first four miles of the paved, two-lane road are within the Blue Ridge Parkway National Park boundaries, to include overlooks looking down on the mountain ridges. The rest of the road falls within the Great Smoky Mountains National Park. The second photograph, taken by Sebastian Sommer on May 4, 1952, shows the Great Smoky Mountains National Park from the Mile High pullover – elevation 5,250 feet – of the Blue Ridge Parkway where the Heintooga Road forks off and becomes an entrance to the park, with the first several miles managed by the parkway. This is the only stopping off point that provides travelers any view of the Smokies as the parkway ends and the park begins. The high ridge visible in the distance is the North Carolina–Tennessee state line. *Library of Congress* (road) and *Amy Waters Yarsinske* (view)

VII

MUST-SEE MILEPOSTS ON AMERICA'S FAVORITE DRIVE

Blue Ridge Parkway superintendent (1977 – 2000) Gary E. Everhardt observed just five years before his retirement: "I am convinced, as I know you are, that ensuring the protection of the Blue Ridge Parkway into the twenty-first century will take our collective energy working together for widespread public support and action [...] to preserve America's favorite drive and add to the quality of life. I leave you," he continued, "with the challenge to join with others to explore new ways to ensure that places like [...] the Blue Ridge Parkway are passed to future generations to enjoy, to explore, to learn of nature and a way of life that has meant so much to each of us."[194]

Blue Ridge Parkway records indicate that by the 1960s, the only incomplete section of the parkway was the 7.7-mile section around Grandfather Mountain near Linville, North Carolina. The large quartzite mountain was the highest mountain in the range and a prominent landmark visible for miles around. The Interior Department had tried to acquire the area as early as 1917, long before the parkway was conceived, and again in the 1940s, when the federal government tried to get the property as a recreational area for the parkway. While Interior had failed to close the deal on Grandfather Mountain, the state of North Carolina had acquired eight miles of right-of-way from the Linville Company, a family-owned corporation which controlled the mountain, in the 1930s. Approximately three-and-a-half miles of road was constructed on this section south of U.S. Route 221 at Beacon Heights. During this period, the National Park Service considered utilizing a portion of this highway – the old Yonahlossee Trail – north from Beacon Heights for the parkway route, but the plan was eventually dismissed, and the park service determined the parkway should be routed higher on the mountain. The Second World War interrupted all construction on the parkway, and it was not until the Mission 66 program that attention was again devoted to the Grandfather Mountain part of the road.

The so-called "high route" laid out by the National Park Service would require construction of a tunnel through Pilot Ridge at an elevation of nearly 4,000 feet, and a segment over Rough Ridge just 1,300 feet below the crest of Grandfather Mountain. On learning of park service plans, Hugh MacRae Morton, of the Linville Company voiced stringent opposition, claiming the proposed construction would destroy his mountain and pointing out that he had already transferred sufficient land to the state for construction to proceed on the "low line" route along the Yonahlossee Trail. The National Park Service and the Federal Highway Administration [better known throughout most of the parkway's history as the Bureau of Public Roads] refused to yield, and a stalemate ensued. North Carolina governor James Terry Sanford (1917–1998) informed National Park Service director Conrad L. Wirth that the state would proceed with the acquisition of the right-of-way desired by the park service, but two weeks later Sanford reversed himself. Since the state already owned the land for the lower level route, he did not feel there was legal authority to condemn property for the higher route.[195]

Testifying before the North Carolina Highway Commission in May 1962, Wirth declared that "rather than do an inferior job," he would prefer to see the parkway remain incomplete around Grandfather Mountain. The "high line" route was, he iterated, the only one that could meet National Park Service standards for scenic beauty. Morton again disputed the claim, stating the lower route could be designed as one of the most attractive sections of the parkway. The term "low line" was misleading anyway, as it would be the highest point along the first 350 miles of the parkway beginning in Virginia. Morton argued that the higher route would desecrate "the wild, wilderness aspects of Grandfather Mountain which is the main thing we have to offer our visitors." Morton had constructed a road to the summit to provide access to a mile-high swinging bridge and may have feared the high line route might have reduced the appeal of his attraction to potential visitors. North Carolina newspapers characterized the location problems as a personal issue between Wirth and Morton. Governor Sanford appointed a committee to study possible alternative routes around Grandfather Mountain in 1963 and that May the committee recommended a compromise route between the "high line" favored by the National Park Service and the U.S. Route 221 parallel route urged by Morton but which had been rejected by the park service. The state highway commission accepted the recommendation and Sanford asked Secretary of the Interior Stewart Udall (1920–2010) to concur. Udall, however, deferred judgement until park service director Wirth could study the location on the ground.[196]

Over the course of 1967 and 1968, National Park Service and Federal Highway Administration planners selected the compromise route, which seemed to satisfy Morton. In June 1968, North Carolina governor Daniel Killian Moore (1906–1986) told new park service director George Benjamin Hartzog Jr. (1920–2008) that the state would acquire the remaining right-of-way along this newly proposed line if the park service would pledge to begin the construction soon afterwards. Hartzog agreed, and on October 22, Moore presented Hartzog with the deed at a ceremony held at the Grandfather Mountain visitor center. Before the year was out, construction was, as promised, underway. For more than two decades, the Grandfather Mountain route was the Blue Ridge Parkway's missing link. Visitors had to make a fourteen-mile detour around the mountain via U.S. Route 221 before returning to

the parkway. The continued feuding with Hugh Morton was the initial cause of the delay, but then came budget delays. In the early 1970s, President Richard M. Nixon's administration froze funding for the parkway, preventing any work going forward. Another fifteen years would pass before motorists could enjoy a continuous journey over the parkway between the Shenandoah and the Great Smoky Mountains national parks.

The most difficult construction of the 7. 7-mile "missing link" on Grandfather Mountain was in the vicinity of Linn Cove Branch, a tributary of Wilson Creek. The terrain was extremely steep and covered with large and precariously perched boulders. National Park Service and Federal Highway Administration (FHWA) engineers determined that cutting a bench for the parkway through this section would endanger the stability of the boulders and cause major scars to the mountainside. As an alternative, FHWA engineer Reginald Bifield "Rex" Cocroft Jr. (1921–1987) suggested that the highway might be elevated across the section on a viaduct following the slope's contours. National Park Service planners agreed that this would be the most feasible solution [a similar project at Mount Rainier National Park carried a roadway over the unstable rim of Stevens Canyon at several points], and the decision resulted in the construction of the most significant structure on the parkway, the Linn Cove Viaduct. The design of this viaduct would become the crowning achievement of Cocroft's career.

The Linn Cove Viaduct [Milepost 304], a segmental post-tension viaduct built using custom-cast interlocking sections, was executed by Figg and Muller Engineers and built from the top down with construction progressing from completed sections of the viaduct itself rather than from the ground. Construction began in 1979. Five years later, in 1984, the viaduct project was awarded the Presidential Award for Design Excellence from President Ronald Reagan. The viaduct is 1,243 feet long and consists of 153 segments weighing fifty tons each. Commensurate with the viaduct project contractors completed work on four remaining bridges in the Grandfather Mountain area, paved the roadway, and installed signs and striping. The parkway constructed the twelve-mile Tanawha Trail through the area in conjunction with the road work. This hiking trail itself is of engineering merit, using boardwalks and wood and steel bridges to carry foot traffic through the fragile terrain. Fifty-two years of parkway construction came to an end in August 1987 when the viaduct and all other projects associated with it were completed. The final work was Project 2G10-H11, a $1.7-million contract awarded to Brown Brothers Construction Company to pave the final 7. 7 miles of road on the Grandfather Mountain segment between the Holloway Mountain Road and Beacon Heights. The final phase of parkway construction cost more than $24 million to construct, and utilized eleven bridges in addition to the viaduct [which was $10 million].[197]

With all construction finally complete, the parkway sponsored a series of events under the overall auspices of "Dedication '87." The governors of Virginia and North Carolina each appointed five members to a coordinating committee, and both states donated $25,000 for the events. The highlight of the celebration was the formal dedication ceremony held on September 11, 1987, at Grandfather Mountain. Following a three-hour delay occasioned by a bomb threat, officials cut the ribbon opening the "missing link." Secretary of Transportation Elizabeth Dole, National Park Service director William Penn Mott, and regional director Robert Baker participated in the program. A "Parade of Years on Wheels" was staged in which cars

from each year of the parkway's construction passed over the Linn Cove Viaduct, where the ribbon-cutting was held. Later, participants gathered at MacRae Meadows on Grandfather Mountain for the formal ceremony and a full day of activities, including traditional arts and crafts demonstrations and performances by musicians Doc Watson and Raymond Fairchild, a banjo player from the Great Smoky Mountains.

As sections of the parkway were completed, land values along the route began to increase. While the restricted right-of-way would not allow most neighboring landowners to connect their properties to the motor road itself, the parkway was quickly recognized as an asset – a moneymaker. Being protected parkland, the parkway made an excellent neighbor. Many were drawn to the parkway corridor in order to be near this linear park. Others foresaw opportunities for commercial development. The very popularity of the parkway carried with it threats to its integrity. According to the National Park Service, approximately three hundred miles of the parkway passes through private land, meaning the majority of the scenic viewsheds beyond the right-of-way were subject to threats from development. The remaining one hundred-and-seventy miles or so was routed through national forests, which offer a different sort of challenge through the possibility of logging clearcuts, logging road construction, mineral extraction or other environmental damage. Protecting the scenic values of the parkway from development and other threats was, and remains, a major concern to parkway staff, local governments, tourism interests, and parkway users.

The numerous public and private access roads entering onto the parkway are largely responsible for off-parkway development. Parkway land managers have long sought to reduce the number of grade crossings. Over the years, many grade crossings have been eliminated either by abandonment, by combination with other secondary roads or through construction of grade separation structures, but eliminating, or at least reducing the number of the remaining intersections, continue to pose one of the greatest challenges to parkway managers. Conscious of the significance of the parkway to their tourist economies, Virginia and North Carolina have enacted some legislation that helps preserve the parkway viewshed. The state of North Carolina passed an ordinance prohibiting all junkyards and commercial signs within six hundred-and-sixty feet of the boundaries of the Blue Ridge Parkway or any scenic easement administered by the parkway in the general assembly's 1973 session. Exceptions were made for signs advertising the sale of land on which the sign was located, and on-premises signs identifying businesses adjacent to the parkway. Existing signs were grandfathered in, but the state Department of Natural and Economic Resources was authorized to acquire, by purchase or condemnation, any junkyards or nonconforming signs within the zone.[198] But this legislation was not designed to stop what happened next: the construction of a massive condominium atop Beech Mountain near Linville in clear view of the parkway. As a result of the condominium project, North Carolina's legislature enacted a Mountain Ridge Protection Act in 1983, that prohibited construction of structures over thirty feet in height on ridge tops above 3,000 feet. Water towers, antennae, utility poles, church steeples and the like were exempted from the regulations.

Much of the parkway passes through national forest land, which generally affords a measure of protection, as the United States Forest Service provided a "scenic zone" similar

to scenic easements and controlled rights-of-way elsewhere on the parkway. Even so, this zone does not hide, on occasion, logging operations from the parkway. A massive clearcut on the Pisgah National Forest below the Linn Cove Viaduct in the summer of 1988 outraged environmentalists and tourism dependent business owners, who complained parkway visitors did not want to see scalped ridges. Faced with the criticism, forest service officials signed a pact with the National Park Service in 1989 giving parkway officials the right to review timber sales, logging road construction, and other projects that might affect the parkway's scenic viewshed. While the National Park Service has no veto power, it can comment and suggest modifications to proposed projects. Forest service officials pledged greater effort to design clearcuts that would not be seen from the parkway, though in areas with expansive vistas, this has not always proved the case. Still, the cooperation between the two agencies has helped preserve the scenic beauty along the parkway corridor, according to the park service's narrative.

Beyond forest service clearcutting and outside the control of federal authorities, cutting of timber by property owners along the parkway has caused problems since the days of land acquisition. In numerous cases in the 1930s and 1940s, property owners removed timber once they understood their lands would be taken for the parkway right-of-way, or after the land was optioned but before payment was made. In such cases, the parkway staff could only hope to secure a restraining order to prohibit such practices. In more recent years, there have been incidents in which trees along the right-of-way have been removed without permission in order to open views to billboards or developments along the parkway. For example, in 1995, the parkway was able to secure a major judgement from Gerald V. Morgan of Little Switzerland, who had removed at least twenty-two trees in order to open up the line of sight to his Mountain View Motel. The parkway sued and was awarded the cost of replacing the trees, revegetating the land which had been disturbed, and for staff time devoted to the matter. The parkway successfully argued for a cost formula based on the value of the trees as a landscape screen, not simply for the board feet of sawtimber and cords of pulpwood removed, the usual standards by which timber is valued.[199]

Scenic America, a national conservation organization dedicated to preserving the nation's countryside, listed the Blue Ridge Parkway as one of America's ten most endangered roads in 1992. The group listed air pollution and the concomitant loss of scenic vistas, and commercial and residential development within the parkway's viewshed as the major threats. The park service notes that while these threats have been acknowledged, the parkway, with its limited resources and management planning limited to its right-of-way, has not always been in a position to respond with effective scenic resource protection techniques. Four years later, in 1996, the Asheville city council granted a conservation easement on its 20,000-acre watershed to the Conservation Trust of North Carolina, a statewide not-for-profit land conservation group. The easement effectively protects one of the most scenic areas along the parkway while guarding the purity of the city's water supply. Another milestone that year came when North Carolina governor James Baxter "Jim" Hunt's Year of the Mountains Commission identified protecting the scenic values of the parkway as a major goal. The commission established a working group, the Preservers of the Parkway, to collect donations to buy critical tracts of

land visible from the parkway. To set priorities under the program, parkway planners and volunteers began cataloguing and assessing views along the roadway in 1997.

Such measures as have been taken are highly important in preserving the parkway and its incomparable setting. Regardless, priorities change and the parkway still faces some of its greatest challenges since the first years of its construction. Protections put in place two decades or more ago have been challenged with the rise of adjacent new residential and commercial development. The location of cellular phone and other communications towers along the parkway remains a matter of concern because these structures would be highly visible intrusions in the viewshed. Signs located just off the parkway right-of-way are other discordant intrusions. Although the viewshed is largely intact through national forest lands and in rugged terrain poorly suited for development, new developments, especially around Roanoke, Blowing Rock, and Asheville, are in many cases all too visible to parkway travelers. Parkway land managers remain attentive to these intrusions and open to working with developers and local governments to reduce the impact of such development on the viewshed, but as the Southern Highlands continue to draw more residents, the long-term prospect of protecting the parkway's scenic values, according to the park service, "is unsettling at best."[200]

Located just off Milepost 120 is the Mill Mountain [also called the Roanoke] Star, the world's largest freestanding illuminated manmade star. Located at the top of Mill Mountain, at eighty-eight-and-a-half feet tall, the star is made up of two thousand feet of neon lights. When it was constructed in 1949, the Roanoke Merchants Association intended only to light it during the Christmas season but when it became a hit, the association and the chamber of commerce opted to keep it lit year-round. After it was built, Roanoke, Virginia, was nicknamed the "star city of the South." Of note, the star is visible for sixty miles from the air and sits 1,045 feet above the city, providing a commanding view of the Roanoke downtown. This photograph of the Mill Mountain Star was taken on November 17, 2008. *TampAGS*[201]

The Blue Ridge Music Center, devoted to the celebration of the music and musicians of the Blue Ridge, was established by the United States Congress in 1997, with support from the National Council for the Traditional Arts, and is located in Galax, Virginia, Milepost 213 on the Blue Ridge Parkway near the Virginia-North Carolina state line. The music center includes the outdoor amphitheater shown in this June 22, 2015 photograph, an indoor interpretive center and theater, and the Roots of American Music, an interactive, entertaining exhibition highlighting the historical significance of the region's music. The Blue Ridge Music Center is operated by the National Park Service and its theater is coordinated through a partnership with the Blue Ridge Parkway Foundation. *Blue Ridge Parkway Foundation*

The Blue Ridge Music Center features a number of static displays of musical instruments in the award-winning interactive Roots of American Music exhibit. The picture was taken on August 29, 2015. *R. M. Lark*[202]

In Valle Crucis, Mast General Store is one of the oldest continuously operating general stores in the United States and is accessible from Milepost 292 and others off the Blue Ridge Parkway. According to the store's history, legend has it that a large tract of land – one thousand acres – in the Watauga River bottom was traded for a dog, a rifle and a sheepskin in the late eighteenth century. Land was plentiful but a working rifle and a well-trained dog and a hide to keep you warm were highly desirable just then. The Mast General Store Annex stands today on a parcel of that land. Land speculation had brought Henry Taylor (1819 – 1899) to the Valle Crucis in or about 1851. Taylor opened a small store before the Civil War called Taylor and Moore Company, located across the road from the present-day Mast General Store. *Continued on next page.*

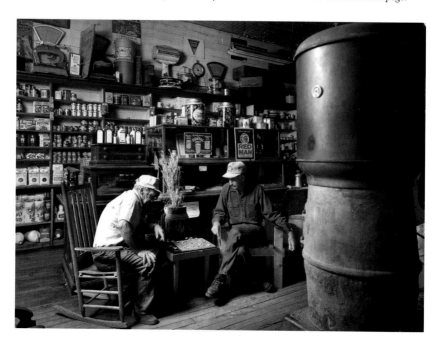

Continued from previous page: In 1882/3, Taylor built the first room of the Taylor General Store. Taylor died in 1899, leaving the store to his son Charles Davis Taylor (1861 – 1937). William Wellington Mast (1876 – 1959), another prominent valley resident who had bought half interest in the store from the Taylor family in 1897, continued to operate the business as Taylor and Mast General Store until 1913, when Mast became the sole owner. Of note, the Mast Farm, established in 1812, is today part of the Mast Farm Inn complex, which became a popular tourist destination of its own by 1915. The Mast Farm Inn is on the National Register of Historic Places. The original Mast General Store, located on North Carolina Highway 194 [N.C. 194] in Valle Crucis, Watauga County, North Carolina, is shown here as it looked on November 11, 2007. *Ken Thomas*[203]

The 3,500-acre Moses H. Cone Memorial Park [Milepost 294], near Blowing Rock, North Carolina, on the Blue Ridge Parkway, preserves the country estate of Moses Cone, a prosperous textile entrepreneur, conservationist, and philanthropist of the Gilded Age. Its centerpiece is Flat Top Manor, a gleaming white twenty-room, 13,000-square-foot mansion built in 1901 in the grand Colonial Revival style. The manor is now the home of the Parkway Craft Center, one of five shops of the Southern Highland Craft Guild which features handmade crafts by hundreds of regional artists. Throughout the season, local artists demonstrate crafts such as quilting, embroidery, weaving, pottery, glass-blowing, and woodcarving on the front porch of the manor. The picture of the manor house (shown here) was taken on February 5, 2009. *Ken Thomas*[204]

Opposite below: Carol M. Highsmith took this contemporary picture of checker players inside Mast General Store in Valle Crucis, North Carolina. The Mast family continued to operate the store until the early 1970s when it was sold to an Appalachian State University professor and an Atlanta, Georgia surgeon. After a few bumps in the road, to include several owners and a brief closure, the store was eventually bought by John and Faye Cooper, who reopened it on June 6, 1980. The tiny village of Valle Crucis is situated high in North Carolina's Blue Ridge Mountains near Boone, and is North Carolina's first National Register Historic Rural Community, added in 2004, and when the historic district was established in the 1990s, it was the only one in a rural area recognized by the state of North Carolina. The store, the heartbeat of the community, is home to the local post office and still offers a five-cent cup of coffee. The store was added to the National Register of Historic Places in April 1973, where it is noted as one of the best remaining examples of an old country general store. *Library of Congress*

The Moses H. Cone Memorial Park carriage house is shown in this February 5, 2009 photograph. *Ken Thomas*[205]

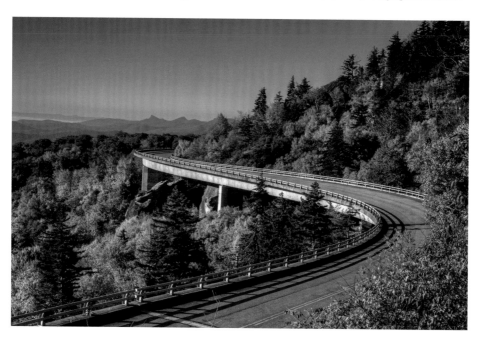

The Linn Cove Viaduct, photographed by Matthew Trudeau on October 12, 2015, is a 1,243-foot concrete segmental bridge on the Blue Ridge Parkway that snakes around the slopes of Grandfather Mountain. This 7.7-mile "missing link" to the parkway (shown here) was completed in 1987 at a cost of $10 million and was the last section of the parkway to be built. Located in the Boone area of the North Carolina High Country at Milepost 304, the Grandfather Mountain part of the parkway took decades to complete because choosing the route involved a standoff between the National Park Service and Grandfather Mountain owner Hugh MacRae Morton. The discord was resolved amicably and the viaduct was built. *Continued on next page.*

Continued from previous page: The complex, S-shaped, undulating balcony across the side of the mountain was constructed of 153, fifty-ton segments cast to precisely adjoin the next segment, each of which was lowered out over the elongating end of the viaduct, then epoxied into place and torsioned with internal cables. The viaduct – one of the most complicated concrete bridges ever built – is an engineering marvel and the most photographed section of the parkway. The Linn Cove Visitor Center is located at the south end of the viaduct on the Asheville, North Carolina side. *Matthew Trudeau Photography*[206]

At 5,946 feet, Grandfather Mountain, near Linville, North Carolina, is the highest peak on the eastern escarpment of the Blue Ridge Mountains [of note, Mount Mitchell is in the Black Mountains range]. According to historic record, while geologists believe that Grandfather Mountain was formed about 300 million years ago, some of the rock formations on it are even older than the mountain itself, dating back 1.1 billion years. The original Cherokee name for Grandfather Mountain was Tanawha, meaning "a fabulous eagle." Pioneers later named it "Grandfather" according to the lore, which informs that they saw the face of an old man in one of mountain's cliffs. The Blue Ridge Parkway passes by the south side of the mountain and also passes over the nearby Grandmother Gap. The mountain is located at the merge point of Avery, Caldwell (highest point) and Watauga (highest point) counties. It was privately owned and operated as a nature preserve and tourist attraction until 2008, and is still best known for its mile-high swinging bridge – the highest in the United States – first built by Hugh MacRae Morton. Morton, who died on June 1, 2006, had inherited the mountain from his grandfather and developed it as a tourist attraction. North Carolina governor Michael Francis "Mike" Easley announced on September 29, 2008, that the state had agreed to purchase 2,600 acres of the undeveloped portions of the mountain from the Morton family for $12 million. This backcountry area has since been added to the North Carolina state park system, becoming the Tar Heel state's thirty-fourth state park the following year. As part of the purchase agreement, the state also acquired a conservation easement and right of first refusal over the remaining tourist attraction side of the mountain. The Morton family further established the Grandfather Mountain Stewardship Foundation to continue operation of Hugh Morton's educational nature park. Grandfather Mountain, with the summit buried in the clouds, is shown in this August 1, 2011 photograph. *ForestWander*[207]

Hugh MacRae Morton (1921–2006) (center) was photographed on April 16, 1964, with North Carolina governor James Terry Sanford (left) and Andy Anderson. Morton, an internationally renowned photographer and nature conservationist who developed Grandfather Mountain, was a University of North Carolina Chapel Hill graduate and lifetime sports fan who befriended many influential North Carolinians. He inherited the mountain from his great-grandfather, Donald MacRae, who had bought the development rights for the 16,000 acres around it in 1889 from Walter Waightstill Lenoir (1823–1890), grandson of Revolutionary War officer and prominent statesman William Lenoir (1751–1839). Later, in 1952, Morton inherited more than 4,000 acres on Grandfather Mountain from his grandfather, Hugh MacRae, and immediately set out to make the property more accessible to tourists, extending and improving a vehicular road to the mountain's summit and also erecting the Mile-High Swinging Bridge. He then developed animal habitats that now contain black bears, eagles, river otters and mountain lions, as a sampling of the mountain's protected residents. In Morton's lifetime, Grandfather Mountain became, in 1993, the first privately owned property in the world to receive UNESCO recognition as an International Biosphere Reserve. *University of North Carolina Chapel Hill*

Opposite above: According to Grandfather Mountain[208] information, the Mile-High Swinging Bridge (shown in this April 30, 2008 photograph) was built to give visitors easy access to the breathtaking view from Grandfather Mountain's Linville Peak. The 228-foot suspension bridge spans an 80-foot chasm at more than one mile in elevation. Surveys show that the journey to the other side is always considered the highlight of a trip the mountain. Of note, the bridge was designed by Charles Hartman Jr., of Greensboro, North Carolina, where it was fabricated and reassembled on the mountain. The build-out took three weeks. The bridge was dedicated on September 2, 1952, by North Carolina governor William Bradley Umstead (1895–1954). The bridge's name was coined by former state tourism director Charles Jackson Parker (1900–1963) and refers to the structure's elevation above sea level – at 5,280 feet. The mile-high point is actually located near the center of the bridge, 98.2 feet from the Linville Peak side. The bridge was rebuilt in 1999 using modern building materials. The cables, floor boards and side rails were all replaced using galvanized steel. The redesign was executed by Sutton, Kennerly and Associates Engineering, and rebuilt by Taylor and Murphy Construction Company, both of Asheville, North Carolina. *Ken Thomas*[209]

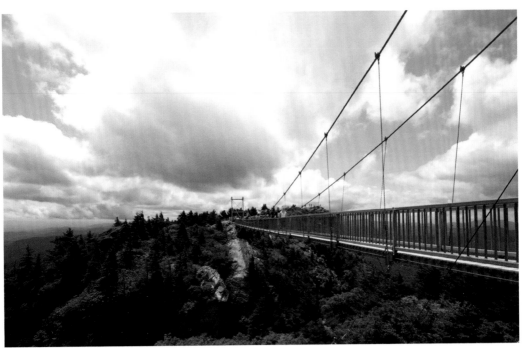

Grandfather Mountain, near Linville, North Carolina, is popular not only for the rebuilt Mile-High Swinging Bridge (also shown in this December 18, 2009) but panoramic views, wildlife and many remarkable hiking trails. Today, the North Carolina Division of Parks and Recreation and the Grandfather Mountain Stewardship Foundation work together to manage and protect this natural treasure for the good of the people of North Carolina. *David Joyce*[210]

An American black bear [sp. *Ursus americanus*] was photographed in the Grandfather Mountain animal habitat on April 30, 2008. There are seven environmental habitats – large enclosures – that allow visitors to the mountain to see animals in their natural native habitats [unlike a city zoo in which the habitats must be recreated]. *Ken Thomas*[211]

The Linville River (shown here) begins in the slopes of Peak, Sugar and Flat Top mountains in Avery County, where it flows from the southern face of Grandfather Mountain. The river snakes through the communities of Grandfather, Linville, Pineola, and Crossnore. The river flows over Linville Falls in Burke County and through Linville Gorge before traveling nearly thirty miles, where it ends at Lake James and the Catawba River. The gorge has been called "the Grand Canyon of North Carolina." The lake straddles the border between Burke and McDowell counties. *Ken Thomas*[212]

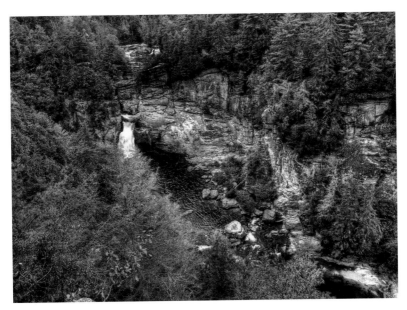

Linville Falls, located at Milepost 316.4 and shown in this November 23, 2013 photograph, is one of the most impressive waterfalls found on the Blue Ridge Parkway. The Linville River flows from its headwaters high on the steep slopes of Grandfather Mountain and cascades through two falls as it begins a nearly 2,000-foot descent through this rugged and spectacularly beautiful gorge. Known by the Cherokee as "the river of many cliffs," Linville Gorge was the nation's first officially designated wilderness area. Towering hemlocks, dense stands of rhododendron, and native wildflowers grow along the trails that begin at the visitor center and encircle the falls. *Kadokal*[213]

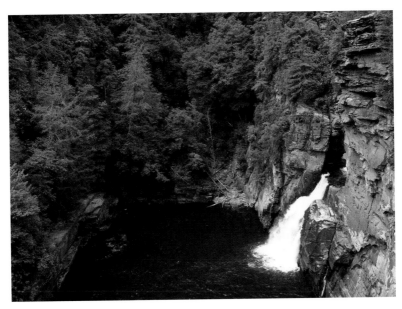

The Linville Falls [Milepost 316.4], photographed from the Plunge Basin overlook on the eastern side of twelve-mile Linville Gorge, is shown as it looked on June 1, 2008. The falls drop ninety feet into the gorge. *Ken Thomas*[214]

Near the town of Spruce Pine, Mitchell County, North Carolina, at Milepost 328.3 of the Blue Ridge Parkway lies The Orchard at Altapass, a reclaimed historic orchard that dates back to 1908, the product of Clinchfield Railroad speculation in the area. The Clinchfield Railroad constructed an engineering marvel of loops consisting of eighteen tunnels in thirteen-miles of track built beside and below the present-day orchard. The Orchard's first resident, pioneer Charles Ephraim McKinney (1773–1852), had given the community the name McKinney Gap but once the new railroad came on scene, it renamed the town Altapass, meaning high pass. The railroad saw an opportunity to cultivate the apple business and planted trees on several hundred acres. According to the orchard's history, the first trees were planted facing southeast, where the land is frost-free most of the time, with cold air sinking into the nearby valleys, replaced by warm air. The orchard grew state champion apples for many years and at its peak produced 125,000 bushels of apples each year. When the Blue Ridge Parkway was built through the area in the 1930s, it split the orchard in half. After that, the orchard largely faded as a gaining agricultural enterprise. In January 1995, Cary, North Carolina real estate agent Katherine "Kit" Carson Trubey bought the orchard and surrounding property and enlisted the help of her brother William David "Bill" Carson to restore the orchard operation. Trubey and Carson sold the upper half of the acreage to the Conservation Trust of North Carolina and on the lower half established a nonprofit Appalachian cultural and history center, preserving the land and promoting the region's rich backstory while also continuing the apple orchard operation. Of interest, the orchard sits almost astride of the Eastern Continental Divide. The photograph shown here was taken November 16, 2008. *Ken Thomas*[215]

Located at Milepost 334 and a stone's throw from the parkway is the community of Little Switzerland and the Emerald Village North Carolina Mining Museum, collocated with the historic Bon Ami Mine. Little Switzerland is an unincorporated town in McDowell and Mitchell counties located on North Carolina Highway 226A [N.C. 226A] off the Blue Ridge Parkway. The Switzerland Company was established there in 1909 by North Carolina State Supreme Court Justice Heriot Clarkson to build a resort village. Of note, the Switzerland Company later filed suit against construction of the Blue Ridge Parkway, arguing that it was seeking a right of way of eight hundred feet wide and through the resort and had no intention of compensating the company the fair market value. The suit was settled and the parkway got a two-hundred-foot wide access and paid out $25,000; this remains the narrowest point on the parkway in North Carolina. The access to the historic Switzerland Inn is the only commercial access road on the parkway. The photographs of the mining museum were taken on August 1, 2008. The outdoor display includes the elevator car and old train engine shown in the second photograph. *State Archives of North Carolina*

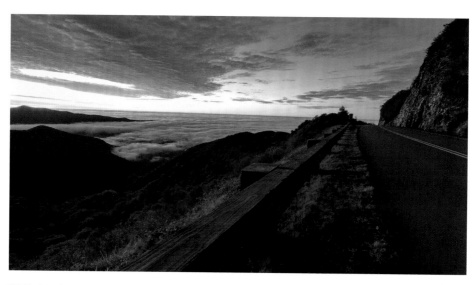

While it is the twisted, jagged, rocky crags that give the place its name, this high elevation summit is home to the most spectacular floral display along the 469-mile Blue Ridge Parkway. Craggy Gardens [Milepost 364], just north of Asheville, North Carolina, is one of the most dramatic viewpoints on the parkway. Tourism guides promote stunning vistas of the Blue Ridge Mountains that stretch far into Tennessee to the west and toward central North Carolina to the east. These views can be enjoyed from the parking area near the Craggy Gardens Visitor Center and along nearby hiking trails. This is the road leading to Craggy Gardens, photographed on October 17, 2013. *Will Thomas*[216]

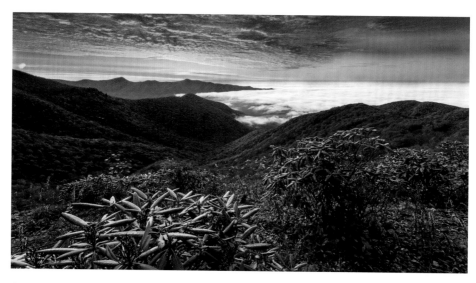

Craggy Gardens becomes a mountain-sized bouquet when the rhododendron thickets on the upper heights cover the landscape in pink and purple beginning in the early summer. A favorite hiking trail, Craggy Pinnacle, leads hikers through a tunnel of rhododendron to the summit, which offers an incomparable 360-degree view. Some of those rhododendrons are shown in the foreground of this photograph, taken on October 15, 2013. The combination of high altitude, cool weather, and exposed rocky outcrops creates the necessary habitat for a number of rare and endangered plants. Craggy Gardens has been recognized by the state of North Carolina as a Natural Heritage Area and has also been recommended as a National Natural Landmark. *Will Thomas*[217]

The Folk Art Center [Milepost 382] at Asheville, North Carolina, is home to the Southern Highland Craft Guild and showcases the finest in traditional and contemporary crafts of the Southern Appalachians. The guild was first chartered in 1930. During the Great Depression it cultivated commerce for craftspeople in the Appalachian region, a legacy that continues today as the guild exercises a significant role in the Southern Highlands craft economy through the operation of four craft shops and two annual craft expositions. Vicki Dameron took this contemporaneous photograph of the Folk Art Center's vibrant central gallery *National Park Service*

Located at Hemphill Knob on the southeastern outskirts of Asheville, North Carolina, and two miles west of the Folk Art Center, the Blue Ridge Parkway Visitor Center [Milepost 384] features an award-winning film – *The Blue Ridge Parkway – America's Favorite Journey* – and exhibits that spotlight the natural and cultural heritage, economic traditions, and recreational opportunities found in western North Carolina and the Blue Ridge Parkway. The $9.8 million center opened on December 17, 2007. Vicki Dameron took this contemporary picture of the center. *National Park Service*

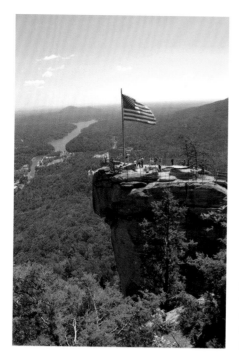

Exit the Blue Ridge Parkway at Milepost 384.7 near Asheville onto U.S. Route 74A East [U.S. 74A East]. Stay on U.S. 74A East for twenty miles and the Chimney Rock State Park entrance is on the right. The 6,807-acre park is in Rutherford County. Chimney Rock, which rises 1,200 feet above the valley floor, is surrounded by the towering cliffs of Hickory Nut Gorge and visitors can see more than seventy-five miles across Lake Lure, the Blue Ridge Mountains and Carolina Piedmont. The park had its beginnings when, in 1902, Dr. Lucius Boardman Morse[218] (1871 – 1946), a physician diagnosed with tuberculosis and looking for a healthier climate, bought his first sixty-four acres of Chimney Rock Mountain from Jerome Benjamin "Rome" Freeman (1849 – 1919), including the now-famous chimney and cliffs. Morse and his family owned and operated Chimney Rock Park as a privately managed attraction from 1902 to 2007. *Continued below.*

Many smaller tracts had been purchased over the years to expand the park to 996 acres. But in 2006 the land was put up for sale. Troubled that the property might end up in the hands of private developers, the state and the Morse family reached an agreement and on May 21, 2007, Governor Mike Easley announced that the park was fully owned by the state. Later, that July, the North Carolina General Assembly approved the renaming of Hickory Nut Gorge State Park to Chimney Rock State Park, thus enjoining the former private park with the state-run park that surrounded it. The photograph of Chimney Rock looking east towards Lake Lure was taken on August 11, 2008, from the Opera Box observation point. David Dugan took the photograph of the Chimney Rock State Park entrance on May 23, 2015. *J.M. Turner*[219] and *David Dugan*[220]

One of the top attractions just off the Blue Ridge Parkway in Asheville occurs at Milepost 388.8 where U.S. Route 25 [U.S. 25] crosses, from the parkway, with George Washington and Edith Stuyvesant Gerry Vanderbilt's Biltmore Estate just three miles to the north. Carol M. Highsmith took these contemporary photographs of the house, which Vanderbilt moved into in October 1895, one of the Italian rose marble [Rosso di Verona] lions that greet guests as they enter the residence and the magnificent banquet hall with a seventy-foot ceiling. While on the estate, the other must-sees are the gardens, winery and the River Bend Farm. *Library of Congress*

In Asheville, there are four primary entrances to the parkway. The first entry point is Milepost 382.6 where U.S. Route 70 [U.S. 70] crosses it; the Folk Art Center is a short drive north. The best entrance is Interstate 40 [I-40] heading west. The second point occurs at Milepost 384.7 at U.S. 74A, the best route from I-40 heading east. The third entry node occurs at Milepost 388.8 where U.S. 25 crosses, from the parkway, with the Biltmore Estate three miles to the north. Milepost 393.6, where North Carolina Highway 191 [N.C. 191] crosses, is the nearest entrance from Interstate 26 [I-26]. The North Carolina Arboretum is located at this intersection. The arboretum is nestled in the Bent Creek Experimental Forest of the Pisgah National Forest southwest of Asheville but still near the parkway. The idea of establishing an arboretum and botanical garden close to the Biltmore Estate began with drawings made by Frederick Law Olmsted in 1898 but today's facility was not created by the North Carolina General Assembly until 1986, when it was made part of the University of North Carolina system. Three years later, the site was officially designated the North Carolina Arboretum. The arboretum's Baker Exhibit Center, Blue Ridge Quilt Garden and Bonsai Garden are shown in these July 21, 2008 photographs. *Ken Thomas*[221]

The Pisgah National Forest Inn [the former Old Pisgah Inn and Cottage] [Milepost 408.6] is an important complex within the framework of the recreational history of western North Carolina. Located twenty-five miles south of Asheville on the left side looking south, about three miles southwest of the parkway and North Carolina Highway 151 [N.C. 151] intersection, the inn was a favorite retreat for the area's wealthy elite and certain noted professionals from other areas. The property is an excellent example of rustic architecture and retains integrity of location and setting, as well as materials, workmanship, design, feeling, and association. Derived from William West Durant's Adirondack architecture known as Pine Knot Style, the irregular mass of inn buildings and additions are informally planned, with rustic gray board and batten siding, uncoursed stonework chimneys, and bark covered structural members composing a structure sitting on a shelf overlooking a broad forest expanse. Built in 1919, the inn sits at 5,120 feet elevation on a shelf of Mount Pisgah, a peak named for the biblical mountain ridge. The inn consists of what was formerly a main lodge with restaurant facilities, a gift shop, eleven bedrooms with baths, and four overnight cabins adjacent to the lodge: Kalmia Cottage, Chinquapin Cottage, Chewink Cottage, and Tree-Top Cabin. A rambling porch wraps around the back or south side of the inn. From it there is an exceptional panorama of the Pink Beds Valley of the Pisgah National Forest. George Farrington Weston (1863 – 1946), an architect and engineer and the designer and original owner of the inn, had a preoccupation with Pisgah's beauty and the surrounding bountiful forests. Weston had worked as the superintendent of farms (dairy, pig and poultry) for millionaire George Washington Vanderbilt (1862 – 1914) from 1895 to 1903. At the turn of the twentieth century, Vanderbilt owned Mount Pisgah as part of his Biltmore Estate. After George Vanderbilt's death, his wife, Edith Stuyvesant Gerry Vanderbilt (1873 – 1958), sold 36,000 acres of the Pisgah Forest to the United States government. Under the direction of the United States Forest Service, Pisgah Mountain became the backbone of Pisgah National Forest. George and Mary Cynthia Weston moved back to Asheville from New York City in 1918. As outdoor enthusiasts, they appreciated the beauty of the Pisgah area and it was there that George Weston told his wife he wanted to spend the rest of his life. The inn opened for business in 1920. The photographs shown here – exterior and interior – were taken for a Historic American Buildings Survey in April 1988. *Library of Congress*

The inn and its four adjacent cabins and two outbuildings are built of pine, and the interior of the inn is of wormy chestnut. Weston's structures reflect little stylistic influences except in the unpeeled log beams and supports as seen on the porches of all buildings and in the decorative unpeeled log motif on the façade, portico and in the lobby/dining room of the inn. The unpeeled log motif was a popular decorative technique used, and perhaps originated, by William West Durant in the 1890s for his summer camp resorts in the Adirondacks. The inn was constructed on 2.91 acres of leased land within the Pisgah National Forest, on the Haywood – Transylvania county line. The photographs shown here were taken for a Historic American Buildings Survey in April 1988. *Library of Congress*

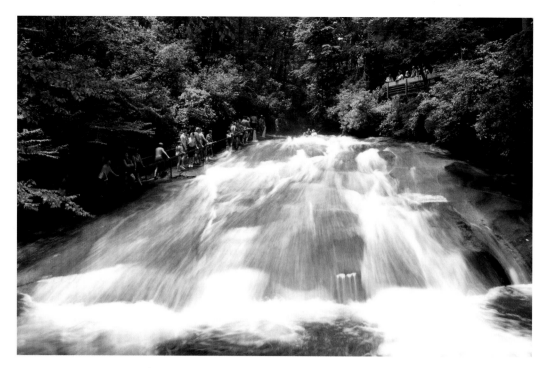

Located down U.S. Route 276 [U.S. 276] near Milepost 412, Sliding Rock got its name because visitors can slide all the way down the waterfall into the plunge pool below. The attraction is located on Looking Glass Creek in the Pisgah National Forest eight miles from Brevard in Transylvania County. The rock formation has a gentle slope and is about sixty feet long. The slide is fueled by eleven thousand gallons of water flowing down the rock each minute. The water here is very cold, making it particularly popular during the hot summer months. This photograph of Sliding Rock was taken on June 25, 2013. *Lincolnh*[222]

Located at 3,500-feet elevation in Balsam, Jackson County, North Carolina, in a gap dividing the Plott Balsam and Richland Balsam mountain ranges, the historic wooden neoclassical and victorian Balsam Mountain Inn, per its history, was once the home to the highest passenger rail station in the east. Guests arriving to what was then called the Balsam Mountain Springs Hotel used the inn as the springboard for day trips to nearby peaks, some of which rise to over 6,000 feet. Today's guests use the inn's accommodations to launch hikes to the nearby North Carolina Mountains-to-Sea Trail or to drive the magnificent Blue Ridge Parkway. The inn was begun by Athens, Georgia brothers-in-law Joseph Key Kenney (1856 – 1940) and Walter Scott Christy (1858 – 1923), who operated a boarding house in Balsam at the turn of the twentieth century. *Continued on next page.*

Continued from previous page. From that first accommodation they took patrons out on hunting and fishing excursions and built their reputation on the wonderful food they served. In 1905 Kenney and Christy began construction of a 100-room hotel and opened the present fifty-room inn in 1908. Due to the inn's 100-foot porches, spectacular views and fine food it came to be called the "grand old lady of Balsam." Passenger rail ended in 1949. The inn is the last railroad resort hotel still standing in Balsam. In July 1982 it was added to the National Register of Historic Places. The inn was purchased by an experienced East Tennessee innkeeper and preservationist – Merrily Teasley – in 1990. She restored the inn and built an addition that serves as a dining porch that won the Gertrude S. Carraway Award of Merit from Preservation North Carolina in 1995. This photograph of the Balsam Mountain Inn was taken on May 15, 2015. *Vanessa Ezekowitz*[223]

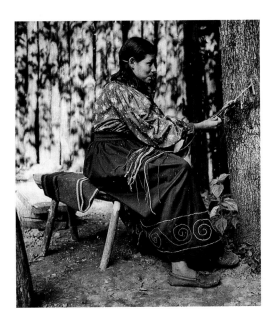

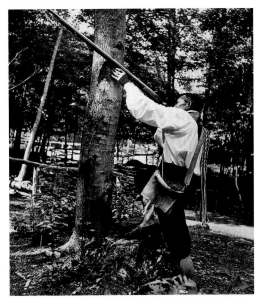

The Eastern Band of Cherokee Indians (EBCI) can be found in Cherokee, Swain County, North Carolina, at the end of the parkway. From this location, visitors will find the Museum of the Cherokee Indian, the Qualla Arts and Crafts Mutual, the Oconaluftee Indian Village and the Mountainside Theater featuring the outdoor drama *Unto These Hills*, which first debuted on July 1, 1950. The Oconaluftee Indian Village [Milepost 469.1], a replica of an eighteenth-century Eastern Cherokee community and a living museum, is located in Cherokee at the end of the Blue Ridge Parkway and the gateway to great Smoky Mountains National Park. These scenes from the re-created village were taken in 1952. *State Archives of North Carolina*

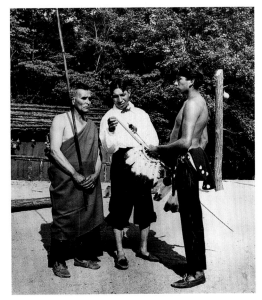

In the first photograph, taken at the re-created Oconaluftee Indian Village, wood carvings hang from an open-air display, and in the second picture, an elderly Cherokee woman demonstrates basket weaving. Both images were taken after 1963 for the United States Department of the Interior, Indian Arts and Crafts Board, Cherokee Field Office. *National Archives*

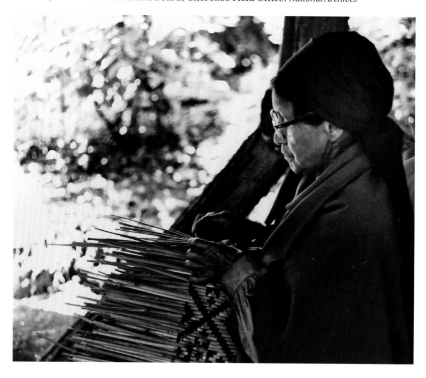

At the start of the Great Smoky Mountains Expressway, U.S. Route 19 [U.S. 19] exits towards the towns of Bryson City and Cherokee in Swain County. At Cherokee, travelers can go north on U.S. Route 441 [U.S. 441] to the Great Smoky Mountains National Park or to the Blue Ridge Parkway before traveling through the rest of the Qualla Boundary. John Margolies took this picture in 1979 of Cherokee's Indian Store on U.S. 19 as part of his Roadside America documentation project. In the 1940s, additional construction work on U.S. 19 was assured by a compromise made with the Eastern Band of Cherokee Indians (EBCI) in return for right-of-way through the Qualla Boundary for the Blue Ridge Parkway. The Qualla Boundary includes Cherokee and several other communities that would have been clan townships in earlier times. The EBCI is a sovereign nation with a three-branch government: executive branch, headed by a principal chief and vice chief; legislative tribal council, and judicial branch. The EBCI tribal government provides services typical of those provided by most municipal governments. *Library of Congress*

Passing over a spur of Heintooga Ridge Road, the Blue Ridge Parkway drops through the Qualla Reservation, home of the Eastern Band of Cherokee Indians, to reach its terminus at the Oconaluftee River [the bridge at Milepost 469.1] in Great Smoky Mountains National Park [469.9 miles from the parkway's beginning]. Located in downtown Cherokee, North Carolina, the Cherokee Trader gift shop was originally built by Lois Queen Farthing (1923 – 2006), the matriarch of Cherokee tourism, who led the town's 1950s expansion from a remote craft town to a full-scale tourist destination. Cherokee is on the reservation home of the Eastern Band of Cherokee Indians. At Oconaluftee Indian Village, the eighteenth-century Cherokee lifestyle is preserved by way of demonstrations. *Continued on next page.*

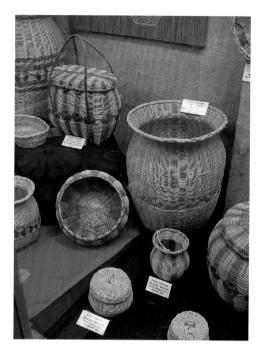

Continued from previous page. During the summer months, the outdoor Mountainside Theater production of *Unto These Hills* tells the Cherokee tribal story. Though Farthing is now gone, the shop is still owned by her family, and they maintain its elaborate neon sign, erected in 1964, in good repair. Carol M. Highsmith took this contemporary photograph of the double-sided neon sign and local landmark. *Library of Congress*

Located at the Qualla Arts and Crafts Mutual, the oldest Native American cooperative, founded in 1946, these baskets made of honeysuckle vines by Cherokee artisan Lucy George in the 1950s, were on display when the picture was taken on July 31, 2007. *State Archives of North Carolina*

Paul Qually, a preservation specialist, took this picture of the reinforced concrete arch Oconaluftee Bridge, located at the terminus of the parkway and the beginning of Great Smoky Mountains National Park in Cherokee, Swain County, on October 1, 1981, five years after it had been closed to vehicular traffic. The bridge was designed by Daniel Benjamin Luten (1869–1946) and built in 1921 by his firm, Luten Bridge Company of Knoxville, Tennessee. Luten was responsible for the building of some 11,000 concrete bridges and held forty-nine patents for improvement of bridge construction. When he retired in 1932, the final number of bridges in his portfolio totaled 15,000. Though it is unknown how many of them remain in existence today, there are more than twenty believed to exist in Tennessee, North Carolina and Georgia. *Library of Congress*

Right: Chief Dennis Ray Wolfe (1954 – 1998), a full-blooded Cherokee Indian, was photographed by Carol M. Highsmith at his home in Cherokee, North Carolina, in or about the decade prior to his death. Wolfe was the ambassador for the Eastern Band of Cherokee Indians. *Library of Congress*

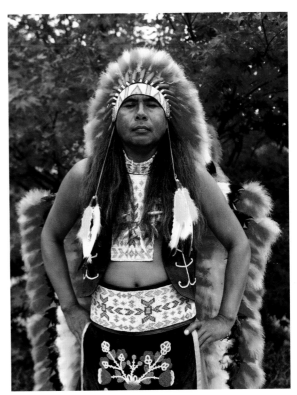

Below: Located in front of the Museum of the Cherokee Indian in Cherokee, North Carolina, the massive carving is a bust of Sequoyah wearing a pendant around his neck and a head wrap with a large protruding feather. According to the sculptor, the carving is a representative image created using a combination of various Native Americans. It depicts Sequoyah aged over seventy as can be seen from the lines in his face and is unlike typical depictions that show him much younger. There are also three tears on his face, two on the right and one on the left that represent the beginning of the Trail of Tears. Carved from a single redwood tree donated by Georgia-Pacific and trucked from California, it stands twenty-two-feet tall, is five-feet in diameter and held in place by a seven-sided stone and masonry base. Attached to the base are marble plaques with pictographs representing the seven clans of the Cherokee Nation. A lectern shaped stone structure holds the dedication plaque. A low circular stone wall is bisected with sidewalks allowing approach to the statue. This Sequoyah carving is number 63 in artist Peter "Wolf" Toth's Whispering Giants series of sculptures that have been placed in all fifty states and Canada to commemorate Native Americans. Of note, Sequoyah invented the Cherokee alphabet. The statue was dedicated on September 30, 1989, and subsequently photographed by Carol M. Highsmith. *Library of Congress*

ENDNOTES

1. Department of the Interior/National Park Service. Historic American Engineering Record [HAER]. Blue Ridge Parkway [HAER No. NC-42] [1996/7] http://cdn.loc.gov/master/pnp/habshaer/nc/nc0400/nc0478/data/nc0478data.pdf [This source is used throughout the text as original source material provided via the National Park Service.]

2. Department of the Interior/National Park Service. *Visual Character of the Blue Ridge Parkway – Virginia and North Carolina*. Washington, D.C., January 1997. https://ia800609.us.archive.org/6/items/visualcharactero00nati/visualcharactero00nati.pdf

3. Department of the Interior/National Park Service. Blue Ridge Parkway [HAER] [1996/7], ibid.

4. Ibid.

5. Department of the Interior/National Park Service. *Visual Character of the Blue Ridge Parkway*, January 1997.

6. Department of the Interior/National Park Service. Blue Ridge Parkway [HAER] [1996/7], ibid.

7. Anderson, C. Thomas, ed. *Arthur Rothstein's American Portraits*. Washington, D.C.: thegreatdepressionphotos.com, 2014. https://thegreatdepressionphotos.files.wordpress.com/2014/07/arthur-rothsteins-american-portraits.pdf

8. "Corbin's Hollow Guffaws," (*Washington*) Post, October 1931. [clipping]

9. Department of the Interior/National Park Service. *Visual Character of the Blue Ridge Parkway*, January 1997.

10. Department of the Interior/National Park Service. Blue Ridge Parkway [HAER] [1996/7], ibid.

11. Bayliss, Dudley C. *Planning Our National Park Roads and Our National Parkways*. Washington, D.C.: National Park Service, 1957.

12. 12 Bayliss, Dudley C., "Parkway development under the National Park Service," *Parks and Recreation*, Volume 20, February 1937.

13. Ibid.

14. Ibid.

15. Department of the Interior/National Park Service. Blue Ridge Parkway [HAER] [1996/7], ibid.

16. Ibid.

17. Ibid.

18. Demaray was a native of Washington, D.C., who first entered government service as a messenger when he was sixteen years old, working his way through school. He became a draftsman with the

United States Geological Survey, at various times testifying before congressional and budgetary committees but also writing about the federal park system. Demaray moved to the National Park Service when its headquarters was first staffed in 1917, serving as associate director from 1933 and one brief tenure as director [April–December 1951].

19. Department of the Interior/National Park Service. Blue Ridge Parkway [HAER] [1996/7], ibid.
20. Ibid.
21. Ibid.
22. Ibid.
23. Ibid.
24. Ibid.
25. Ibid.
26. Harry Flood Byrd was the Democrat senator from Virginia from 1933 to 1965, and the fiftieth governor of the commonwealth from 1926 to 1930. Possibly his greatest legacy was the creation of Shenandoah National Park as well as accompanying Skyline Drive, the Blue Ridge Parkway and the Virginia state park system. Shenandoah National Park's main visitor center is named in his honor. The Blue Ridge Parkway bridge over the James River in Big Island, Virginia, was also named and dedicated to him in 1985.
27. Department of the Interior/National Park Service. Blue Ridge Parkway [HAER] [1996/7], ibid.
28. Ibid.
29. McAlister was governor of Tennessee from 1933 to 1937.
30. Ehringhaus, a native of Elizabeth City, North Carolina, a legislator and also solicitor of the First Judicial Circuit, was governor from 1933 to 1937.
31. Bailey was a United States senator from North Carolina from 1931 to 1946.
32. Kirchner was a graduate of the Yale University School of Forestry and became, as his career progressed, one of the country's leading forestry experts, serving in posts throughout the United States. At the end of the Second World War, he was dispatched to Berlin, Germany, to do an assessment of forestry within the American zone for the military headquarters.
33. Goetz, a Tennessee native, first went to work as an engineer for the Tennessee State Highway Department in 1916. When he retired in 1951, just four months before his death, Goetz had been employed with the highway department, with the exception of a couple of small breaks in service, for thirty-five years.
34. Department of the Interior/National Park Service. Blue Ridge Parkway [HAER] [1996/7], ibid.
35. Anderson graduated with a bachelor of science degree in civil engineering from Virginia Military Institute [VMI] in 1913 [with honors], and earned the degree of civil engineer from Cornell University [advanced degree] in 1917. He served in the United States Army prior to the First World War and from 1917 to 1919, during the Great War, he was on the United States Army General Staff, rising to the rank of lieutenant colonel. He returned to VMI in 1919 and in 1920 was put in charge of the Department of Civil Engineering. Anderson performed various functions for the federal Bureau of Public Roads from 1921 to 1923. From 1932 to 1935, Anderson served as state engineer and director of the Federal Public Works Administration for Virginia, in which capacity he made many significant and enduring improvements to schools and public buildings in Virginia. In 1935, he returned to VMI and in 1937 was appointed dean of the faculty and academic executive, a position carrying the rank of brigadier general in the Virginia Militia. In 1941, he was appointed Virginia State Highway commissioner and retained this post until his retirement in 1958. He made significant contributions to highway progress and received the George S. Bartlett Award in 1955 in recognition of his service to this field. He was active in developing some of the commonwealth's outstanding bridge and tunnel projects, including the Elizabeth River Tunnels; the Hampton Roads Bridge-Tunnel project; the George P. Coleman Memorial Bridge; the Robert O. Norris Jr. Bridge, and the Richmond-Petersburg toll road.
36. Department of the Interior/National Park Service. Blue Ridge Parkway [HAER] [1996/7], ibid.
37. McKellar was in office from 1917 to 1953.
38. Department of the Interior/National Park Service. Blue Ridge Parkway [HAER] [1996/7], ibid.

39. Ibid.
40. Ibid.
41. Ibid.
42. Ibid.
43. Ibid.
44. Ibid.
45. Ibid.
46. Clarke, a Cornell University 1913 graduate, had been the dean of the Cornell University College of Architecture and was also, at the end of his life, a Cornell professor emeritus of landscape architecture. He had joined the Cornell faculty in 1935 as a professor of city and regional planning. Clarke was made a doctor of humane letters by Yale University. He was chairman of the National Commission of Fine Arts from 1937 to 1950, after it had been established to advise on art and architecture in the nation's capital. He was responsible for siting the Pentagon complex on a former federal experimental farm in Arlington, Virginia.
47. Department of the Interior/National Park Service. Blue Ridge Parkway [HAER] [1996/7], ibid.
48. Simonson first joined the Bureau of Public Roads in 1929 as a landscape architect on the Mount Vernon Memorial Highway in Virginia. When Simonson retired, the bureau's retirement notice praised his "far-sighted contribution to roadside development and highway location-design brought about a closer understanding and cooperation between engineers and landscape architects."
49. Department of the Interior/National Park Service. Blue Ridge Parkway [HAER] [1996/7], ibid.
50. Ibid.
51. Shirley, a Virginia Military Institute graduate and civil engineer who earned his doctorate degree from the University of Maryland, was first appointed as state highway commissioner in 1922, a position he held to the time of his death.
52. Department of the Interior/National Park Service. Blue Ridge Parkway [HAER] [1996/7], ibid.
53. Umstead, a Durham County native, was a congressman [1933 – 1939] at the time the Blue Ridge Parkway was in its salad days. But he went on to become a United States senator [1946 – 1948], appointed by Sam Ervin to fill the seat of Clyde Hoey, who died in office, and the sixty-third governor of North Carolina [1953 – 1954], when he died in office.
54. Hancock was a real estate developer, farmer, North Carolina legislator, congressman, federal official and county judge. He attended the University of North Carolina at Chapel Hill, where he studied law.
55. Jeffress graduated from Asheville High School in 1903 and thereafter matriculated to the University of North Carolina at Chapel Hill. He became an editor of the *Canton Observer* and by 1911 had purchased half interest in the *Greensboro Daily News* and took on the role of business manager. He was president of the paper by 1918. Jeffress was elected to the North Carolina General Assembly in the 1931 session and was also appointed to the state highway commission, a body he chaired for two years. After the 1933 reorganization, which produced the North Carolina State Highway and Public Works Commission, he was appointed to a four-year chairmanship but illness cut his tenure short. Jeffress was praised as an innovator who greatly improved the highway system of the Tar Heel state.
56. Maloney was the vice president of the Great Smoky Mountains Conservation Association and has been credited with conceiving of the idea of Tennessee's Foothills Parkway. He was also a brigadier general and the adjutant general of Knoxville, which has often led to his name being preceded by that title. Maloney was a constitutional officer of Tennessee from 1911 to 1915.
57. Department of the Interior/National Park Service. Blue Ridge Parkway [HAER] [1996/7], ibid.
58. The National Park Service account incorporated Edward H. Abbuehl's April 9, 1971 interview with Samuel Herbert Evison (1892 – 1988), the park service's long-time chief of information.
59. From the Samuel P. Weems interview conducted by S. Herbert Evison on August 28, 1975.
60. Department of the Interior/National Park Service. Blue Ridge Parkway [HAER] [1996/7], ibid.
61. Woodward was the local representative for the Federal Security Agency (FSA) Office in Raleigh

and also the field recreation representative for the Office of Community War Services. Before the war, he was an inspector for the National Park Service.

62. Stewart Woodward wrote a letter to Clyde R. Hoey, U.S. Senate, dated July 3, 1945.
63. Department of the Interior/National Park Service. Blue Ridge Parkway [HAER] [1996/7], ibid.
64. Ibid.
65. Ibid.
66. Ibid.
67. Ibid.
68. Robert Marshall was born in New York City on January 2, 1901, to prominent New York lawyer and American Jewish leader, Louis Marshall, and his wife, the former Florence Lowenstein. One of four Marshall children, Robert was raised in New York and received a bachelor of science degree from the New York State College of Forestry in 1925, a master of forestry degree from Harvard University in 1926 and a doctoral degree from Johns Hopkins University in 1930. Marshall was a devoted conservationist and environmentalist and he committed his life's work to these causes. He served first as the assistant silviculturist at the Northern Rocky Mountain Experiment Station from 1925 to 1928 before engaging in exploration, ecological studies, and anthropological research in northern Alaska from 1929 to 1931. From 1933 to 1937 Marshall served as director of forestry, Office of Indian Affairs, for the United States Department of Interior. In 1937 Marshall was appointed chief of division of recreation and lands, United States Forest Service, Department of Agriculture, the position he held at the time of his death in 1939. Marshall authored many books and articles on forestry and conservation, including *The Problem of the Wilderness* (1930), *Arctic Village* (Literary Guild selection for May 1933), *The People's Forests* (1933), *The Forest for Recreation* (selection in the forest service's A National Plan for American Forestry, 1933), *The Universe of the Wilderness is Vanishing* (1937), and *Alaska Wilderness: Exploring the Central Brooks Range* [(1970), first edition published as *Arctic Wilderness* (1956)]. He also made a map of 12,000 square miles of previously unchartered country in northern Alaska in 1934 which was published by the United States Geological Survey.
69. Department of the Interior/National Park Service. Blue Ridge Parkway [HAER] [1996/7], ibid.
70. Ibid.
71. Ibid.
72. Ibid.
73. Ibid.
74. Ibid. McKellar lost favor with Roosevelt when he opposed his administration's appointments. The most noted of these would be a prolonged feud with Roosevelt's appointee to head the Tennessee Valley Authority (TVA) – David Eli Lilienthal (1899 – 1981) – and as ranking member of the Senate Committee on Appropriations, he was a thorn in Roosevelt's side. Lilienthal ended up leading the TVA and later the Atomic Energy Commission (AEC).
75. Ibid.
76. Ibid.
77. Ibid.
78. Ibid.
79. Ibid.
80. Ibid.
81. There was an eighteen-hole course at Green Park-Norwood [now Blowing Rock Country Club], completed in 1922 [assumed to have been designed by famed Scot designer Donald Ross], and also the nine-hole Linville Golf Course, known to have been designed by Ross, on the grounds of an inn that burned in 1936 and was rebuilt as the Eseeola Lodge.
82. Cone built a textile empire with his brother Caesar Cone in Greensboro, North Carolina, that became the largest provider of denim in the world – surpassing even Levi Strauss and Company. This led to Moses Cone being called "the Denim King." Cone split his time between his residence in Greensboro and the summer retreat he called Flat Top Manor at Blowing Rock, a property of more than 3,600 acres and shown herein.
83. Department of the Interior/National Park Service. Blue Ridge Parkway [HAER] [1996/7], ibid.

84. Ibid.

85. Ibid.

86. Ibid.

87. Ibid.

88. In the law of succession, this is the part of the estate left over after legacies and bequests have been met – that which remains of something after taking away a part of it; as, the residue of an estate, which is what has not been particularly devised by will.

89. Department of the Interior/National Park Service. Blue Ridge Parkway [HAER] [1996/7], ibid.

90. Per National Park Service documentation, Edwin Maxwell Dale was interviewed by S. Herbert Evison in August 1980. Dale was listed as 'Mac Dale' in the park service notes pertaining to the interview. While serving on the parkway detail, he lived in Marion, McDowell County, North Carolina. Dale was born in Newport News, Virginia.

91. Department of the Interior/National Park Service. Blue Ridge Parkway [HAER] [1996/7], ibid.

92. A single-pen is just one unit: a rectangle of four walls of a log cabin.

93. Department of the Interior/National Park Service. Blue Ridge Parkway [HAER] [1996/7], ibid.

94. Ibid.

95. Ibid.

96. Ibid.

97. Ibid.

98. William Paschal "Pack" Murphy was born on July 2, 1867, in Meadow Creek, Grayson County, Virginia, and died on May 4, 1937, at Glade Creek, Alleghany County, North Carolina. A marker at this location is just a few hundred yards from the Virginia-North Carolina border near Cumberland Knob. Roughly one hundred Civilian Conservation Corps (CCC) workers started clearing and grading land on Pack Murphy's farm on September 11, 1935, the start of the first stretch of the Blue Ridge Parkway.

99. Teer, a construction contractor, was the son of George Washington Teer, brickyard owner, who with his partners in 1907, built the highway between Chapel Hill and Durham. The younger Teer took over his father's road construction enterprise two years later. Teer's company subsequently built 180 miles of the highly acclaimed Blue Ridge Parkway, a job beset with many problems caused by weather and terrain.

100. Department of the Interior/National Park Service. Blue Ridge Parkway [HAER] [1996/7], ibid.

101. Ibid.

102. Ibid.

103. McCarter (1899 – 1963) had also worked on Yellowstone and Grand Teton national parks.

104. After Charlie Goad died on March 30, 1946, in his home in Meadows of Dan, he was buried in the Goad Cemetery, Mabry Mill, Floyd County, Virginia. The cemetery is adjacent to the overflow parking area on the east side of the Blue Ridge Parkway.

105. Department of the Interior/National Park Service. Blue Ridge Parkway [HAER] [1996/7], ibid.

106. Ibid.

107. Ibid.

108. John Therone Johnson was the son of Castleton Johnson (1790 – 1859) and the former Nancy Eubank (1789 – 1849), originally of Botetourt County. Benjamin Wilkes (1801 – 1886) was the adjacent property owner in Peaks of Otter, Bedford County, Virginia.

109. Mary Polly Dooley Wood (1775 – 1854) was the wife of Jeremiah Wood (1774 – 1829).

110. Puckett's twenty-four children highly likely died of Rh disease, a condition caused by an incompatibility between the blood of a mother and that of her baby.

111. The National Park Service attributes the cabin to Jesse Sheets but it could not have been built by him in the year indicated – 1818 – because Jesse was not born until September 4, 1818; he died on September 11, 1902. Jesse and his wife, the former Sarah "Sally" Wyatt, had ten sons, all of who lived to adulthood.

112. By Famartin (Own work) [CC BY-SA 4.0 (https://creativecommons.org/licenses/by-sa/4.0)], via Wikimedia Commons

113. By PumpkinSky (Own work) [CC BY-SA 3.0 (https://creativecommons.org/licenses/by-sa/3.0)], via Wikimedia Commons
114. By Famartin (Own work) [CC BY-SA 4.0 (https://creativecommons.org/licenses/by-sa/4.0)], via Wikimedia Commons
115. By The original uploader was Nationalparks at English Wikipedia. [CC BY-SA 2.5 (https://creativecommons.org/licenses/by-sa/2.5)], via Wikimedia Commons
116. By jpmueller99 from Shenandoah Valley of VA, USA [CC BY 2.0 (http://creativecommons.org/licenses/by/2.0)], via Wikimedia Commons
117. By jpmueller99 from Shenandoah Valley of VA, USA [CC BY 2.0 (http://creativecommons.org/licenses/by/2.0)], via Wikimedia Commons
118. By Thea Ganoe [Public domain], via Wikimedia Commons
119. By vastateparksstaff [CC BY 2.0 (http://creativecommons.org/licenses/by/2.0)], via Wikimedia Commons
120. By Laura A. Macaluso Ph.D. (Own work) [CC BY-SA 4.0 (https://creativecommons.org/licenses/by-sa/4.0)], via Wikimedia Commons
121. Boblett married Ann Polly Carter (1829 – 1875) on April 19, 1849, and from this marriage nine children were born, all of who lived to adulthood.
122. By Tim Menzies from Morgantown, West Virginia (Blue Ridge Parkway: more pretty things) [CC BY-SA 2.0 (https://creativecommons.org/licenses/by-sa/2.0)], via Wikimedia Commons
123. By Niagara66 (Own work) [CC BY-SA 4.0 (https://creativecommons.org/licenses/by-sa/4.0)], via Wikimedia Commons
124. By Nyttend (Own work) [Public domain], via Wikimedia Commons
125. By Becky Cortino from Virtual, USA (Magnolia in bloom uploaded by uleli) [CC BY 2.0 (http://creativecommons.org/licenses/by/2.0)], via Wikimedia Commons
126. Eiler, Lyntha Scott, Terry Eiler and Carl Fleischhauer. *Blue Ridge Harvest: A Region's Folklife in Photographs*. An essay from the Blue Ridge Parkway Folklife Project conducted by the American Folklife Center in cooperation with the National Park Service in August and September 1978. https://www.loc.gov/folklife/blueridgeharvest/BlueRidgeHarvestBook_sm.pdf
127. Department of the Interior/National Park Service. Blue Ridge Parkway [HAER] [1996/7], ibid.
128. Ibid.
129. Ibid.
130. Robert Ward Gray was a civil engineer who worked as a project engineer for the Florida Highway Department from 1946 to 1947 before leaving the Sunshine State to manage the pottery shop at Old Sturbridge Village from 1949 to 1951, taking over coordination of the craft program in his last year there [1951]. Gray was the director of the Worcester Craft Center [1951 – 1961] before moving to Asheville, North Carolina, to take the job as executive director of the Southern Highland Craft Guild from 1961 to 1980.
131. Though Wolfe was an English professor at Middle Tennessee State University, he was also a respected music scholar and highly published author. He taught courses in literature, science fiction and folklore. He was on the project to document Blue Ridge Parkway folklore for his expertise in bluegrass, old-time music, southern fiddling and string bands, gospel, blues and rockabilly.
132. Eiler, et al., ibid.
133. Penland lived in Yancey County prior to the Civil War and owned considerable property not only in Burnsville but in present-day Mitchell County, much of it in the Crabtree Meadows area.
134. Benjamin Wade Ward (1892 – 1971) was an old-time music banjo player and fiddler from Independence, Grayson County, Virginia, best known for his clawhammer banjo playing. He won the Galax, Virginia Old Time Fiddlers Convention many times. Ward's Gibson RB-11 five-string banjo is now on display in the Smithsonian Institution. He began performing in public in 1919 and his first group, the Buck Mountain Band, included Van Edwards on fiddle and Van's son Earl on guitar. By the early 1930s he joined the Ballard Branch Bogtrotters, formed by his older brother David Crockett Ward (1873 – 1964), twenty years his senior. Among the

members were Fields Mack Ward (1911 – 1987), Crockett Ward's son, and Alexander W. "Uncle Eck" Dunford (1875 – 1953). Folklorist and pioneering musicologist John Avery Lomax (1867 – 1948) discovered the group in 1937 at the Galax Fiddlers Convention and recorded them for the Library of Congress. There are nearly two hundred recordings of Ward archived by the Library of Congress' American Folklife Center.

135. By Ungenda (Own work) [Public domain], via Wikimedia Commons

136. Wolter, Beverly. "Hartley, Sing on Mountain's founder, dies," *Winston-Salem Journal*, March 1, 1966.

137. Watson played guitar in both flatpicking and fingerpicking style, but is best known for his flatpick work. His guitar playing skills, combined with his authenticity as a mountain musician, made him a highly influential figure during the folk music revival. Watson pioneered a fast and flashy bluegrass lead guitar style including fiddle tunes and crosspicking techniques which were adopted and extended by Clarence White, Tony Rice and many others. Watson was also an accomplished banjo player and sometimes accompanied himself on harmonica as well. Known also for his distinctive and rich baritone voice, Watson over the years developed a vast repertoire of mountain ballads, which he learned from the oral tradition of his home area in Deep Gap, North Carolina.

138. https://www.ncparks.gov/mount-mitchell-state-park/history

139. Ibid.

140. Hicklin, James Blaine (1900 – 1957), "Mount Mitchell...then and now," *The State* [no date]. Source located in the State Archives of North Carolina [photographs and newspaper clippings of Mount Mitchell State Park (1928 – 1946)].

141. To settle the matter of which peak was the highest, in 1856 Elisha Mitchell ran a series of levels from the terminus of the railroad near Morganton, Burke County, North Carolina, to the half-way house [a depot] for travelers, one of two built by Wilkes County, North Carolina native and Charleston, South Carolina merchant William Patton (1794 – 1857) in 1851. This particular depot was referred to as Patton's mountain house; it was located four miles up the Black Mountains, just in the edge of the balsam growth. Patton died at Warm Springs, Madison County, North Carolina, on June 3, 1857.

142. Clingman, a Civil War general, had explored the area extensively in the 1850s, before the war, and then spent many years promoting it. Arnold Henry Guyot (1807 – 1884), a Swiss-American geologist and geographer and Princeton University professor, renamed the former Smoky Dome for Clingman in 1859. Guyot did this due to the argument between Clingman and Dr. Elisha Mitchell over which mountain was actually the highest in the area. Mitchell argued that it was the peak then named Black Dome – now Mount Mitchell – and Clingman insisted it was Smoky Dome. Guyot would eventually determine that Black Dome was, indeed, the highest peak.

143. Hicklin, ibid.

144. Ibid.

145. "Mount Mitchell State Forest – opinions of representative men as expressed at the convention of the North Carolina Forestry Association, Raleigh, North Carolina, January 13, 1915," North Carolina Geological and Economic Survey [bulletin], February 2, 1915.

146. Ibid.

147. Weaver was responsible for the bill that resulted in the creation of the Great Smoky Mountains National Park.

148. Mount Mitchell State Forest [February 2, 1915], ibid.

149. Thomas Wallace Morse (1906 – 1986) served as superintendent of North Carolina's state park system from 1935 to 1961 with a break in service during his World War II military service.

150. Morse, Thomas W. Reports on State Parks presented to the Board of Conservation and Development [1948]. State Archives of North Carolina.

151. Ibid.

152. This new type of siphon barometer was invented in 1816 by the French chemist Joseph-Louis Gay-Lussac.

153. By Internet Archive Book Images [No restrictions], via Wikimedia Commons

154. Simpson Jr., Marcus B., "Mount Mitchell Railroad," *Encyclopedia of North Carolina*. Chapel Hill, North Carolina: University of North Carolina Press, 2006. https://www.ncpedia.org/mount-mitchell-railroad

155. The Camp Alice Trail is a quarter-mile from the summit and descends the south face of Mount Mitchell to Camp Alice, the tourist camp built between 1914 and 1915. Logging operations had ceased by 1921 due largely to the depletion of timber resources. The tracks and ties were pulled up and the old railroad bed was repurposed to create the Mount Mitchell Motor Road, which opened for automobiles in June 1922. Between the 1920s and 1940s tourists drove to Camp Alice and then hiked the remaining mile to Mount Mitchell's summit. Today, nothing remains of Camp Alice and in spite of its name, camping is not allowed there.

156. The background of the Mount Mitchell Railroad [shown in the postcard] includes the important backstory of the Dickey and Campbell Company, of Marion, Virginia, which became one of the largest lumber producers in western North Carolina. Dickey and Campbell were in business with the Highland Spruce Company, which owned nine thousand acres of spruce timber on the eastern slope of the Black Mountains, including Mount Mitchell and Highland Spruce's treasurer, Marcus Llewellyn Foster (1871 – 1931), of Worcester, Massachusetts, was also Dickey and Campbell's treasurer. Dickey and Campbell would own eighteen thousand acres of spruce timber land in the Black Mountains and would, of course, operate its own railroad. The company began construction in 1911 of a narrow-gauge railroad that originated at Black Mountain and traveled over twenty-one miles to Mount Mitchell. Historical record informs that the line included nine switchbacks, extremely sharp curves, and some grades over 5.25 percent. Two years later, in 1913, the company was sold to Perley and Crockett Company of Williamsburg, Pennsylvania, and it would be under Perley and Crockett, with an investment of over $1 million that the mill and railroad was greatly improved. The following year, the railroad reached Camp Alice, near the summit of Mount Mitchell. Tourist trains ran from 1913 to 1918, when government pressure forced the end of tourism trade in favor of spruce lumber removal, which the military needed to build aircraft during the First World War. Though passenger service briefly revived after the war, it ended when it was realized that the motor car could better navigate the trip via a toll road. Dickey and Campbell Company was formed by Pennsylvanians Clarence A. Dickey (1871 – 1938) and Joseph Cameron Campbell (1863 – 1917), the president of United States Spruce Company, of Marion, Smyth County, Virginia, who were first granted right-of-way for a logging railroad on December 14, 1911. Later, it would be Fred Perley and Clarence Dickey who introduced the idea of a tolled motor road to Mount Mitchell.

157. Simpson Jr., ibid.

158. The warden's cabin was built for $3,000 and had a large living area and meeting room.

159. Herbert Charles Hoover was also known has Herbert Hoover Jr. But he was, in truth, named for his father and maternal grandfather, Charles Delano Henry.

160. Walter Matson Cline Jr. was a naval aviator – an instructor pilot – during World War II.

161. North Carolina Department of Cultural Resources: http://www.ncmarkers.com/Markers.aspx?MarkerId=P-67

162. By bobistraveling [CC BY 2.0 (http://creativecommons.org/licenses/by/2.0)], via Wikimedia Commons

163. By KudzuVine (Own work) [Public domain], via Wikimedia Commons

164. By Ken Thomas (KenThomas.us (personal website of photographer)) [Public domain], via Wikimedia Commons

165. By Washuotaku (Own work) [CC BY-SA 4.0 (https://creativecommons.org/licenses/by-sa/4.0)], via Wikimedia Commons

166. Department of the Interior/National Park Service. Blue Ridge Parkway [HAER] [1996/7], ibid.

167. Ibid.

168. Ibid.

169. Ibid.

170. Abbott left in 1949 to head the National Park Service team surveying the feasibility of a Mississippi River Parkway.

171. Department of the Interior/National Park Service. Blue Ridge Parkway [HAER] [1996/7], ibid.

172. Ibid.

173. Ibid.

174. Drury was the fourth director of the National Park Service. Drury had declined appointment as park director in 1933, but accepted the job in 1940. He was the first director without prior national park responsibilities, but came with strong conservationist credentials, having served as executive secretary of the Save-the-Redwoods League in California. During the Second World War he successfully resisted most demands for consumptive uses of park resources. Less eager than his predecessors to expand the park system, he opposed park service involvement with areas he judged not to meet national park standards. Differences with Secretary of the Interior Oscar Chapman over Chapman's support for dams in Dinosaur National Monument contributed to Drury's resignation in 1951.

175. Department of the Interior/National Park Service. Blue Ridge Parkway [HAER] [1996/7], ibid.

176. Ibid.

177. Ibid.

178. Ibid.

179. Ibid.

180. Ibid.

181. Ibid.

182. Weems was followed as superintendent by several successors who remained in the job for relatively short periods of time: James Milford Eden (1913 – 1971), who led the parkway office from January 1, 1967, to February 24, 1968; Granville Liles, February 25, 1968, to June 30, 1975, and Joseph Brown, July 29, 1975, to October 22, 1977.

183. Everhardt, superintendent from 1977 to 2000, was instrumental in the initiation and completion of significant parts of what the parkway has become today, to include the Linn Cove Viaduct – the Grandfather Mountain missing link section of the road – and Asheville's Folk Art Center and the parkway visitor center. There's also the Blue Ridge Music Center, to which he was also a pivotal part.

184. By Famartin (Own work) [CC BY-SA 4.0 (https://creativecommons.org/licenses/by-sa/4.0)], via Wikimedia Commons

185. By Ken Thomas (KenThomas.us (personal website of photographer)) [Public domain], via Wikimedia Commons

186. By Ken Thomas (KenThomas.us (personal website of photographer)) [Public domain], via Wikimedia Commons [both photographs]

187. By Ken Thomas (KenThomas.us (personal website of photographer)) [Public domain], via Wikimedia Commons

188. By J.D. Shepard at en.wikipedia (Transferred from en.wikipedia by SreeBot) [Public domain], via Wikimedia Commons

189. By Kadoka1 (Own work) [CC BY-SA 3.0 (https://creativecommons.org/licenses/by-sa/3.0)], via Wikimedia Commons

190. By Thomson200 (Own work) [CC0], via Wikimedia Commons [Public domain]

191. By Thomson200 (Own work) [CC0], via Wikimedia Commons [Public domain]

192. By Brian Stansberry (Own work) [CC BY 3.0 (http://creativecommons.org/licenses/by/3.0)], via Wikimedia Commons

193. By Washuotaku (Own work) [CC BY-SA 4.0 (https://creativecommons.org/licenses/by-sa/4.0)], via Wikimedia Commons

194. Department of the Interior/National Park Service. *Visual Character of the Blue Ridge Parkway – Virginia and North Carolina*. Washington, D.C., January 1997. https://ia800609.us.archive.org/6/items/visualcharacter00nati/visualcharacter00nati.pdf

195. Department of the Interior/National Park Service. Blue Ridge Parkway [HAER] [1996/7], ibid.

196. Ibid.

197. Ibid.

198. Ibid.

199. Ibid.

200. Ibid.

201. By TampAGS, for AGS Media (Own work) [CC BY-SA 3.0 (https://creativecommons.org/licenses/by-sa/3.0) via Wikimedia Commons

202. By RMLark (Own work) [CC BY-SA 4.0 (https://creativecommons.org/licenses/by-sa/4.0)], via Wikimedia Commons

203. By Ken Thomas (KenThomas.us (personal website of photographer)) [Public domain], via Wikimedia Commons

204. By Ken Thomas (KenThomas.us (personal website of photographer)) [Public domain], via Wikimedia Commons

205. By Ken Thomas (KenThomas.us (personal website of photographer)) [Public domain], via Wikimedia Commons

206. By Matthew Trudeau Photography from Murrells inlet, USA (Linn Cove Viaduct) [CC0], via Wikimedia Commons [Public Domain]

207. http://www.ForestWander.com [CC BY-SA 3.0 us (https://creativecommons.org/licenses/by-sa/3.0/us/deed.en)], via Wikimedia Commons

208. https://grandfather.com/information/mountain-escapes/mile-high-swinging-bridge/swinging-bridge-facts/

209. By Ken Thomas (KenThomas.us (personal website of photographer)) [Public domain], via Wikimedia Commons

210. By David Joyce [CC BY-SA 2.0 (https://creativecommons.org/licenses/by-sa/2.0)], via Wikimedia Commons

211. By Ken Thomas (KenThomas.us (personal website of photographer)) [Public domain], via Wikimedia Commons

212. By Ken Thomas (KenThomas.us (personal website of photographer)) [Public domain], via Wikimedia Commons

213. By Kadoka1 (Own work [1]) [CC BY-SA 3.0 (https://creativecommons.org/licenses/by-sa/3.0)], via Wikimedia Commons

214. By Ken Thomas (KenThomas.us (personal website of photographer)) [Public domain], via Wikimedia Commons

215. By Ken Thomas (KenThomas.us (personal website of photographer)) [Public domain], via Wikimedia Commons

216. Will Thomas [CC BY-SA 3.0 (https://creativecommons.org/licenses/by-sa/3.0)], via Wikimedia Commons

217. Will Thomas [CC BY-SA 3.0 (https://creativecommons.org/licenses/by-sa/3.0)], via Wikimedia Commons

218. Brothers Dr. Lucius Boardman Morse (1871 – 1946), Hiram B. Morse (1864 – 1952), and Asahel U. Morse (1864 – 1939) developed Chimney Rock, to include the dam that created Lake Lure, completed in 1926 and the incorporation, in 1927, of the town of Lake Lure.

219. By Jmturner (Own work) [Public domain], via Wikimedia Commons

220. David Dugan [CC BY-SA 3.0 (https://creativecommons.org/licenses/by-sa/3.0)], via Wikimedia Commons

221. By Ken Thomas (KenThomas.us (personal website of photographer)) [Public domain], via Wikimedia Commons

222. By Lincolnh (Own work) [CC BY-SA 3.0 (https://creativecommons.org/licenses/by-sa/3.0)], via Wikimedia Commons

223. By Vanessa Ezekowitz (Own work) [CC BY-SA 4.0 (https://creativecommons.org/licenses/by-sa/4.0)], via Wikimedia Commons

Select Bibliography

Primary Sources

Bayliss, Dudley C. *Planning Our National Park Roads and Our National Parkways*. Washington, D.C.: National Park Service, 1957.

Department of the Interior/National Park Service. Historic American Building Survey [HABS]. Brinegar Cabin [HABS No. NC-188] Blue Ridge Parkway, Wilkes County, North Carolina [May 27, 1959].

– Pisgah National Forest Inn [Old Pisgah Inn] [HABS No. NC-356] [April 1988] Blue Ridge Parkway, Asheville, Buncombe County, North Carolina.

– Pisgah National Forest Inn [Old Pisgah Inn] [HABS No. NC-356] [April 1988] [Index to photographs] Blue Ridge Parkway, Asheville, Buncombe County, North Carolina.

Department of the Interior/National Park Service. Historic American Engineering Record [HAER]. Oconaluftee Bridge [HAER No. NC-40] [October 1, 1981] Great Smoky Mountains National Park, Cherokee, Swain County, North Carolina.

– Blue Ridge Parkway [HAER No. NC-42] [1996/7]. http://cdn.loc.gov/master/pnp/habshaer/nc/nc0400/nc0478/data/nc0478data.pdf

– Blue Ridge Parkway [HAER No. NC-42] [1996/7] [Index to photographs]. http://cdn.loc.gov/master/pnp/habshaer/nc/nc0400/nc0478/data/nc0478cap.pdf

Department of the Interior/National Park Service. National Register of Historic Places [NRHP] Inventory Form. Brinegar Cabin [NRHP], Blue Ridge Parkway, Whitehead vicinity, Alleghany County [note the difference of county assignment from the HABS], North Carolina [July 28, 1971].

– William Jennings Bryan House, Asheville, Buncombe County, North Carolina [December 31, 1984].

– Penland School Historic District, Mitchell County, North Carolina [NRHP] [October 23, 2003].

– Penland Post Office and General Store, Mitchell County, North Carolina [NRHP] [April 16, 2012].

– Natural Bridge Historic District, Rockbridge County, Virginia [NRHP] [December 16, 2015].

Department of the Interior/National Park Service. *Visual Character of the Blue Ridge Parkway – Virginia and North Carolina*. Washington, D.C., January 1997. https://ia800609.us.archive.org/6/items/visualcharacter00nati/visualcharacter00nati.pdf

Eiler, Lyntha Scott, Terry Eiler and Carl Fleischhauer. *Blue Ridge Harvest: A Region's Folklife in Photographs*. An essay from the Blue Ridge Parkway Folklife Project conducted by the Library of Congress American

Follife Center in cooperation with the National Park Service in August and September 1978. https://www.loc.gov/folklife/blueridgeharvest/BlueRidgeHarvestBook_sm.pdf

Foster, Clifton Dale. Inventory of the Blue Ridge Parkway Archives. [Contract No. CX-5000-9-0046] [September 1990].

Holmes, John Simcox (1868 – 1958), state forester. Forest Fires in North Carolina During 1914 and Forestry Laws of North Carolina [Economic Paper No. 40]. Raleigh, North Carolina: E. M. Uzzell and Company, State Printers and Binders, 1915. Holmes, a native of Ontario, Canada, and professionally trained forester, was hired by North Carolina in 1909. Six years later, in 1915, the first fire wardens were employed by the state. The same year Holmes became the first state forester and state forest warden for the newly created North Carolina Forest Service. He stepped down from this position in 1945.

North Carolina Geological and Economic Survey [bulletin]. "Can Mount Mitchell's spruce forests be saved?" [October 15, 1914].

– "Mount Mitchell State Forest – opinions of representative men as expressed at the convention of the North Carolina Forestry Association, Raleigh, North Carolina, January 13, 1915. [February 2, 1915].

State Archives of North Carolina. Notes on acquisition of Mount Mitchell State Park [1946]. Recorded by John Simcox Holmes (1868 – 1958).

– Reports on State Parks presented to the Board of Conservation and Development [1948]. Recorded by Thomas Wallace Morse (1906 – 1986).

Books

Anderson, C. Thomas, ed. *Arthur Rothstein's American Portraits*. Washington, D.C.: thegreatdepressionphotos.com, 2014. https://thegreatdepressionphotos.files.wordpress.com/2014/07/arthur-rothsteins-american-portraits.pdf

Ashe, Samuel A., Stephen B. Weeks and Charles L. Van Noppen. *Biographical History of North Carolina – From Colonial Times to the Present* [Volume VI]. Greensboro, North Carolina: Charles L. Van Noppen, 1907.

Colbert, Judy. *Scenic Routes and Byways – Virginia*. Guilford, Connecticut: Morris Book Publishing, 2014.

Hall, Karen and Friends of the Blue Ridge Parkway, Inc. *Building the Blue Ridge Parkway*. Charleston, South Carolina: Arcadia, 2007.

Lasley, Robert T. and Karen O'C. Garvey, eds. *Blue Ridge Tales*. Conover, North Carolina: Hometown Memories Publishing Company, 1996.

Logue, Victoria, Frank Logue and Nicole Blouin. *Guide to the Blue Ridge Parkway*. Birmingham, Alabama: Menasha Ridge Press, 2010.

Lord, William G. *The Blue Ridge Parkway Guide*. Asheville, North Carolina: The Stephens Press, 1963.

Whisnant, Anne Mitchell. *Super-scenic Motorway – A Blue Ridge Parkway History*. Chapel Hill, North Carolina: University of North Carolina Press, 2006.

Periodicals, Pamphlets and Papers

Asheville Citizen-Times. "Two observers will live all year on peak," September 20, 1936.

Bayliss, Dudley C., "Parkway development under the National Park Service," *Parks and Recreation*, Volume 20, February 1937.

Guarino, Mark, "Ralph Stanley remembered: bluegrass's humble mountain king," *The Guardian*, June 24, 2016. https://www.theguardian.com/music/2016/jun/24/ralph-stanley-obituary-bluegrasss-musician

Hicklin, James Blaine (1900 – 1957), "Mount Mitchell…then and now," *The State* [1940]. Source located in the State Archives of North Carolina [photographs and newspaper clippings of Mount Mitchell State Park (1928 – 1946)]

Janiskee, Bob, "Stanley W. Abbott, wizard of the Blue Ridge Parkway," *National Parks Traveler*, October 10, 2008. https://www.nationalparkstraveler.org/2008/10/stanley-w-abbott-wizard-blue-ridge-parkway

Johnson, Randy, "Gary Everhardt: the 'right man at the right time' on the Blue Ridge Parkway," *National Parks Traveler*, October 28, 2010. https://www.nationalparkstraveler.org/2010/10/gary-everhardt-%E2%80%9Cright-man-right-time%E2%80%9D-blue-ridge-parkway7132

– "Gary Everhardt's impact on the Blue Ridge Parkway," *National Parks Traveler*, October 29, 2010. https://www.nationalparkstraveler.org/2010/10/gary-everhardts-impact-blue-ridge-parkway7134

– "The wonder that is the Linn Cove Viaduct on the Blue Ridge Parkway," *National Parks Traveler*, October 29, 2010. https://www.nationalparkstraveler.org/2010/10/wonder-linn-cove-viaduct-blue-ridge-parkway7135

Kasper, Andrew, "Galax takes a beating from black market trade," *Smoky Mountain News*, September 26, 2012. http://www.smokymountainnews.com/outdoors/item/8894-galax-takes-a-beating-from-blackmarket-trade

Morrison, Jim, "75 years of the Blue Ridge Parkway," *Smithsonian.com*, September 15, 2010. https://www.smithsonianmag.com/history/75-years-of-the-blue-ridge-parkway-61889786/

Muller, Jean M. and James M. Barker, "Design and construction of Linn Cover Viaduct," *PCI Journal*, September-October 1985. https://www.pci.org/PCI_Docs/Design_Resources/Guides_and_manuals/references/bridge_design_manual/JL-85-September-October_Design_and_Construction_of_Linn_Cove_Viaduct.pdf

Speer, Jean Haskell, Frances H. Russell and Gibson Worsham. The Kelley School [Pate/Ware Store] Blue Ridge Parkway Milepost 149/Historic Resource Study – Volume 1 and Historic Structure Report – Volume 2, prepared for the Blue Ridge Parkway, 1989.

Wolter, Beverly. "Hartley, Sing on Mountain's founder, dies," *Winston-Salem Journal*, March 1, 1966.

Websites

Blue Ridge Parkway: https://visitncsmokies.com/blue-ridge-parkway/

Exploring North Carolina: https://www.ncpedia.org/exploring-state-parks

Mount Mitchell State Park: https://www.ncparks.gov/mount-mitchell-state-park/history

Parks to the Side – Stories from six Blue Ridge Parkway recreation areas: http://blueridgeparks.web.unc.edu/

Visit NC: https://www.visitnc.com

About the Author

Amy Waters Yarsinske is the author of several best-selling, award-winning nonfiction books, notably *An American in the Basement: The Betrayal of Captain Scott Speicher and the Cover-up of His Death*, which won the Next Generation Indie Book Award for General Non-fiction in 2014. To those who know this prolific author and Renaissance woman, it's no surprise that that she became a writer. Amy's drive to document and investigate history-shaping stories and people has already led to publication of over 80 nonfiction books, most of them spotlighting current affairs, the military, history and the environment. Amy graduated from Randolph-Macon Woman's College in Lynchburg, Virginia, where she earned her Bachelor of Arts in English and Economics, and the University of Virginia School of Architecture, where she earned her Master of Planning and was a DuPont Fellow and Lawn/Range resident. She also holds numerous graduate certificates, including those earned from the CIVIC Leadership Institute and the Joint Forces Staff College, both headquartered in Norfolk, Virginia. Amy serves on the national board of directors of Honor-Release-Return, Inc. and the National Vietnam and Gulf War Veterans Coalition, where she is also the chairman of the Gulf War Illness Committee. She is a member of the American Society of Journalists and Authors (ASJA), Investigative Reporters and Editors (IRE), Authors Guild and the North Carolina Literary and Historical Association (NCLHA), among her many professional and civic memberships and activities.

If you want to know more about Amy and her books, go to
www.amywatersyarsinske.com

Also by Amy Waters Yarsinske

AMY WATERS YARSINSKE

NEWPORT NEWS

THROUGH THE 20TH CENTURY

NEWPORT NEWS THROUGH THE 20TH CENTURY

978-1-63499-011-0

$25.99

Also by Amy Waters Yarsinske

NORFOLK THROUGH TIME

978-1-63500-001-6

$22.99

Also by Amy Waters Yarsinske

The

NORFOLK
BOTANICAL GARDEN
A Natural Treasure

AMY WATERS YARSINSKE

THE NORFOLK BOTANICAL GARDEN

978-1-63499-003-5

$28.95